The Architecture of Minimalism

Art and architecture - all the arts - do not have to exist in isolation,

as they do now. This fault is very much a key to present society.

Architecture is nearly gone, but all the arts, in fact all parts

The Architecture of Minimalism

of society, have to be rejoined, and joined more than they have ever

been. This would be democratic in a good sense, unlike the present

increasing fragmentation into separate but equal categories, equal within

the arts, but inferior to powerful bureaucracies. (Donald Judd)

Author

Francisco Asensio Cerver

Editorial manager

Paco Asensio

Project coordinator

Ivan Bercedo (Architect)

Graphic Design

Mireia Casanovas Soley

Layout

Òscar Lleonart Ruiz

Text

Ivan Bercedo: *Introduction. Department of Geosciences, Aveiro University. Le Stadium. The Finnish Embassy in Washington, D.C. Calvin Klein Madison Avenue. Price/O'Reilly House. Faculty of Journalism. Communications Sciences Faculty. Maison des Arts.*

Cayetano Cardelus: *Dr. Baeltz.*

Jorge Mestre: *Vitra Conference Pavilion. House n. 15. Lager Technik Wolfurt Office and Garage Building. Marne-la-Vallée Technical Center. Signal Box.*

Hiroshi Nakao: *House for a flower artist.*

Moises Puente: *The New World School.*

Itziar Sen: *Giorgio Armani Boutique. Bottega Veneta.*

Rob Weiner: *The Chinati Foundation.*

Translation

Richard Rees

Copyediting

Michael Webb

Proofreading

Amber Ockrassa

First published in 1997 by Arco for

Hearst Books International

1350 Avenue of the Americas

New York, NY 10019

Distributed in the U.S. and Canada by

Watson-Guptill Publications

1515 Broadway

New York, NY 10036

Distributed throughout the rest of the world by

Hearst Books international

1350 Avenue of the Americas

New York, NY 10019

1997 © Francisco Asensio Cerver

ISBN: 0-8230-6149-3

Printed in Spain

The Architecture of Minimalism

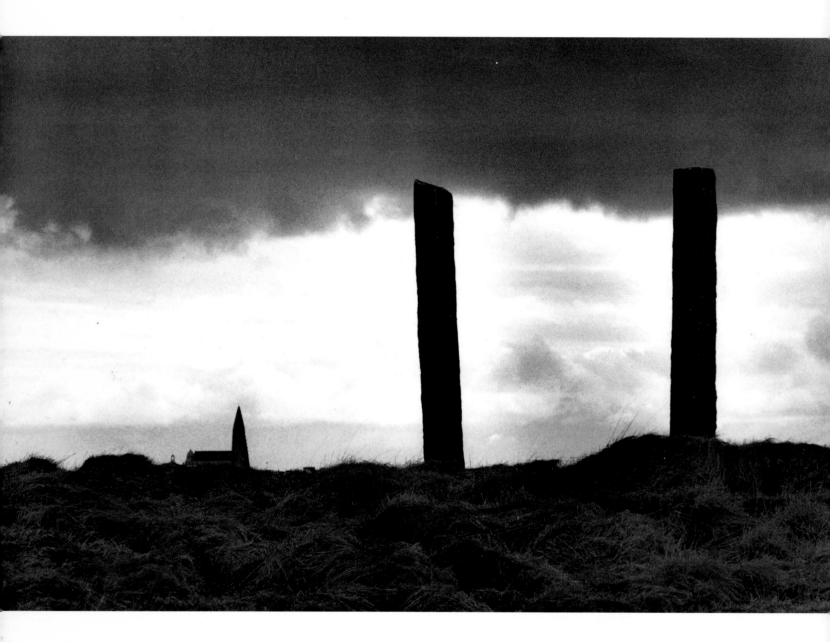

Afangar, Iceland. Richard Serra, 1990.

Untitled, Marfa (Texas). Donald Judd, 1986.

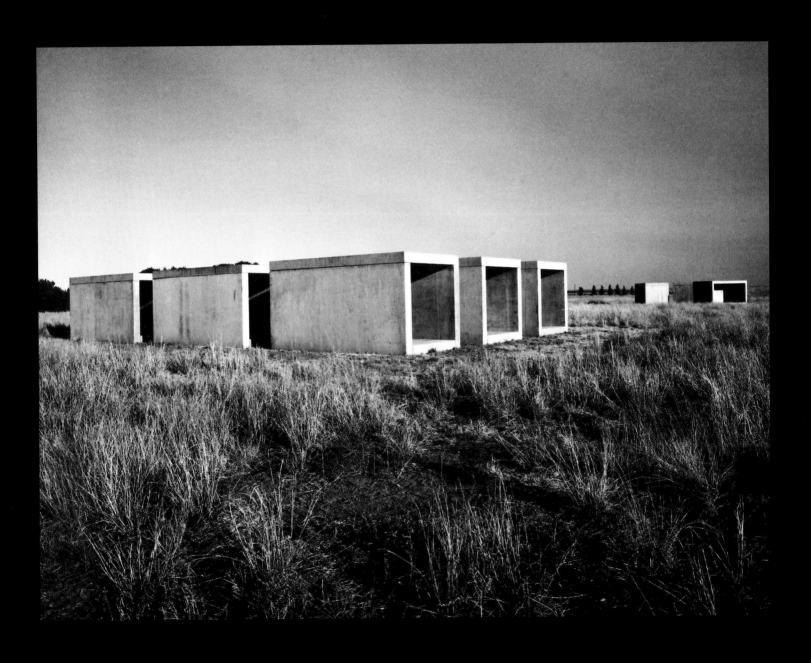

The terms Minimalism or Minimal Art usually refer to the work produced during the 1960s by a group of American artists, among them Robert Morris, Carl Andre, Anthony Caro, Donald Judd, Tony Smith, Frank Stella, Robert Ryman, Walter de Maria, and later, Sol LeWitt, Richard Serra, Dan Flavin, Robert Smithson, Michael Heizer, Joel Shapiro and even James Turrell.

Despite similarities, mutual collaborations, and friendships among these artists, however, obvious differences in their work stand out. When we speak of Minimal Art we refer not to a homogeneous movement based on shared principles, but rather to a group of contemporary artists in whose work we can detect certain similarities. In a sense, it is actually simplification to which critics inevitably cling. In some cases we could speak of Abstract Art (Frank Stella, Sol LeWitt), since it is no coincidence that some of their most immediate references are the paintings of Mark Rothko, Barnett Newman and Ad Reinhardt, or in other cases, of landscape artists (Walter de Maria, Robert Smithson).

Donald Judd himself was one of the people who fought most strongly against having the term Minimalism applied to his work. He considered his sculptures by no means to be minimal. On the contrary, what had driven him to create those objects was the will to move far away from appearance and

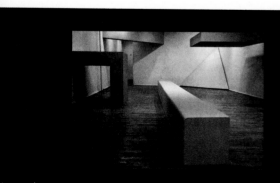

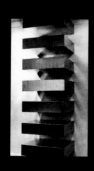

1

2

3

representation, and to create objects whose force lies in their concrete presence in a place, developing properties such as scale, the relationship with the immediate surroundings, direct work with materials, reflections, texture-hardly minimal, in other words. Among Minimalists are painters, sculptors, creators of installations, and artists who work with light or even with topography and land. In practically all their works the formal resources employed are minimal. They transmit a certain conceptual coldness. They often use methods of mathematical composition such as serialization or repetition. What unites the work of all Minimalists is the will to create a specific work whose meaning stems not

from a discourse on what the work evokes or on how it was executed, but rather from direct observation of the work and its relationship to its surroundings.

When we speak of something restrained, of simple forms in which superfluity has been maximally reduced, we call it minimalist (and, of course, the works by Minimalists can be so described, since all allusions, references, and evocations have been removed from them). Many things might be considered minimalist, such as a poem, garment, piece of music or furniture, or the design of a television set, film, or building. Obviously, when speaking of minimalist opera we refer to something completely different from a work by Judd.

And so, we discover that term minimalist has been applied to music, literature, dance, fashion, and architecture. Does this imply that the term has been trivialized, or that Richard Serra is a true Minimalist while Raymond Carver, Anne Kersmeiker, or Claudio Silvestrin are impostors? Absolutely not. What it implies is that the term has been generalized and its meaning has become less precise.

In architecture, we see an obvious tradition of geometric rigor, of formal restraint, and conceptual purity. The predecessors of Mies van der Rohe, Richard Neutra, Rudolph Schindler, Giuseppe Terragni, and Adolf Loos make up a heritage as important as the work of Robert Morris or Donald

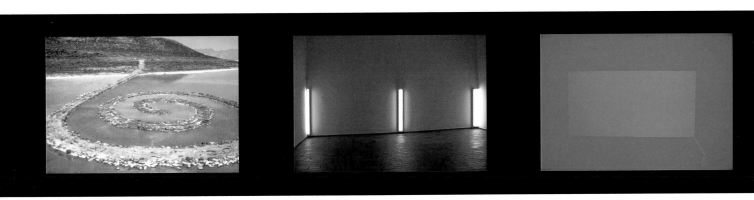

7. Kidosaki House, Tadao Ando, 1986.

*8. Turégano House, Alberto Campo
 Baeza, 1987.*

*9. Gaspar House, Alberto Campo
 Baeza, 1993.*

*10. Houses in Montagnola,
 Campi & Pessina. 1989.*

Judd. Nonetheless, as those who subscribe to the pendular or cyclical view of history have observed, although each cycle recovers the spirit of its earlier counterpart, this never takes place in exactly the same way, because the context is no longer the same. For that reason, although similarities might exist between Mies (Farnsworth House, Pierre Chareau's Maison de Verre or Loos' Tzara House and more recent works) the intentions and concerns of present-day architects obviously differ from those of professionals working during the first half of the 20th century. Similarly, nobody would claim that Ad Reinhardt or Ellsworth Kelly repeat the work of Malevich, even though they might paint a monochrome square, because their purposes are entirely different. Analyzing the work of each architect in his or her own right, noting personal sources and points of reference, is far more revealing than attempting to discover an overall theory that probably does not exist.

The term Minimalism, as applied to architecture, first became popular in the late 1980s, due largely to collaboration between certain fashion designers and architects, above all in London and New York. The boutiques of Calvin Klein, Armani, Issey Miyake, Jill Sander, Donna Karan NY and Bottega Veneta have created their own recognizable aesthetic based on simplicity, the use of white, cold lighting,

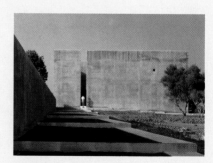

*Villa Neuendorf, John Pawson and
Claudio Silvestrin, 1989.*

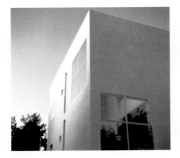 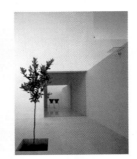 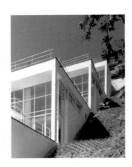

large spaces with few objects on dis-
play, and the minimum of furniture.
The architects responsible for these
boutiques, John Pawson, Peter
Marino, David Chipperfield, Stanton
Wiliams, Claudio Silvestrin, Michael
Gabellini, François de Menil and
Daniel Rowen, call themselves
Minimalists and often have recourse to
pieces of furniture designed by
Donald Judd or to lighting treatment
reminiscent of James Turrell.
Several of these architects earlier had
designed art galleries, and their subse-
quent relationship with Minimalist
sculpture stems from that experience.
Nevertheless, what happens is the
transposition both of content and con-
tainer. For a number of reasons,

Minimalist boutiques are conceived as
art galleries. Few other types of space
exist whose only purpose is to present
an object under the best conditions.
Boutique owners naturally attempt to
display their products exactly as they
are, without deceit or artifacts, adop-
ting the exhibiting tradition of art
galleries. Happily, such identification
also leads the merchandise to acquire
the aura of artworks. The association
between product and work of art is
not new, of course. Paintings and
sculptures displayed in galleries are
also for sale.
The popularization of the term
Minimalism is to a considerable extent
tied to a change in commercial strate-
gies that began when a few designers

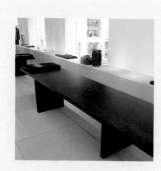

decided to stop barraging their customers with information and instead to display their creations just as they were, allowing customers to appreciate the quality of raw materials and the care with which they had been made. Once the term minimalism was launched in publications and debates, critics created a conceptual bridge to Minimalism in a more formal sense: the Turégano House, Villa Neuerdorf, the Koshino House. Similarly, they turned with particular enthusiasm to other architects who had been experimenting in similar directions for some time: Tadao Ando, Herzog and de Meuron, Campi and Pessina, Dominique Perrault, Souto de Moura, and Alberto Campo Baeza.

In the case of Souto de Moura and Alberto Campo Baeza, the formal rigor, perfect geometric forms, and the whiteness of their buildings undoubtedly stem from a refinement of lessons from the Modern Movement and the Mediterranean vernacular tradition. Both of these Iberians declare themselves heirs to the legacy of some second-generation modern masters, such as Fernando Tavora or Alejandro de la Sota.
In the works of Herzog and de Meuron, Campi and Pessina, and other Swiss architects such as Gigon and Guyer, Peter Zumthor, Diener and Diener, Peter Märkli and Burkhalter and Sumi, what strikes us is their unusual asceticism and surprising simpli-

14. Faculty of journalism,
 Vicens & Ramos, 1996.

15. Maison des Arts,
 Massimiliano Fuksas, 1995.

16. Marne-la-Vallée Technical Center,
 Dominique Perrault, 1995.

17. Signal Box,
 Herzog & de Meuron, 1995.

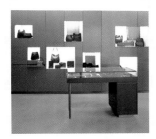

11. Giorgio Armani Boutique,
 Peter Marino, 1996.

12. Calvin Klein Madison Avenue,
 John Pawson, 1995.

13. Bottega Veneta Short Hills,
 François de Menil, 1996.

city. Swiss architecture has inherited the austerity of Calvinism. The sobriety and even hardness of works produced in Switzerland derive from culture and character, and this may also be extended to some Austrian architects, such as Baumschlager and Eberle, Krischanitz, and Riegler and Riewe.

Tadao Ando's architecture transmits both Japanese spirituality and Ando's own personal view of nature. Many British Minimalist architects worked in Japan and recognize the impact made on them by that country. Nonetheless, what is more remarkable is the tremendous influence Ando's work has had on Japanese architecture. His personal interpretation of Japanese aesthetics has spread like a new language among architects in Japan.

In this book, we present the work of architects who, while not normally considered Minimalists, come close to the trend. Examples are Ricciotti's Le Stadium, Fuksas' Maison des Arts and Heikkinen and Komonen's Finnish Embassy in Washington.

In our opinion, the following pages show that the relationship between buildings and what we call the theory, criticism, or diffusion of architecture does not happen in a single direction exclusively. On the contrary, it follows simultaneous, meandering, bi-directional, unpredictable paths. Each project modifies a theory and each phrase sows the seeds of a new project.

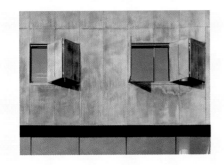

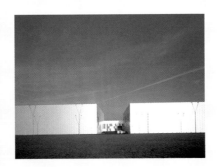

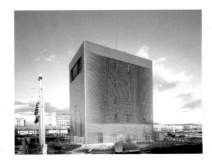

15

16

17

The Chinati Foundation

Donald Judd

The Chinati Foundation, a museum of contemporary art founded by Donald Judd in 1986, is located in Marfa, a remote town of 2,600 in the southwest corner of Texas near the Mexican border. The barren, empty landscape is part of the Chihuahua Desert, with unobstructed views of beautiful mountains with little vegetation. The foundation's site is a former military base, Fort D. A. Russell. The artillery sheds, barracks, and warehouse have been adapted, and now house most of the permanent art collection.

The Chinati Foundation's mission is the permanent installation of large groups of works by a limited number of significant 20th century artists. Currently on display are works by Donald Judd, John Chamberlain, Claes Oldenburg, Ilya Kabakov, Carl Andre, Roni Horn, Richard Long, Ingolfur Arnarsson, and David Rabinowitch.

Donald Judd was the architect when the dilapidated buildings were renovated. Judd designed new windows, doors

Location: *Marfa, Texas, U.S.A.*
Completion date: *1986.*
Architect: *Donald Judd.*
Photography: *Todd Eberle.*

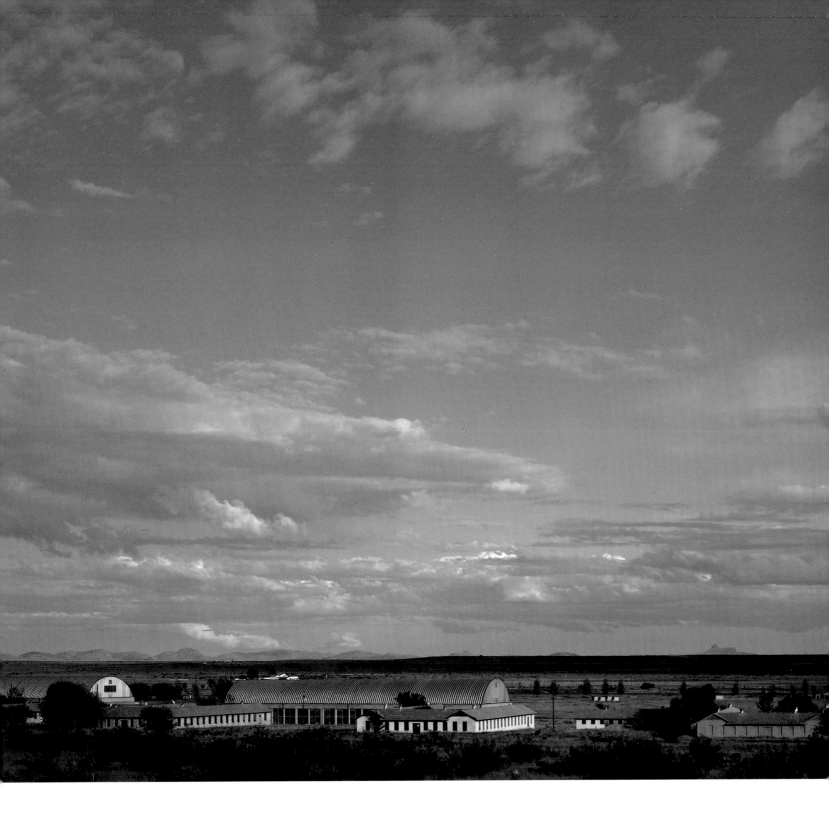

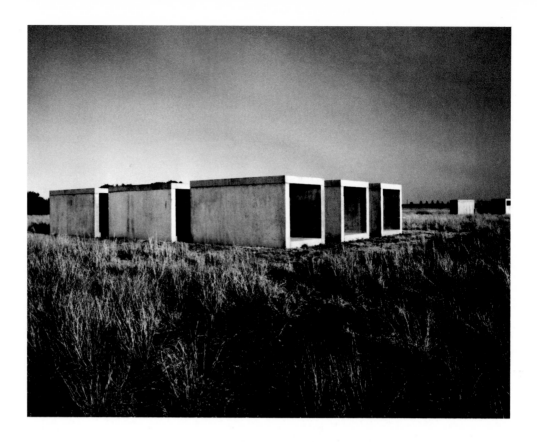

Untitled, Donald Judd, 1981.
Photography by Rob Wilson.

and gates. He also added huge vaulted roofs to the former gunsheds, and he added a courtyard, bath, and outdoor living area to the arena. As part of the buildings' adaptation he had new adobe walls built and he converted barracks and storerooms into exhibition spaces. The interiors have furniture also designed by Judd. Except for the roofs, everything is made from local materials. The buildings are light and clear; the generosity of scale of the enclosed space is in harmony with the outside landscape.

The Arena. Photography by
M. Stockebrand.

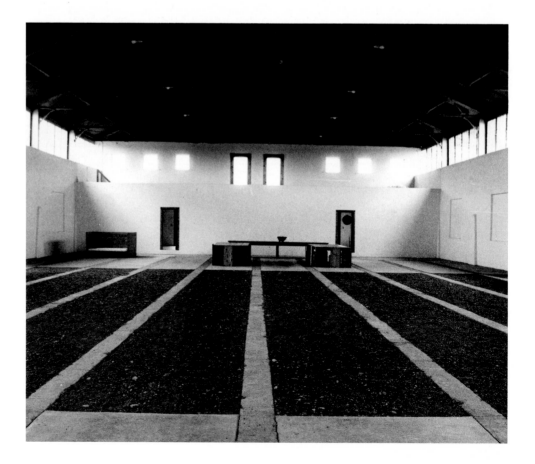

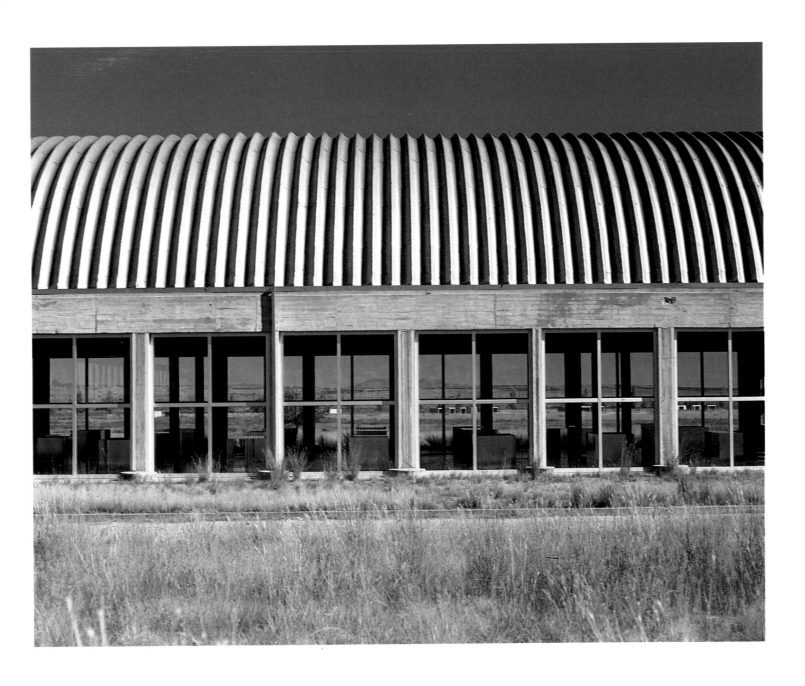

John Chamberlain building. Permanent installation of the artist's work. There is no electric light in the galleries.

Permanent installation of 100 untitled aluminum projects by Donald Judd, 1982-1986.

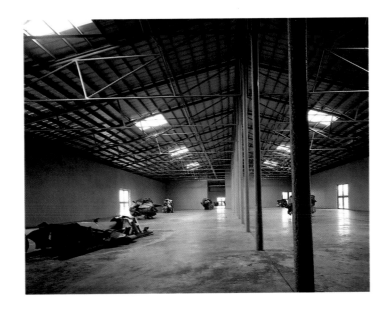

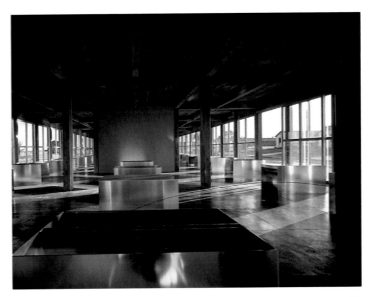

Vitra Conference Pavilion

Tadao Ando

"Architecture, which acquires tranquillity and balance thanks to geometric order, obtains dynamism thanks to natural phenomena and human movements." (Tadao Ando, "Light, Shadow and Form," Via, 11, 1990).

The Vitra's firm specializes in high-quality design, of classic furniture and of objects by contemporary designers. Charles Eames, Mario Bellini and Philippe Starck figure among the creators of Vitra products. The pavilion stands near the company's factory in southern Germany, and inside its walls a variety of activities take place, ranging from personnel training to conferences.

The project's central theme is the relationship between the building, its site and, above all, the form of access. The project and its logic are articulated around nature. Given the extraordinarily level site, Tadao Ando decided to soften the building's impact by keeping it low. Part of the volume of the building is underground and part of the site has been excavated to accommodate a patio. The project has been defined by the use of simple shapes such as circles and cubes to produce a contrast between empty and filled spaces. This counterpoint between emptiness and solidity enriches the interior.

Location: *Weil am Rhein, Alemania.*
Completion date: *1993.*
Architect: *Tadao Ando.*
Photography: *Friedrich Busam/Architekturphoto.*

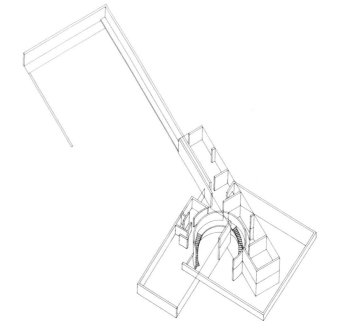

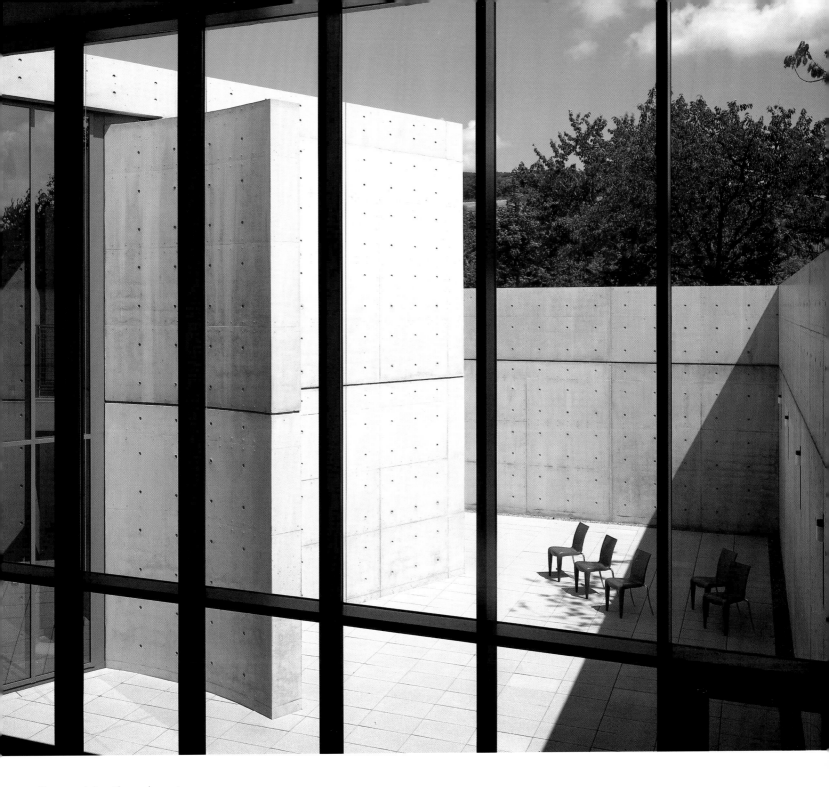

"In my opinion, three elements are
necessary to produce architecture.
One of these would be the material
itself. A genuine, substantial material like
bare concrete or natural wood.
The second element would be pure
geometry, the basis or structure that
endows a work of architecture with
presence. The third element is nature,
not nature in the virgin state but nature
on which man has imposed order."
Tadao Ando, "Spatial Composition and
Nature."El Croquis, 44, 1990.

Tadao Ando

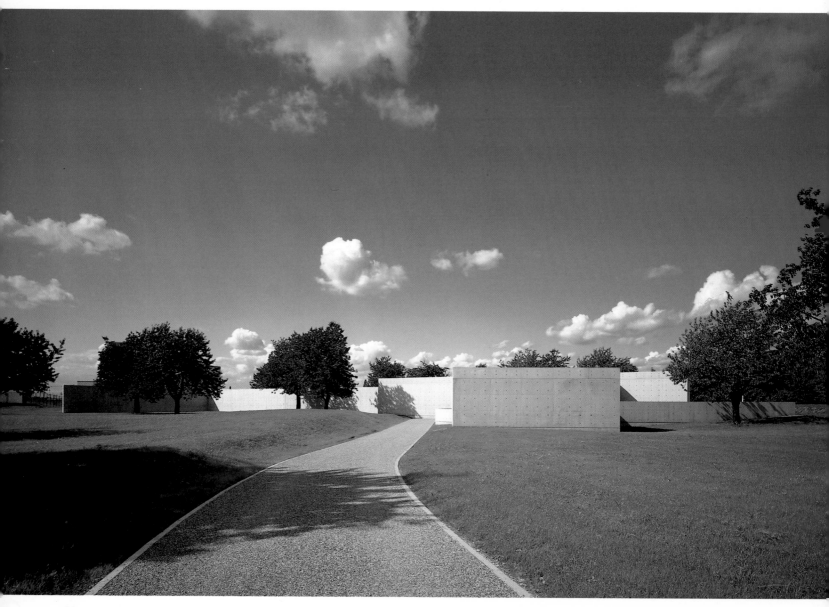

The Vitra Conference Pavilion has two levels, with conference rooms, a library, private offices, and a foyer all overlooking the patio, which acts as a device to attract and trap elements of nature, light, and wind, and to enhance the austere silence of architecture.

The use of squares, circles, or parts of circles helps set the logic of architecture against that of nature. Nature is understood thanks to this contrast when it is framed. In other words, when order high-

lights and transforms it into an object of knowledge. Nature loses something of its integrity when it comes in contact with architecture. Its appearance changes and it is reduced to abstract elements. It becomes light, wind, water, or sky. Nature abstracted is expressed through symbols.

What is most striking about Ando's architecture, besides the individual quality of each of his works, is its intellectual impact. Not as theory, but as the extraordinarily faithful translation into physical space of

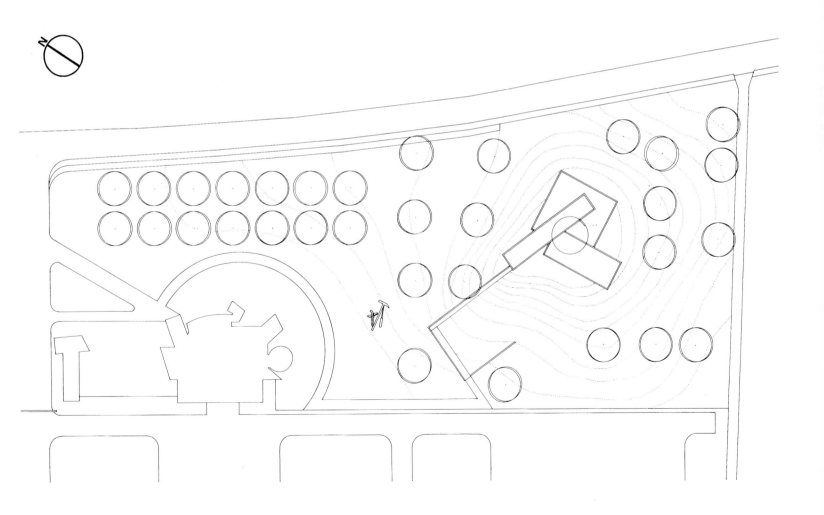

Site plan.

The nearby Vitra Design Museum is by Frank O. Gehry. The Conference Pavilion is oriented in such a way as to obtain harmony and balance both with the Museum and the sculpture by Oldenburg that stands between the two. Furthermore, the trees on the site had to be respected. The visitor walks around the Museum, past the sculpture and approaches the Pavilion by following an L-shaped wall.

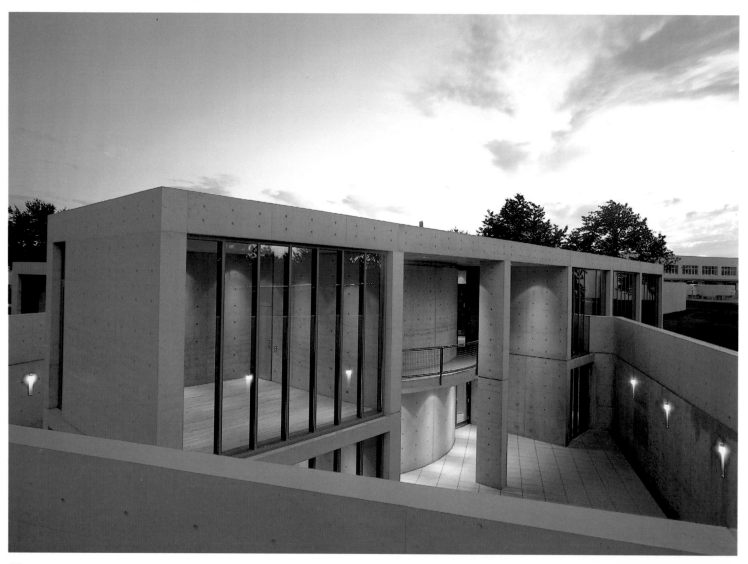

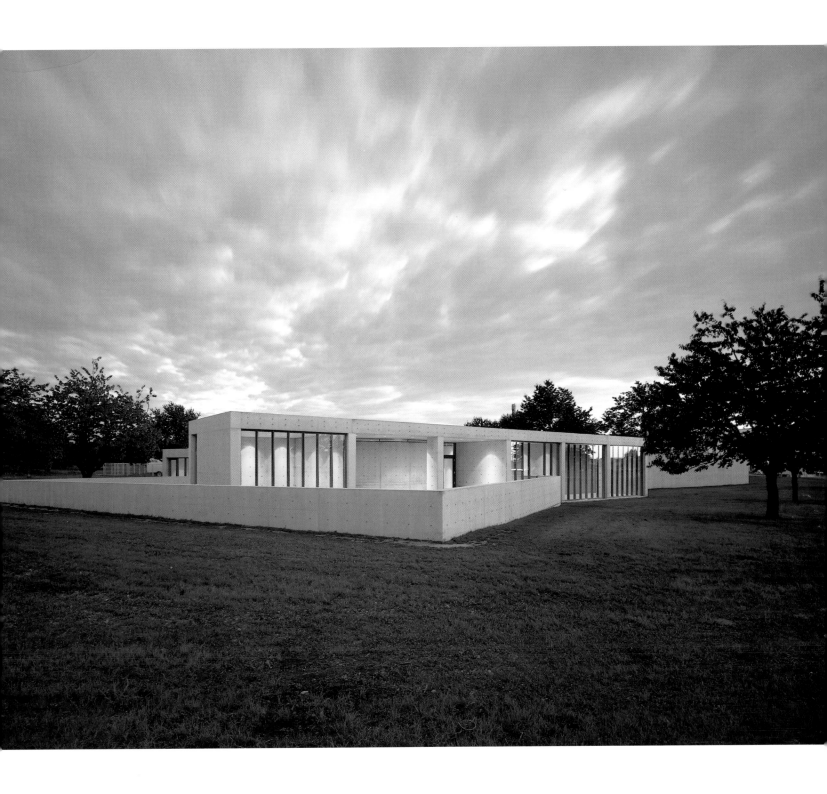

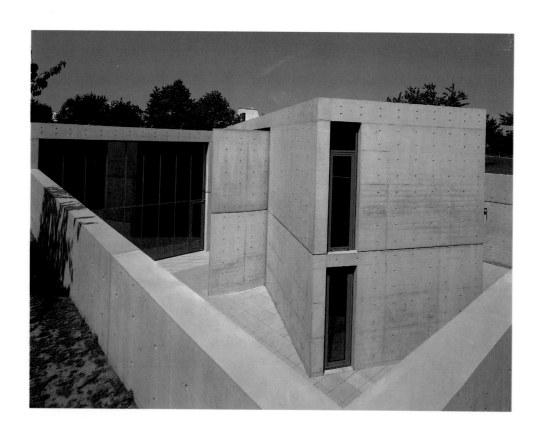

The work of Tadao Ando is one of the fundamental episodes in the architecture of the past two decades. By virtue not only of its quality but also of its impact on architecture in Japan and the rest of the world, it is practically impossible to overlook when studying present-day architectural trends.

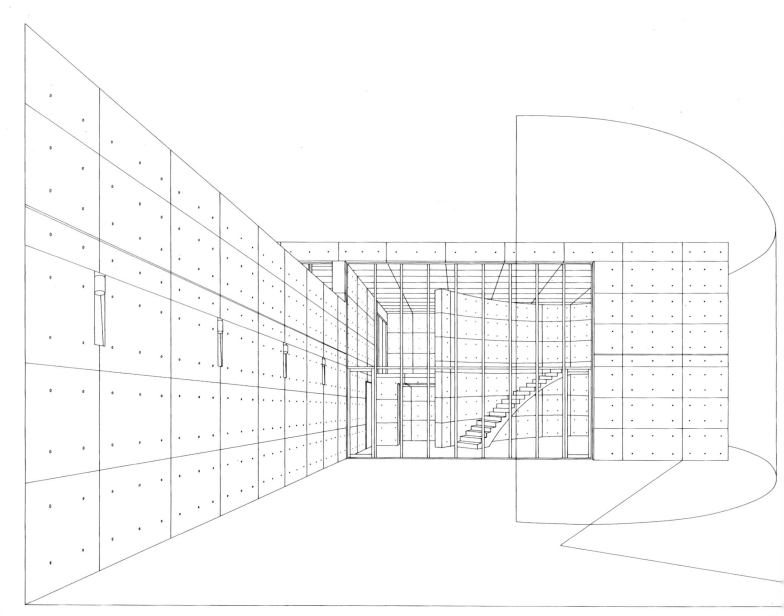

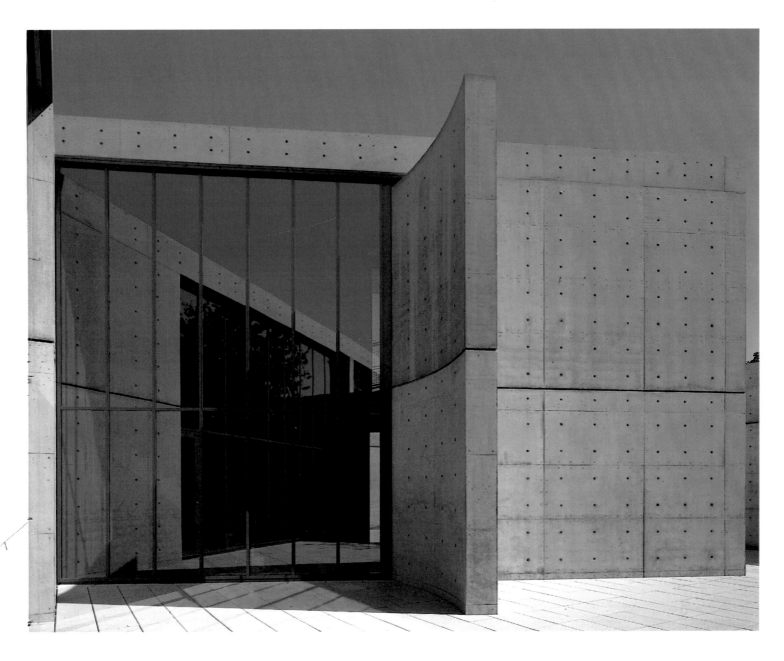

"Simple circles and squares are the foundation stones of my architecture. Just as Josef Albers manipulates different colors in his paintings, I model architectural space. The outcome is the transformation of architecture from something extremely abstract and built on the basis of stringent geometry into something that seeks the traces of the human body. It is the labyrinthine quality of each work that makes this transformation possible."
Tadao Ando, "Représentation et Abstraction," L' Architecture d' Aujourd' hui, 255, February 1988.

Two views of the central hall.

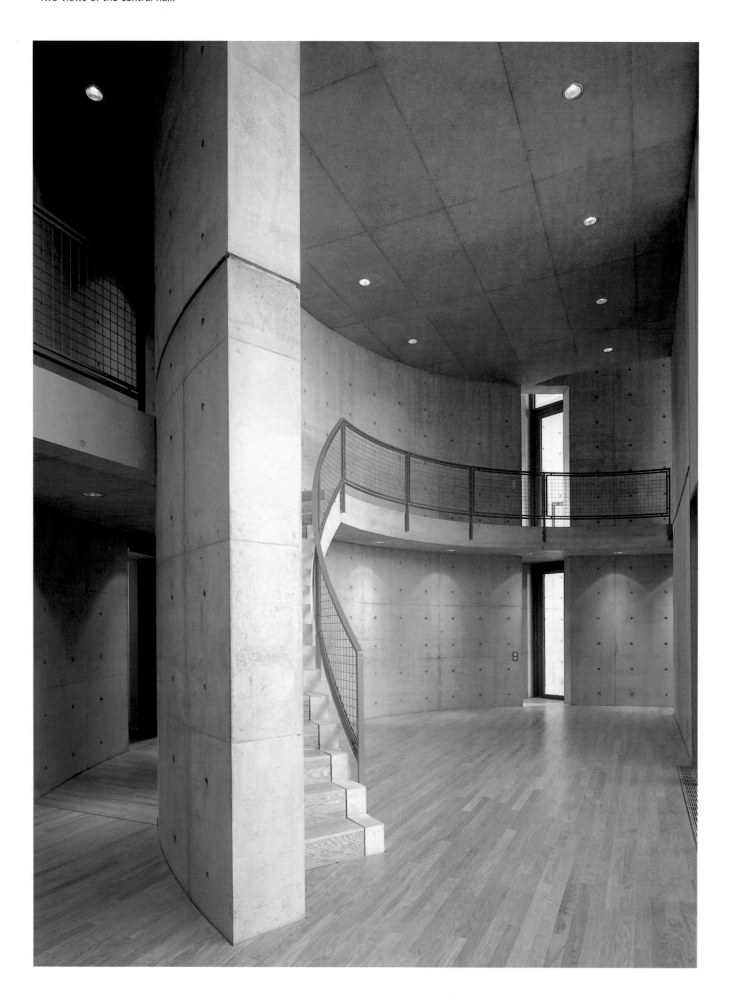

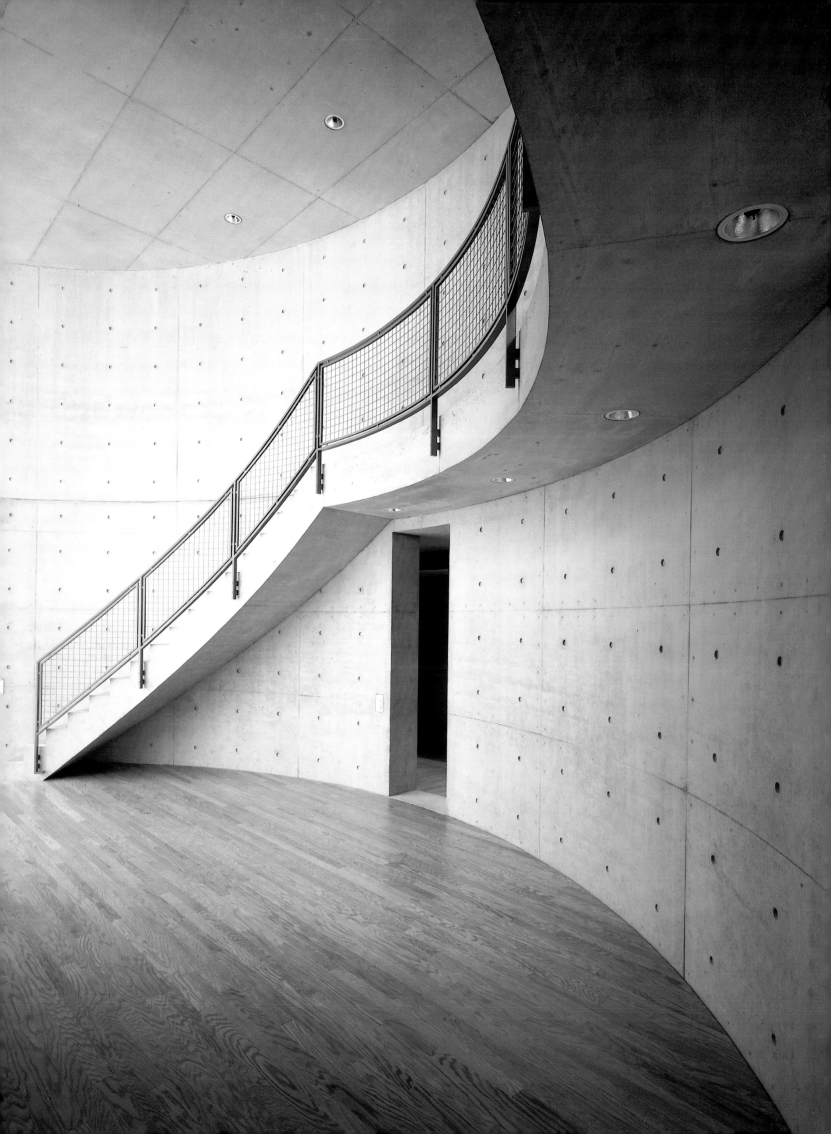

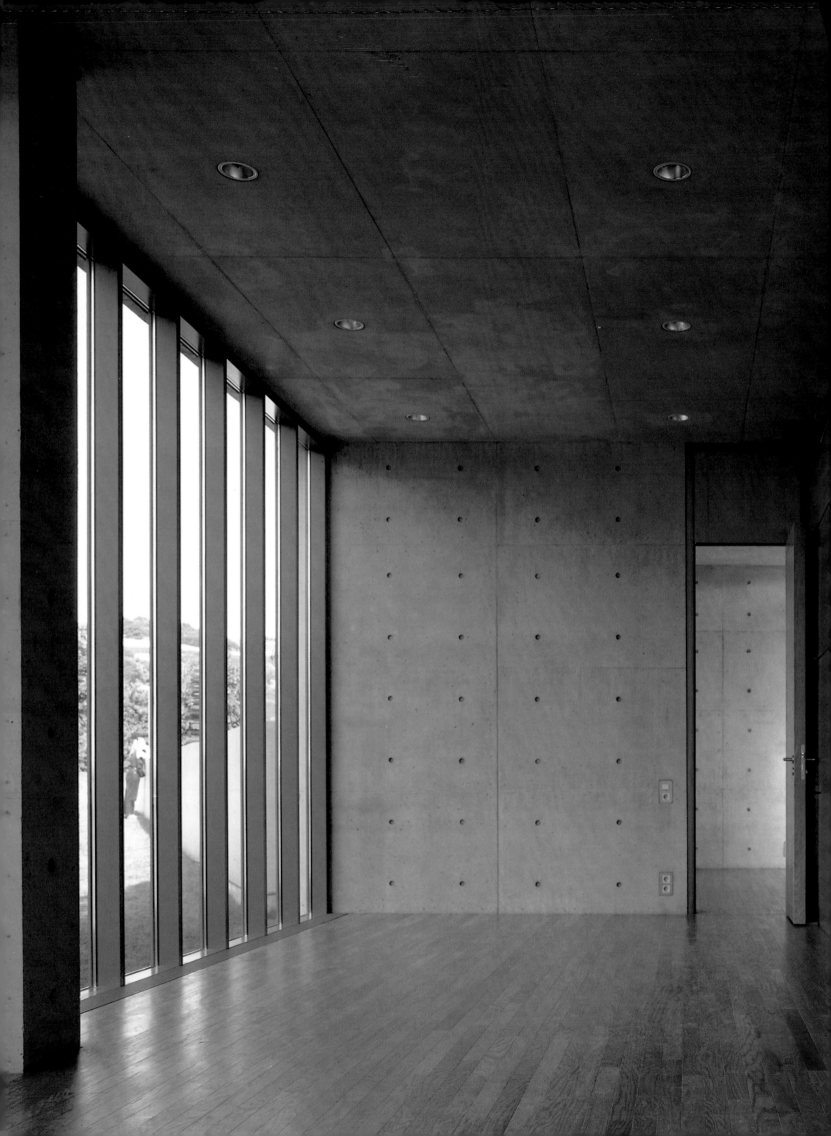

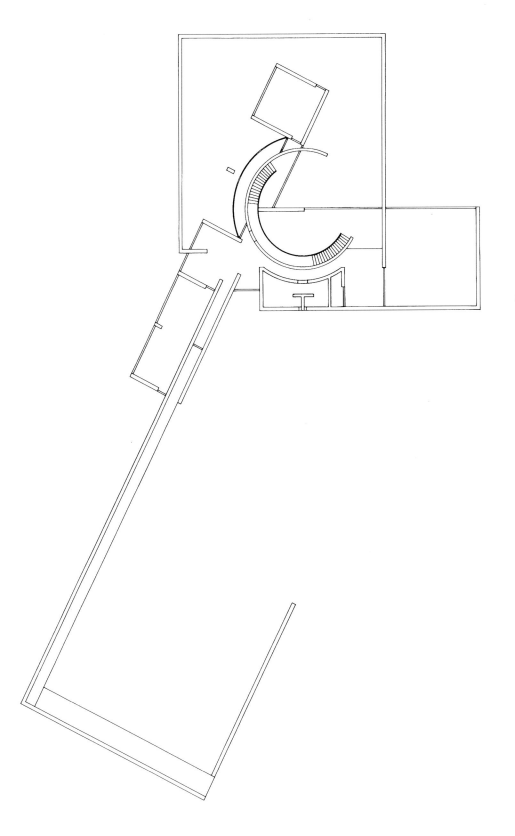

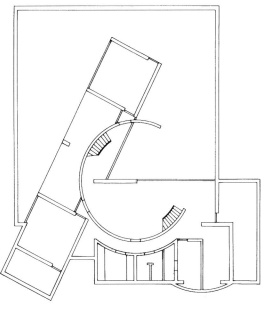

First and basement floors.

ideas with great philosophical weight. Ando's are among the few works that are born of clearly defined philosophical premises. His œuvre is fruit of an ontological calling insofar as it is the transposition to architecture of the dimensions space and time. In Ando, this duality rests on the dialogue between site and nature.

Architecture must be built using simple forms and austere materials, becoming a space able to reveal the matter from which time is made. And time, for Ando, has both an objective and a subjective source; objective because of the changes associated with nature, such as light and shadow variations during the day, the transition from one season to the next, and so on; subjective because of human perception, which is subject to movement and memory.

The finished building is only part of the work. The building is that which allows the work to begin and flow through time. The work is the sum of what persists, what occurs, and of perception on the part of the observer.

Department of Geosciences, Aveiro University

Eduardo Souto de Moura

Minimalism in sculpture or music comes from a clear restraint and from reducing expressive elements in order not to pollute the essence of the work. In many cases this essence is to be found outside the work itself, because its meaning lies in the relationship to the surroundings, such as in sculpture. It would be pointless to comment on a work by Dan Flavin or John Cage on the sole basis of the object alone. Unlike other artistic movements, such as Abstract Expressionism, when referring to Minimalism it is important not to confuse the artist's performance with the overall sense of the work.

Minimalism —above all in architecture— is not synonymous with simplicity and restraint, even though these qualities are common to all minimalist works, because simplicity may be the result of a low budget or even of indifference, leading to simple, insipid forms. The fact that a building is box-shaped certainly does not mean that it is Minimalist.

When Eduardo Souto de Moura was first confronted with the project at

Location: *Aveiro, Portugal.*

Design date: *1991.*

Completion date: *1995.*

Architect: *Eduardo Souto de Moura.*

Photography: *Christian Richters.*

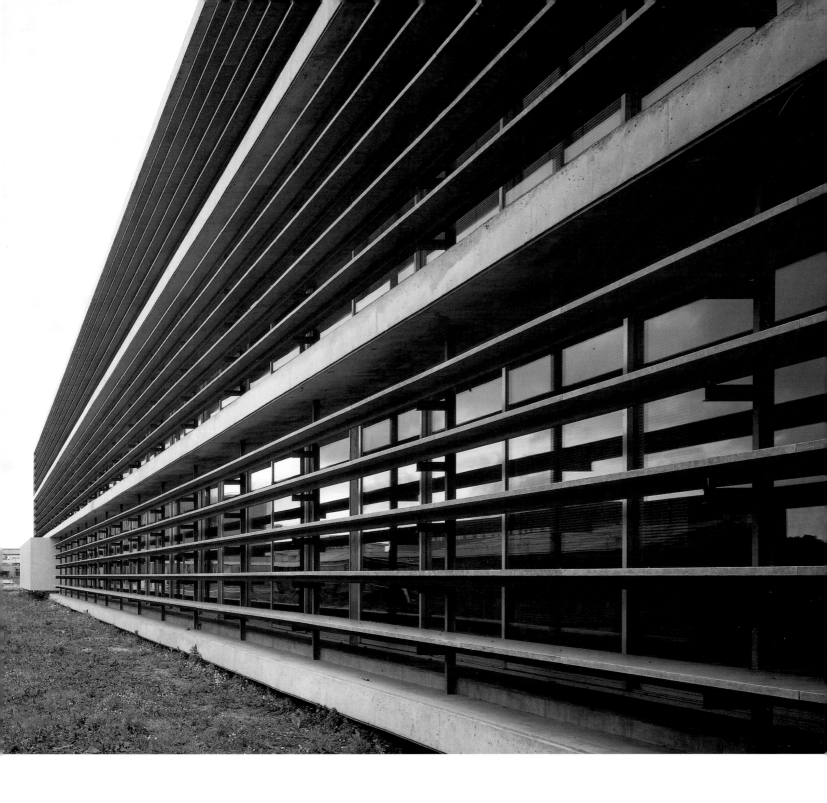

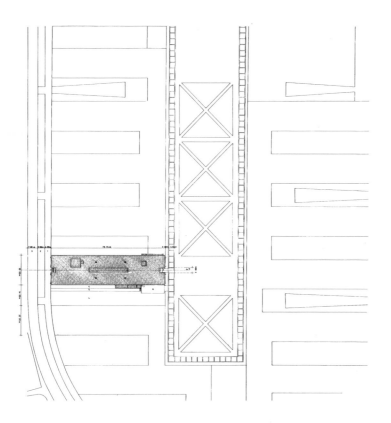

Site plan.

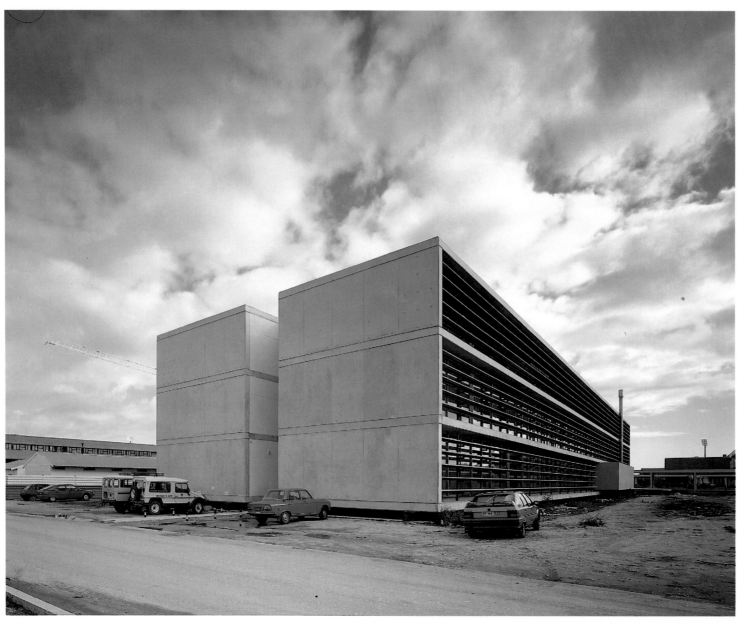

Rough Sketch.

Aveiro University, he realized that he had already been provided with the form. The urbanistic layout of the campus and stipulations on the part of the University together established a set of clear constraints: the total square footage of the building was to be 14,128; the maximum height, three stories; the proportion of the surface area reserved for movement, approximately 20%; the façade material, red brick, and so on. Souto de Moura commented, "As the rules of the game were already defined –and this is something to be thankful for in a pluralist age– the building acquired form almost without discussion: a box cut in half by a central corridor."

Relations between the developer, the planner, and the architect are eternally controversial in the world of construction, and it would be unfair to judge Souto de Moura for how the building sits on the site or of its volumetrics, since these decisions were out of his hands. The building is minimalist not only in form but in the choice of materials, of finishes, and how the light is controlled in the interior spaces. And the Aveiro Geosciences Department building transmits austerity.

Other defining features include a meticulous attention to details, with a view to minimizing their impact on the final appearance of the building; a refusal to cover structural elements,

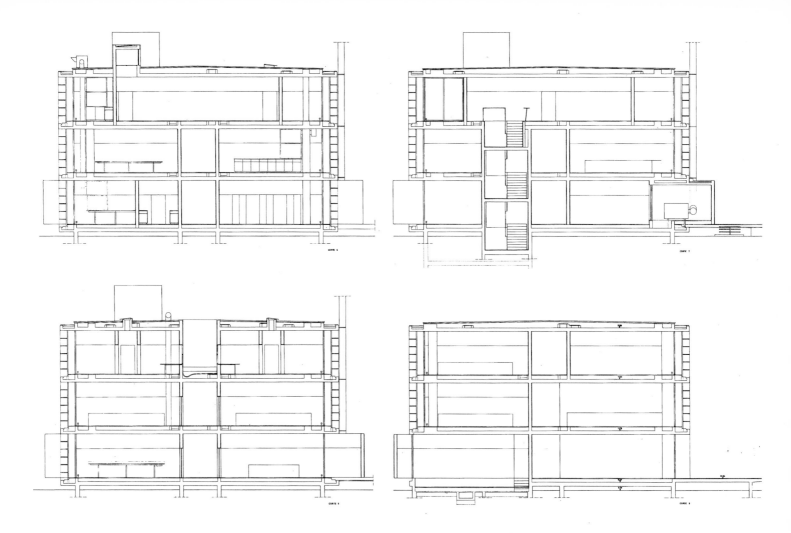

As can be observed from the cross sections, on the two lower floors a central corridor cuts through the building lengthwise, providing access to the laboratories and the classrooms. By contrast, on the third floor this corridor becomes an open patio, due to the fact that the offices are on this floor and, consequently, the surface is more compartmentalized. Some offices receive light from the outside while others are lighted from the patio.

Views of the entry and of the blue-painted body containing the conference hall.

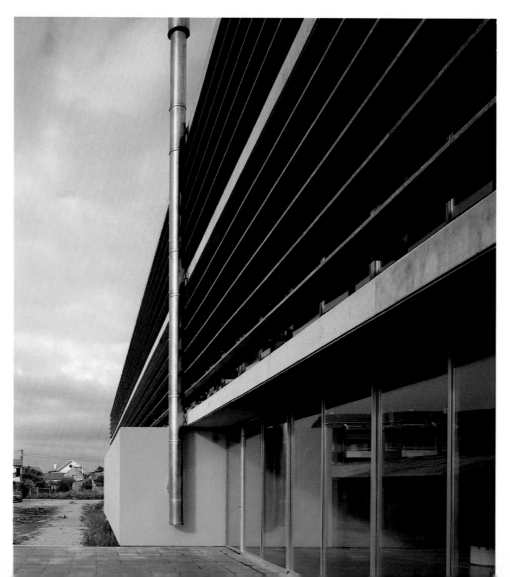

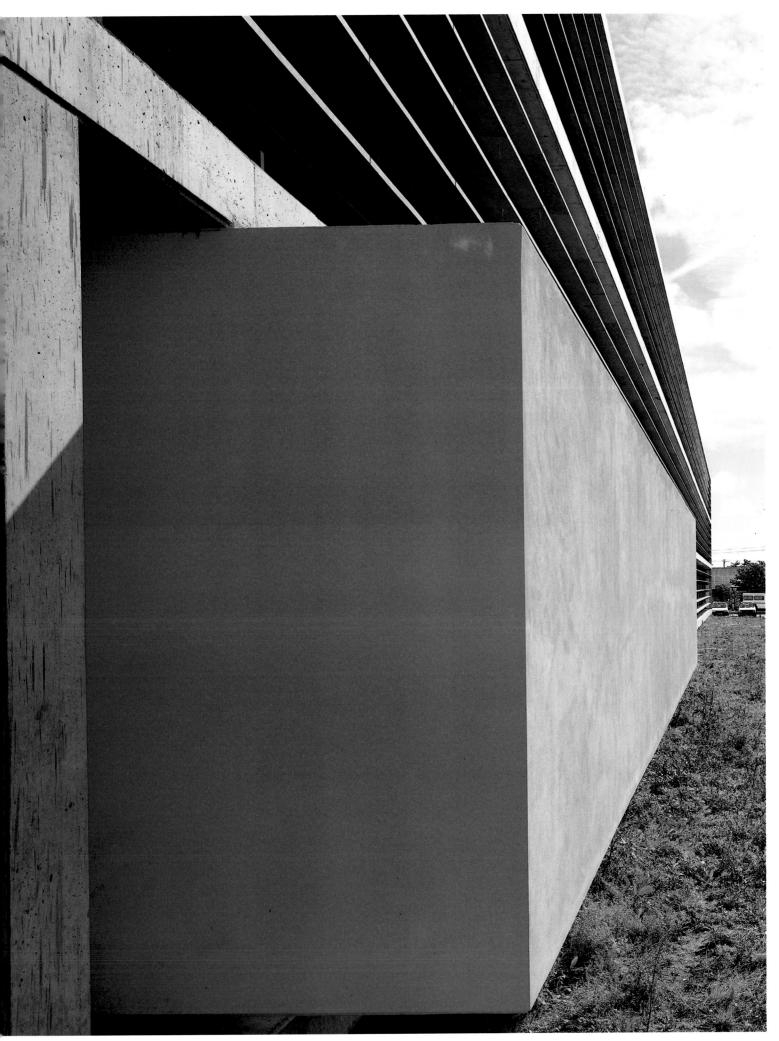

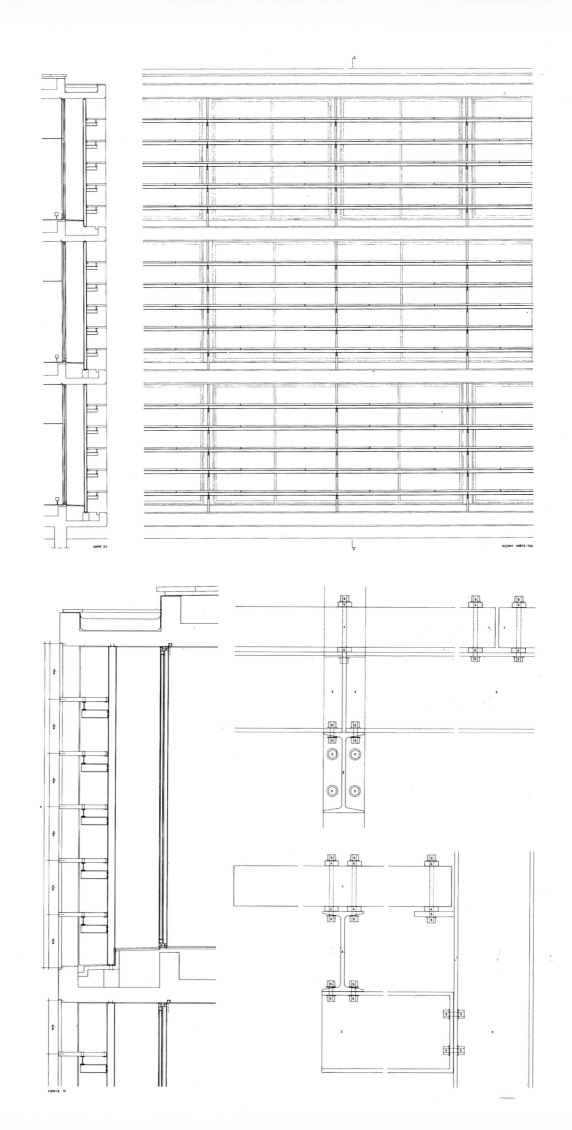

CORTE 3-E

ALÇADO NORTE / SUL

CORTE TT

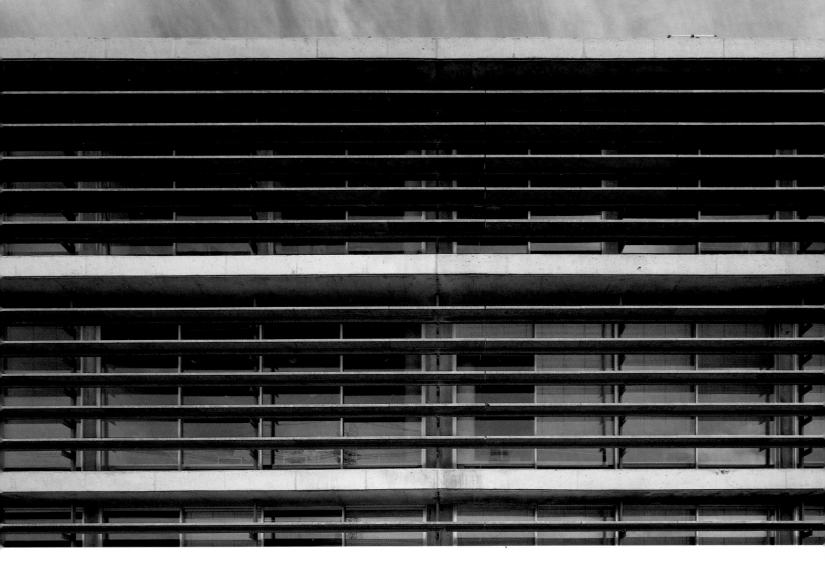

Details of the façade lattice. The slats are of reddish marble resting on IPN-type metal profiles. Souto de Moura confesses that "regarding this issue, I might have found a cheaper solution, since images such as the old market by Manuel Firmino, with iron –oxide painted sheds and warehouses, have always been present in my eyes– in my hands, I mean."

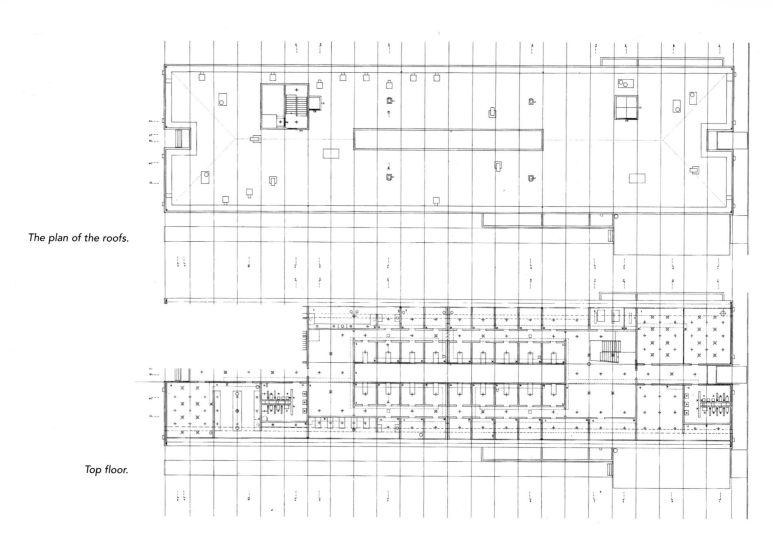

The plan of the roofs.

Top floor.

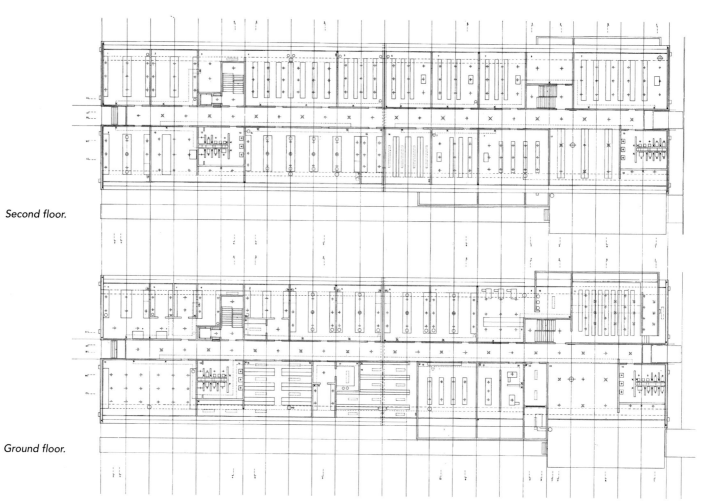

Second floor.

Ground floor.

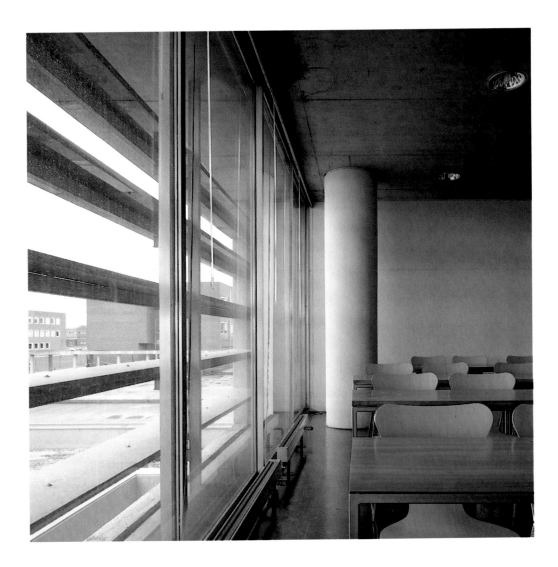

The slate floor of the whole building accommodates all the necessary laboratory installations. The walls are plastered and painted white. The ceiling corresponds to the portion underneath the floor-ceiling concrete slab. Lighting is embedded in the slab in such a way that the electric cables circulate in the floor of the story above.

thereby revealing the governing construction laws; and an effort to consider separately the geometrical elements that constitute buildings. The rooms are stripped of accessories and contain only the most essential pieces of furniture. Perhaps one of the details that most characterizes Souto de Moura's work is his tendency to present noble materials in unusual ways; in this case, for example, the reddish marble slats resting on IPN-type profiles.

Eduardo Souto de Moura has often been defined as a Minimalist. This is a definition, however, that may need to be qualified. Souto de Moura is a member of the so-called Oporto School, which has maintained a substantially coherent philosophy under the directorship first of Fernando Távora and subsequently of Álvaro Siza. Even so, despite

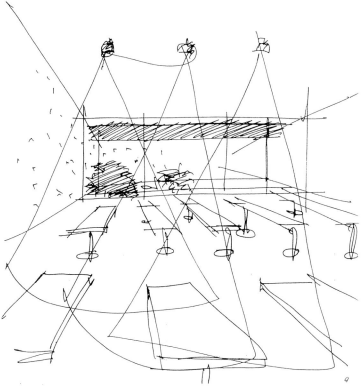

Details of the corridor and the stairway. There is no skirting where the floor and walls meet; the doors are translucent glass; the stair handrail has no uprights. The details (or, better said, the lack of details) create the interior atmosphere.

his evident links with the School, it would be simplistic to overlook the clear differences between Souto de Moura and Siza, for example. Perhaps the most important of these is the fact that while both architects are deeply concerned with light, in Siza's works light reveals forms while in those of Souto de Moura it reveals the void and the dramatic quality of materials in their pure state. In this sense it may be appropriate to consider Souto de Moura the most Minimalist of all the Oporto School architects.

The end walls clearly reveal the division of the building into two independent volumes separated by a central corridor.

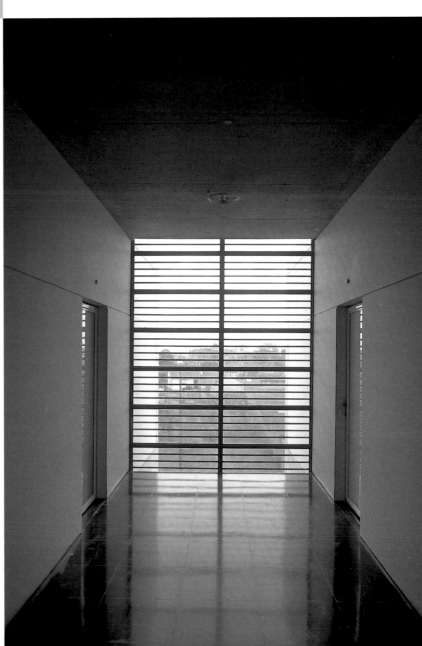

Signal Box

Herzog and De Meuron

Beside the 18th and 19th century walls of the Wolf-Gottesacker cemetery stands a tall copper volume, a railroad signal box and control tower. It is next to the rails, near the garage or shed for the new locomotive. Distributed among its six floors are sophisticated control instruments and electronic equipment to monitor crossings and coordinate the signals.

The building's insulated concrete structure is clad in copper strips approximately 20 cm wide. These strips open in places to admit natural light. When they are open, they cast shadow lines on the façade, creating an effect rather like fish gills. In this way variations are introduced into the texture of the building's skin while tempering its dramatically hermetic character. In short, the building is a milestone that echoes no familiar images or forms codified by culture. It singularly marks the center where signals are received and transmitted, where information is accumulated and processed.

According to Herzog and de Meuron, our civilization tends to reduce the dimensions of space to images of space' in other words, to two dimensions' as a consequence of the development of the technical image, which has

Location: *Auf dem Wolf, Basel, Switzerland*
Design date: *1989.*
Completion date: *1995.*
Arquitectos: *Jaques Herzog, Pierre de Meuron, Harry Gugger.*
Collaborators: *Hansueli Suter, Philippe Fürstenberger.*
Photography: *Margherita Spiluttini.*

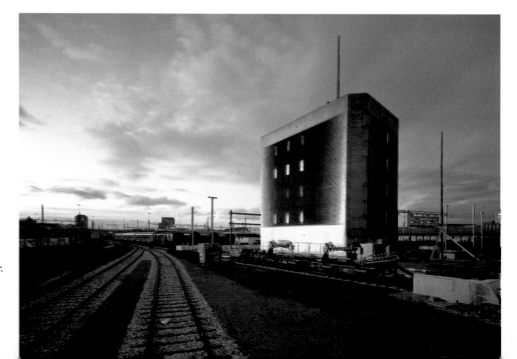

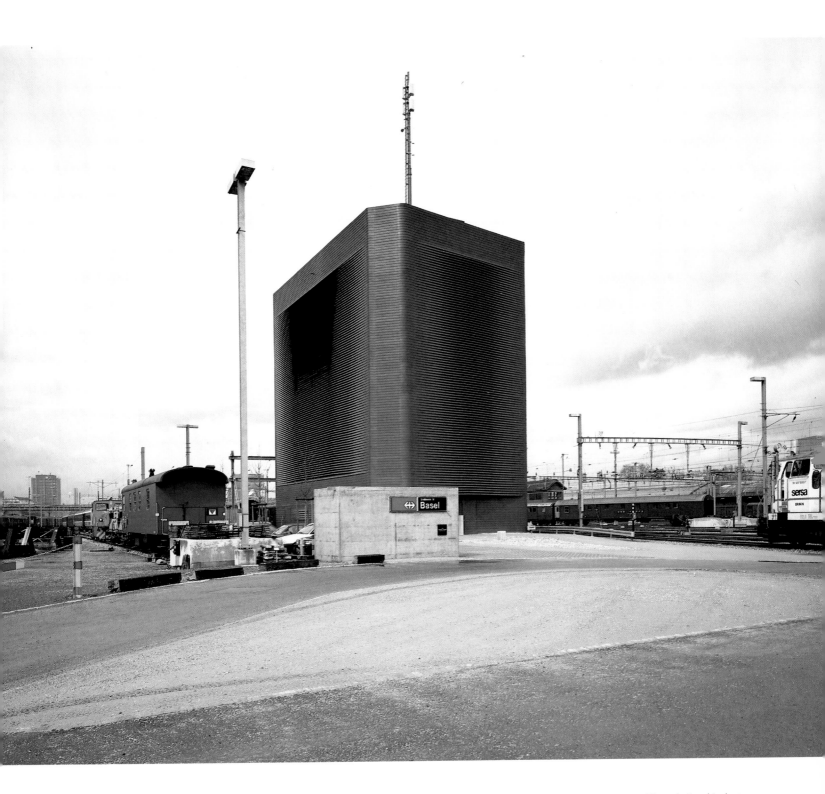

The relationship between architecture and the plastic arts in Herzog and de Meuron's work is not new; indeed, it is a constant in the whole of their œuvre. In 1978, Herzog and de Meuron collaborated with Joseph Beuys on an installation for the Basel carnival, now exhibited at that city's art museum under the title of Feuerstätte II.

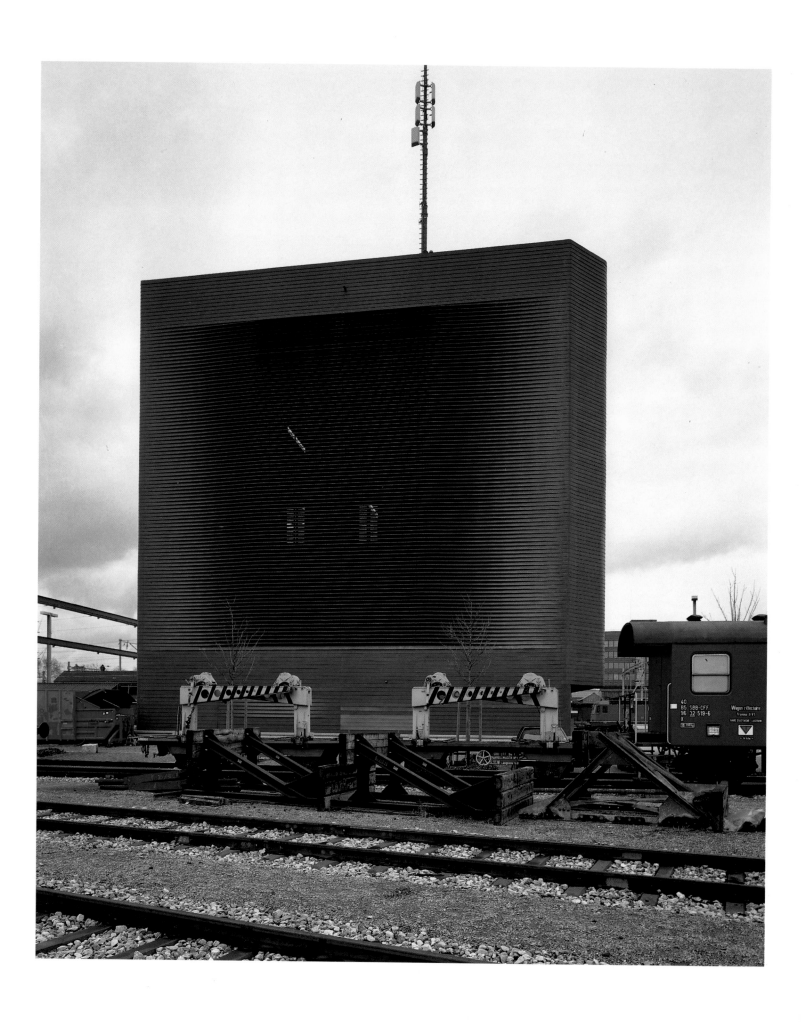

As a consequence of the copper skin, the building behaves like a Faraday's box or Gauss cage, protecting the electronic equipment inside from unexpected external effects or agents that might disrupt the correct functioning of the control system.

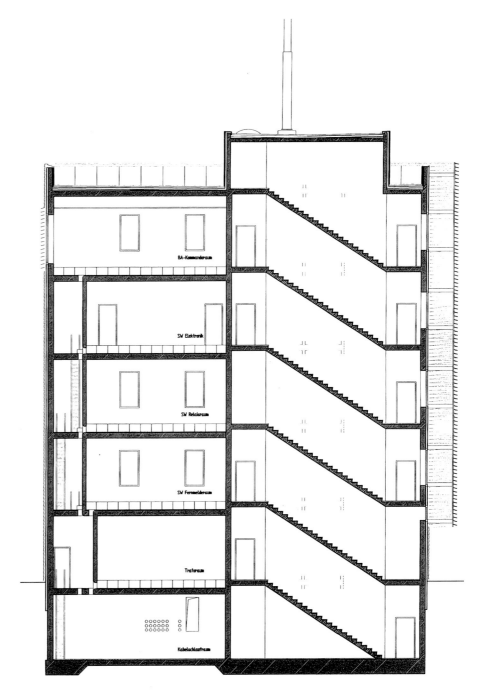

Section through the stairway.

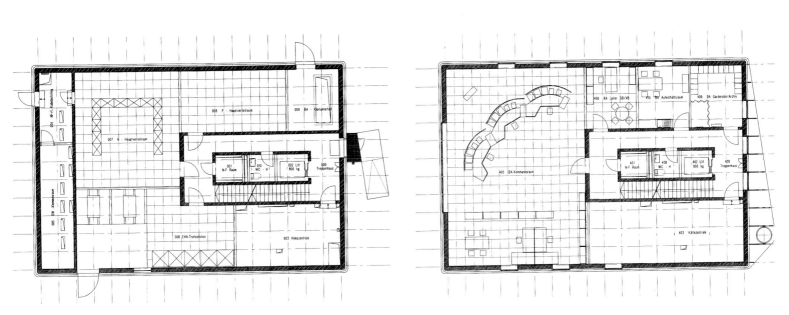

Ground floor.

Typical floor.

Plans of the four elevations. Unlike conventional industrial buildings, the stairway is open and indeterminate. The division of the volume into different floors is not visible; rather, it is a unitary form whose configuration allows a specific, probably abstract, relationship with the surrounding field of railroad lines.

replaced the magical image. For Herzog and de Meuron it is essential to develop new image strategies, strategies that would subvert everyday perception and pose questions instead of satisfying superfluous needs, since this is already done by commercial television and by a large portion of so-called contemporary architecture. This contemporary architecture works somewhat like advertising: it exploits and makes use of art to renovate its own image, but without reflecting on fundamental concepts.

Herzog and de Meuron consider the relationship between works of art and of architecture to be fully justified. It would be wrong, however, to trust the indiscriminate importing into architecture of images conceived in the world of art. It would be wrong to apply the image of art, in either general or specific terms, to architecture. For example, the images of Minimal Art, Deconstructivism,

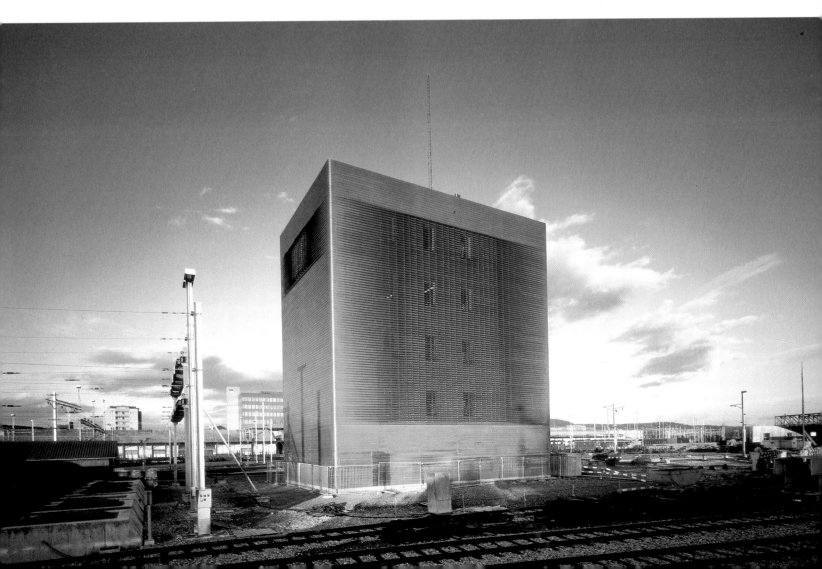

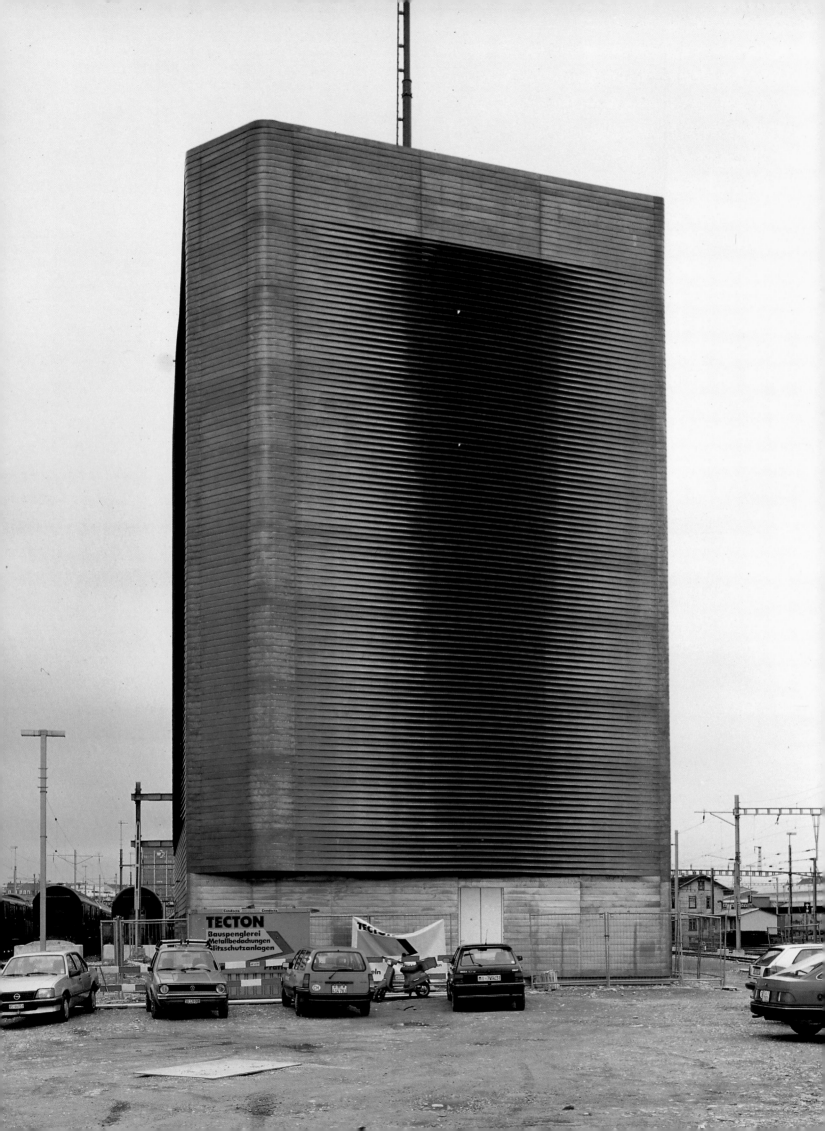

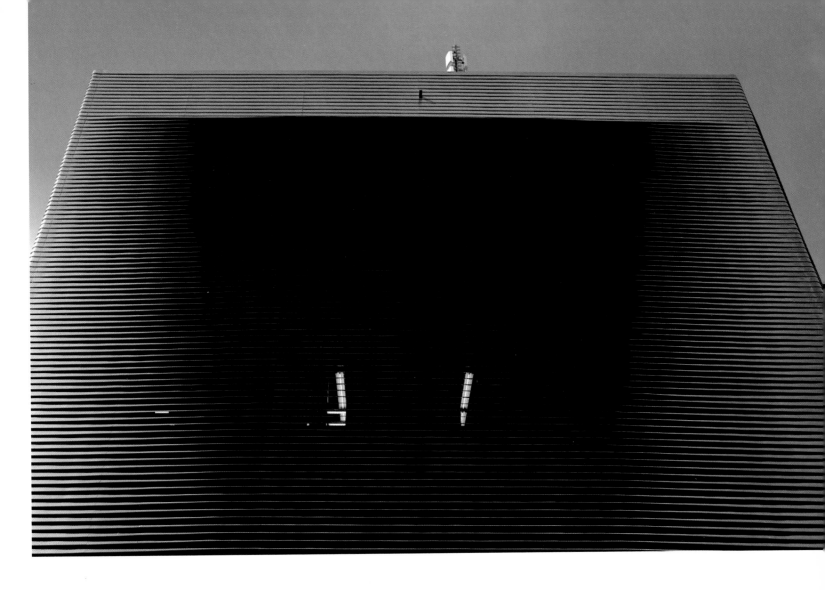

*As in the vast majority of
works by Herzog and de Meuron,
the building' s skin constitutes one
of the main themes.*

or High-Tech are applied to architectural and urbanistic concepts either from the 19th century or from the glorious era of the CIAM and of the Wchutemas in Russia. Herzog and de Meuron' s architecture is full of images' it evokes and contrasts images, and images are central to the project from its outset.

Tradition as that which once provided architects with knowledge regarding how to build a house, make a door or fit a window according to regional types no longer exists. In this situation, therefore,

the question is how must architects now work? For Herzog and de Meuron, the answer lies in the figure of the architect-artist. It is essential to prolong and extend the limits of contemporary architecture, which has now become pragmatic or, at the opposite pole, postmodern graphics. The loss of tradition can be replaced only through the conceptual complexity of the architectural work at all levels, but this will never be achieved through technology or through an attitude that tends to preserve archaic images.

The Finnish Embassy in Washington, D.C.

Mikko Heikkinen and Markku Komonen

Far from the apparent simplicity we perceive at first sight, this building by Mikko Heikkinen and Markku Komonen deals with some of the most incommunicable intangibles in architecture. It is actually made up of diffuse boundaries, lines of movement suspended in the air, and osmotic flux between exuberant nature outside and chromatic intensity inside.

At a time when the aesthetic discussion of architecture as understood by the postmodern movement is losing momentum, Finnish professionals display an outstanding ability to combine the traditional romanticism of Nordic culture, integration with the landscape, closeness to nature and emphasis on light -with the thorough, rational, pragmatic design and the search for purity, order, and structural simplicity that are part of the Lutheran heritage.

The Finnish embassy is on Massachusetts Avenue, in the heart of the diplomatic district and opposite the U.S. Naval Observatory and the residence of the Vice President. This area has a low population density, and has grand buildings scattered among a variety of old, well-established trees, some over 100 feet tall. However, the site on which the embassy building was to be constructed

Location: *Washington D.C, U.S.A.*

Architect: *Mikko Heikkinen and Markku Komonen.*

Completion date: *1994.*

Collaborators: *Sarlotta Narjus, Angelous Demetriou & Associates, Eric Morrison (architects); Lee & Liu Associates (landscape architecture); Chas. H. Tompkins Co. (contracting).*

Photography: *Jussi Tiainen.*

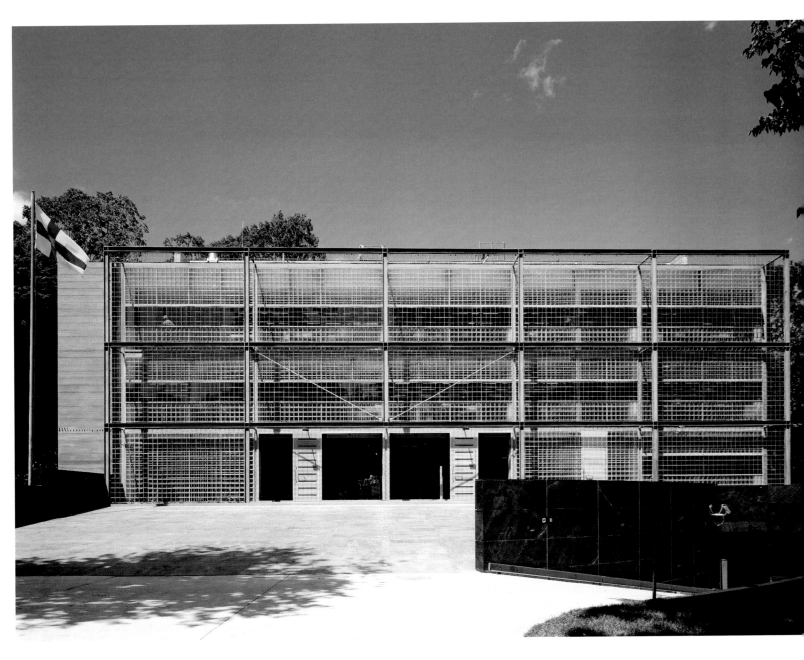

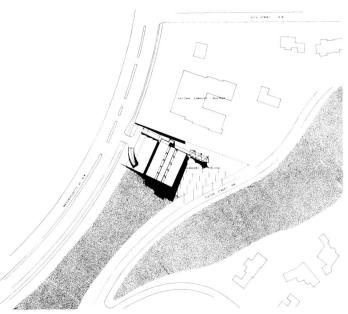

51

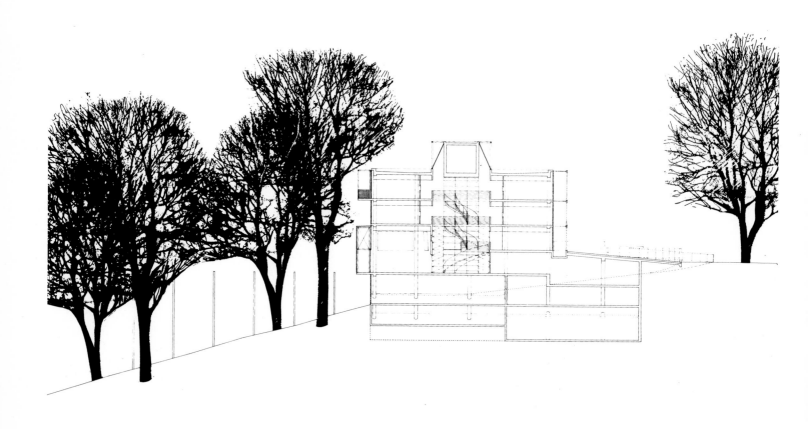

Cross section showing the internal communication systems.

was relatively small: a narrow strip of land between Massachusetts Avenue and 32nd Street NW, sloping abruptly from south to north.

The layout of the embassy basically consists of administrative and office space, conference rooms for up to 50 people, a small library, a cafeteria and a multipurpose area designed to house temporary exhibitions, seminars, concerts and receptions. A third of the 50,000 square-foot area is taken up by the basement parking area, the roof of which forms a slightly sloping empty plaza facing the main façade and the entrance to the building.

Owing to the architects' use of blocks of translucent glass and metal structure, the exterior image of the building immediately brings to mind Pierre Chareau's Maison en Verre. However, the explicit

reference, stressed by the architects themselves, is to I Carceri, Piranesi's engravings showing staircases and bridges suspended in mid-air and crossing over at various heights.

The building combines the rational, coherent distribution of the office space, arranged in two parallel rectangular blocks, with a central four-story Piranesian space with intersecting discontinuous walkways, sections of spiral staircase, and volumes suspended in the air. The great central space, dubbed the Grand Canyon by Heikkinen y Komonen, allows natural zenithal light to enter, so that the offices are illuminated not only through the façades but also through the access corridors.

On the side façades, the green granite reflects an almost mirror-like image of the branches and the foliage of the trees.

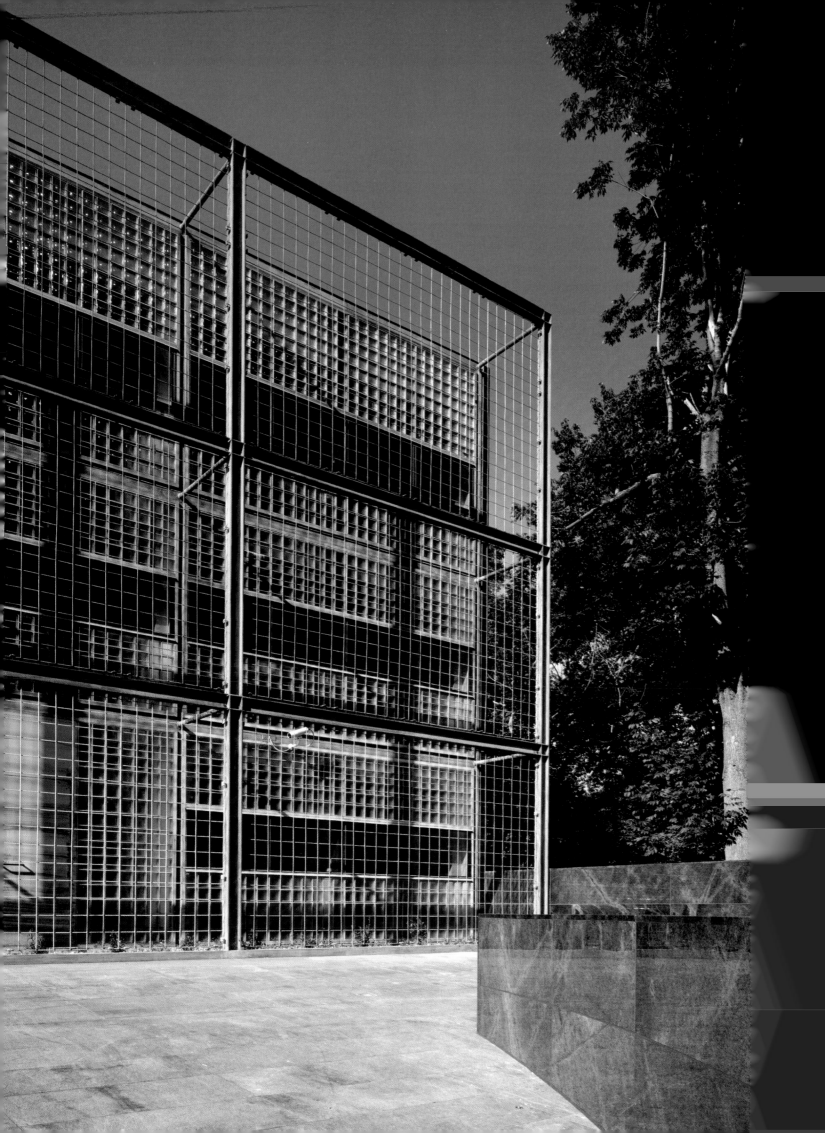

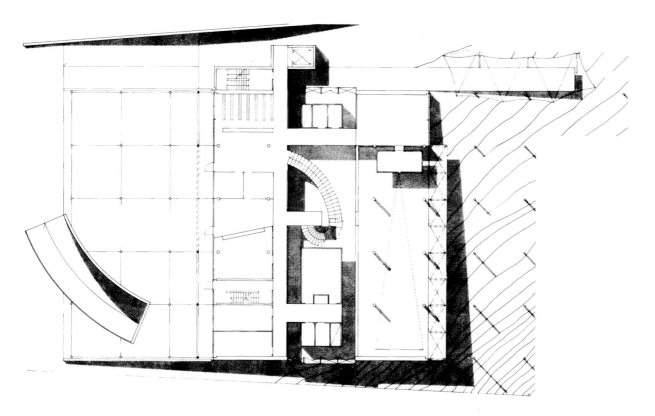

Floor plan of the entrance level.

*The building attempts to evoke the
effect of light through foliage.*

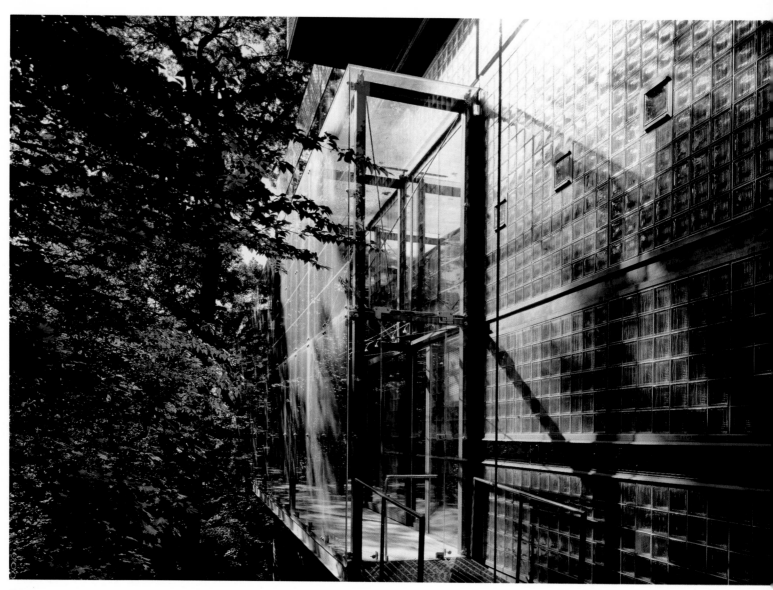

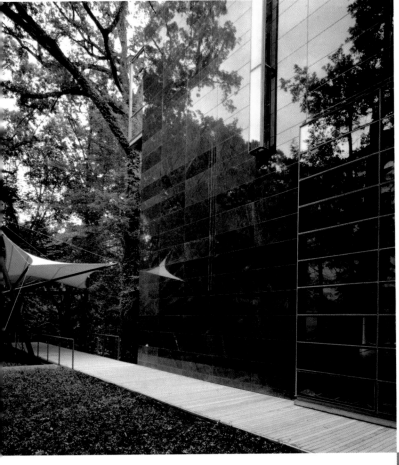

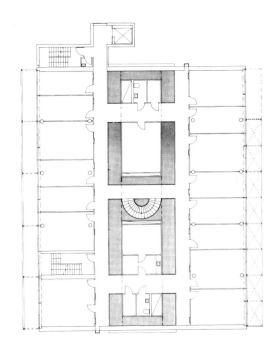

Floor plan of the second level.

Despite the hermeticism and formal austerity of the main façade, the building strikes up a subtle dialogue with the surrounding vegetation.

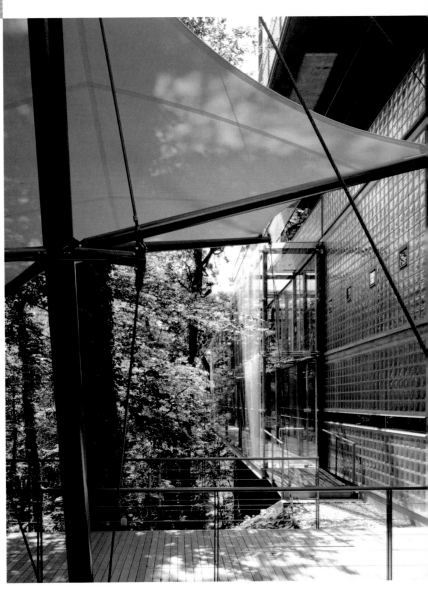

A walkway runs from the cafeteria into the depths of the trees.

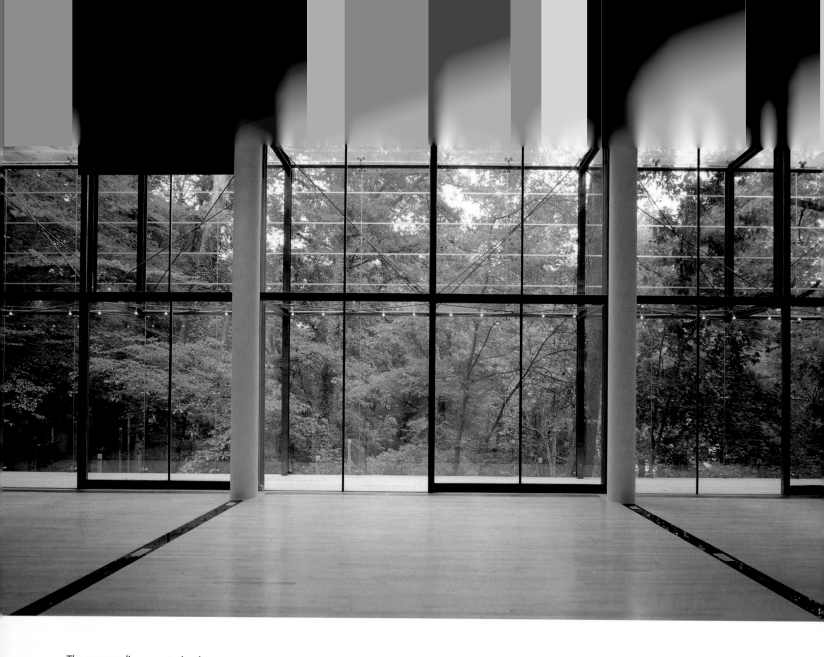

The surrounding vegetation is a presence and a constant reference throughout the building.

Detail of the standard glazed wall.

The front façades are built in blocks of translucent glass with a slightly greenish hue, matching the structural features and the metal panels, which are painted in a patina of the same color. On the south façade there is a grille that acts as a brille-soleil, also serving as a trellis for climbing plants. The greenish tone of the façades, the reflections and shadows, the superimposing of patterns, the sensation of depth all suggests that the interior walls were intended to evoke vegetation or the effect of light through foliage.

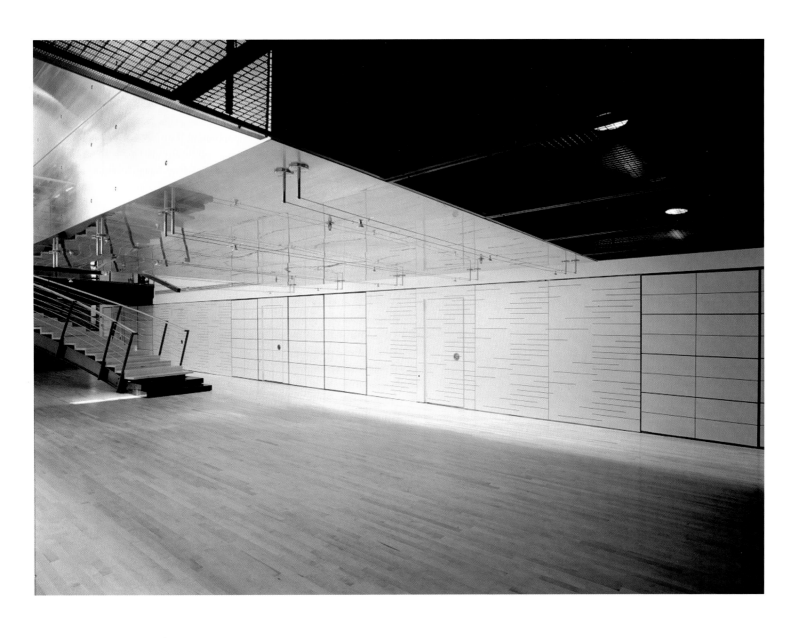

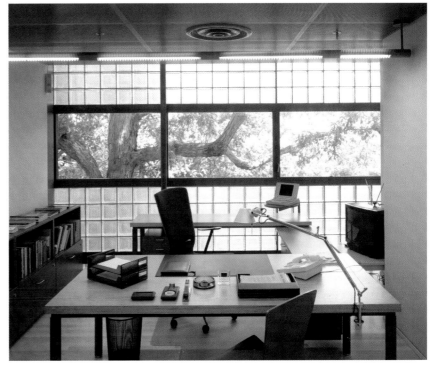

The New World School

Adolf Krischanitz

The New World School project consisted of refurbishing a small house as a school and also of enlarging it. The house had two floors, with a bearing-wall structure and the extension wing comprising a single floor. The main attraction of the building is undoubtedly the choice of materials and the treatment of the exterior. The outer walls are dark gray and the composition of the windows is completely abstract and regular.

On the façade of the former dwelling is a gridiron of ten identical vertical rectangles arranged in two rows. On the new module is a mirror, converting the building into a black hole that absorbs all the light coming from outside while transmitting only mirror reflections. Snippets of the landscape are cut out against stretches of the dark, blind, hermetic wall – deformed trees, of which only the base of the trunk can be appreciated, a branch against the sky, the ghost of a house in the distance.

Location: *Schwarzenstockallee, Vienna, Austria.*
Design date: *1993.*
Completion date: *1994.*
Collaborators: *Eric Red, Mark Gilbert (project team), Manfred Gmeiner, Martin Haferl (construction).*
Photography: *Margherita Spiluttini.*

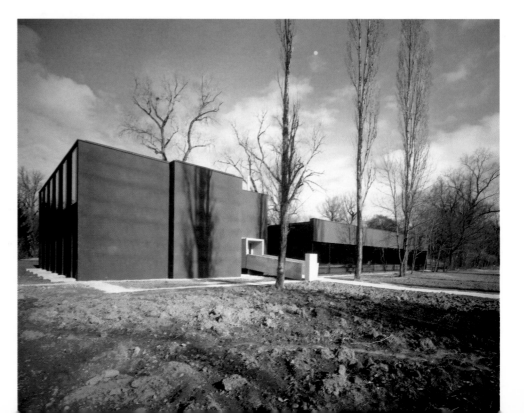

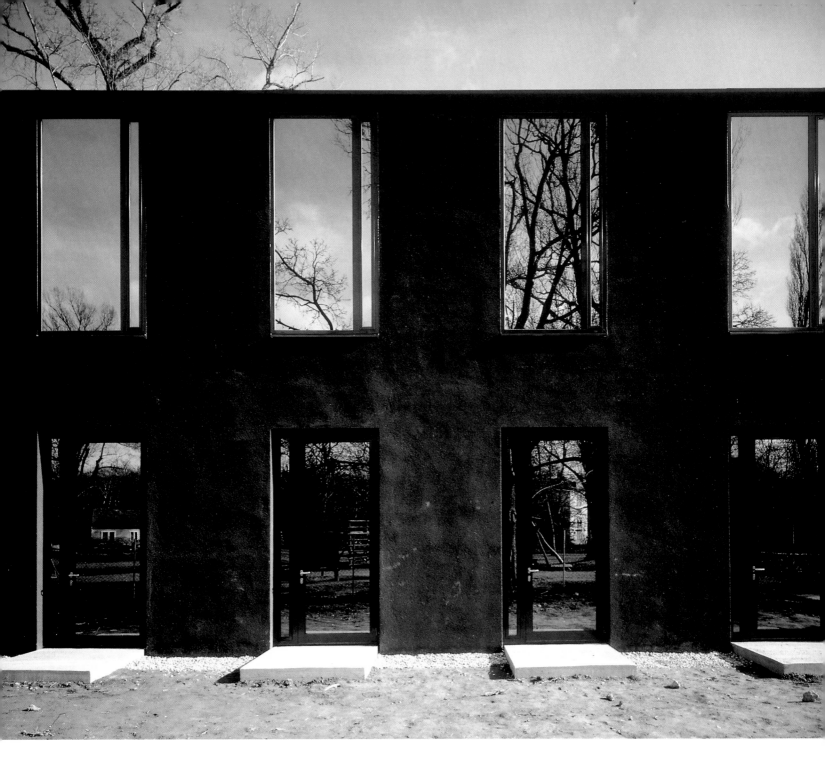

Elevations

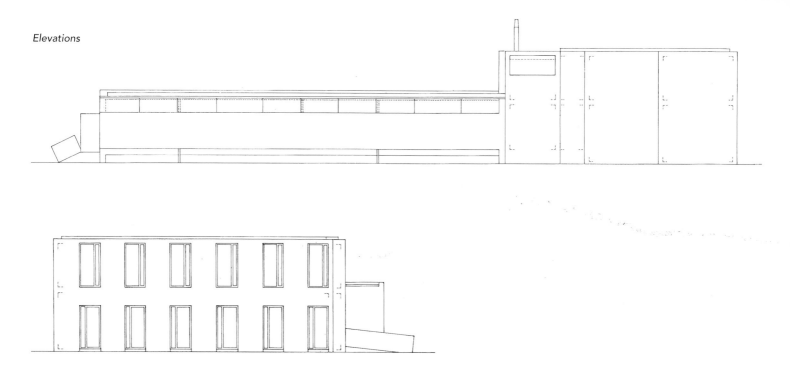

North west corner.

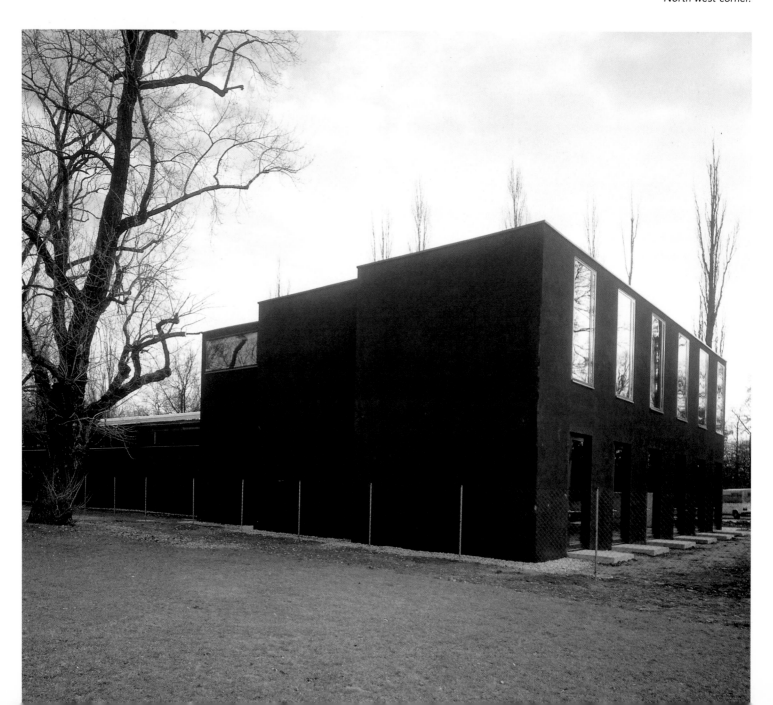

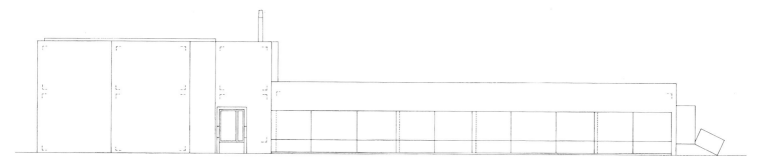

View of main access.

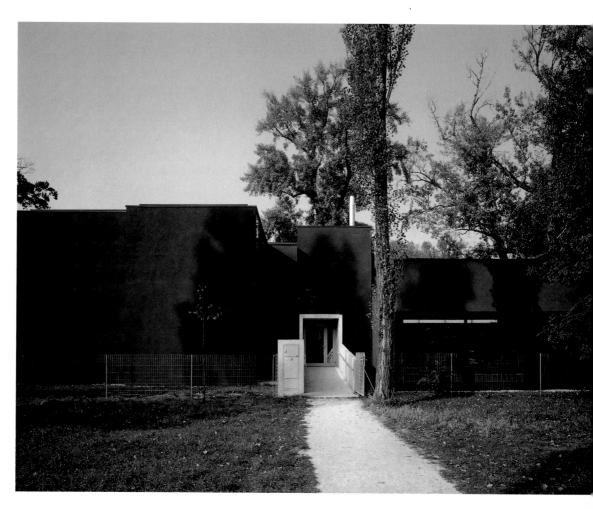

Classroom cross section.

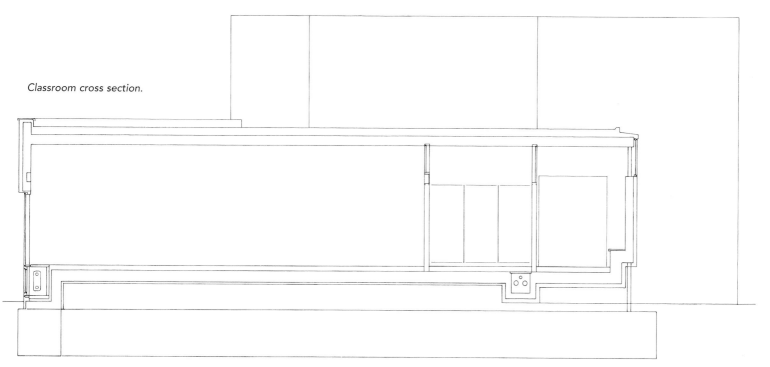

61

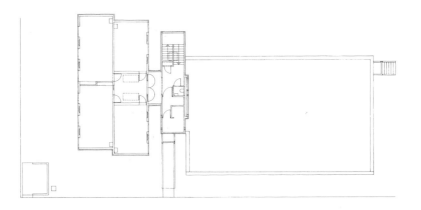

Second floor.

"The theme of the building is unity within multiplicity, the interior, the visible, nature (art), art (nature), the identical and the different, the chemistry of perception, the artists' colors as energy capable of potentiating meanings." Adolf Krischanitz.

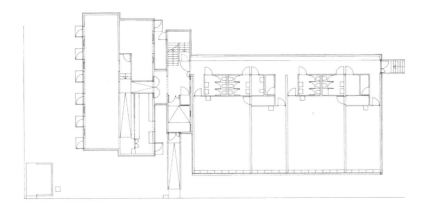

Ground floor.

ERDGESCHOSS

Corridor from which the classrooms lead off.

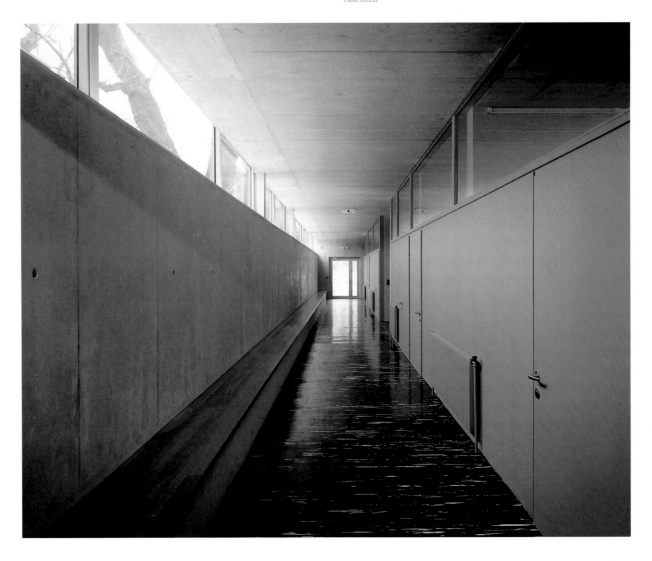

62

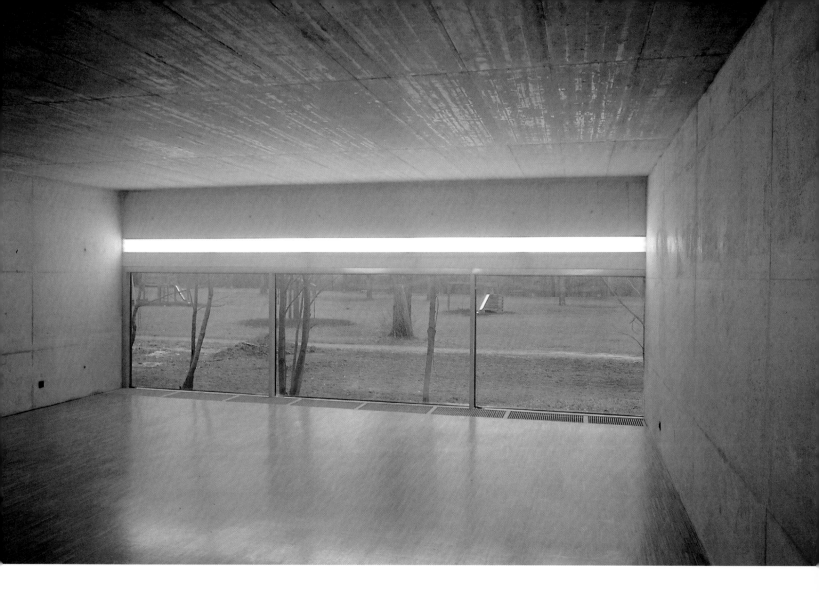

Interior of a classroom. The concrete of the walls and ceilings has been left bare. The lights have been embedded in the wall.

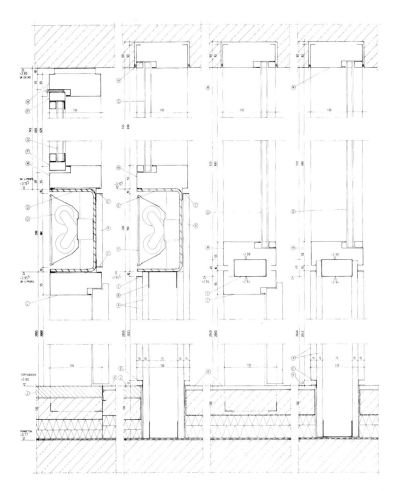

Interior elevations.

Communications Sciences Faculty

Varis arquitectes

One of the stipulations made by the Communications Sciences Faculty program was that during class time the lecture rooms could either be in total darkness (to allow video, slides, or film) or else could admit natural light (during the lectures). This stipulation was turned into one of the main themes of the project. The façade of the main building is covered entirely in aluminum, the joints between the metal sheets forming continuous horizontal strips. Some of these strips are shutters that can be mechanically regulated. One advantage of this system over conventional curtains or blinds is that it is more durable and requires less maintenance.

Above all, however, the mechanism adopted by Varis Arquitectes is much clearer from a conceptual point of view, in that the façade itself opens and closes either to admit light or to keep it out.

Early in the morning, the building appears as a completely hermetic volume. As the day unfolds, the shutters are opened or closed according to the needs of each lecture room, so that the façade is never the same; its composition is random, variable, and unpredictable. The façade plays a prominent role in minimalist architecture. In this case, as in Philip Glass' compositions on a single theme, multiple variations unfold as the day progresses.

Location: *Barcelona, Spain.*
Design date: *1994.*
Completion date: *1996.*
Architect: *Dani Freixes,*
Vicente Miranda, Vicenç Bou,
Eulàlia González.
Collaborators: *Ricard Pie,*
Anton Alsina, Artur Arias.
Photography: *David*
Cardelús, Mihail Moldoveanu.

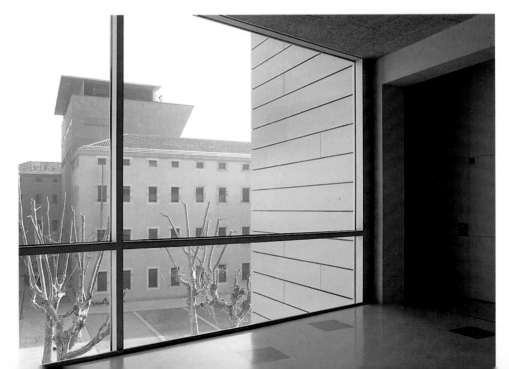

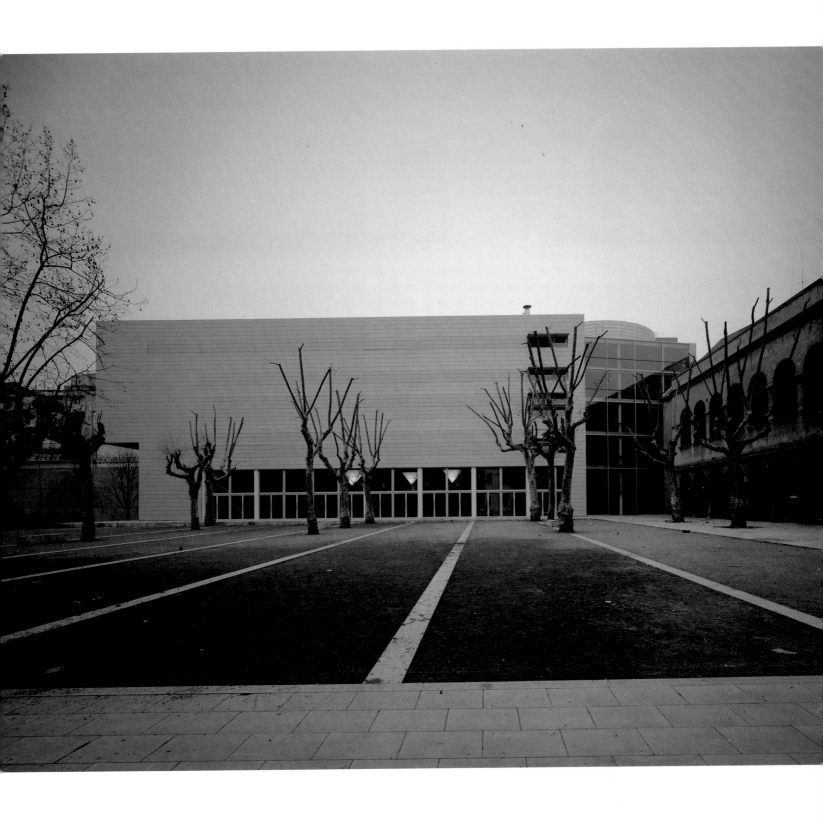

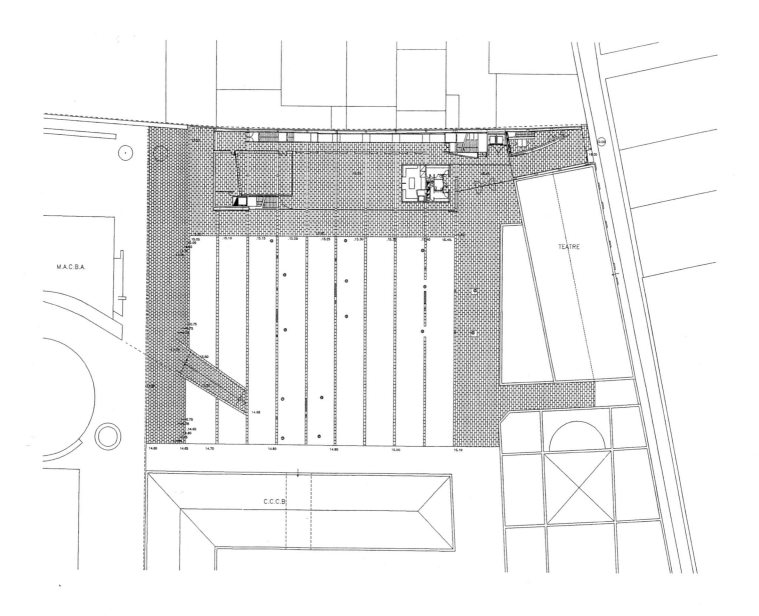

TEATRE

C.C.C.B.

Ground floor site plan.

Two views of the end wall of the
aluminum-covered volume.

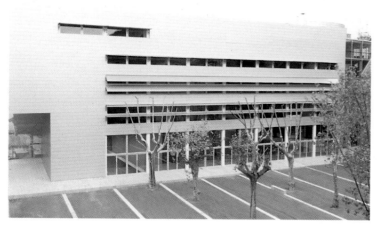

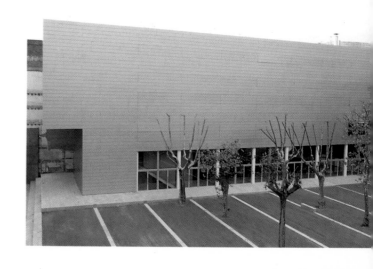

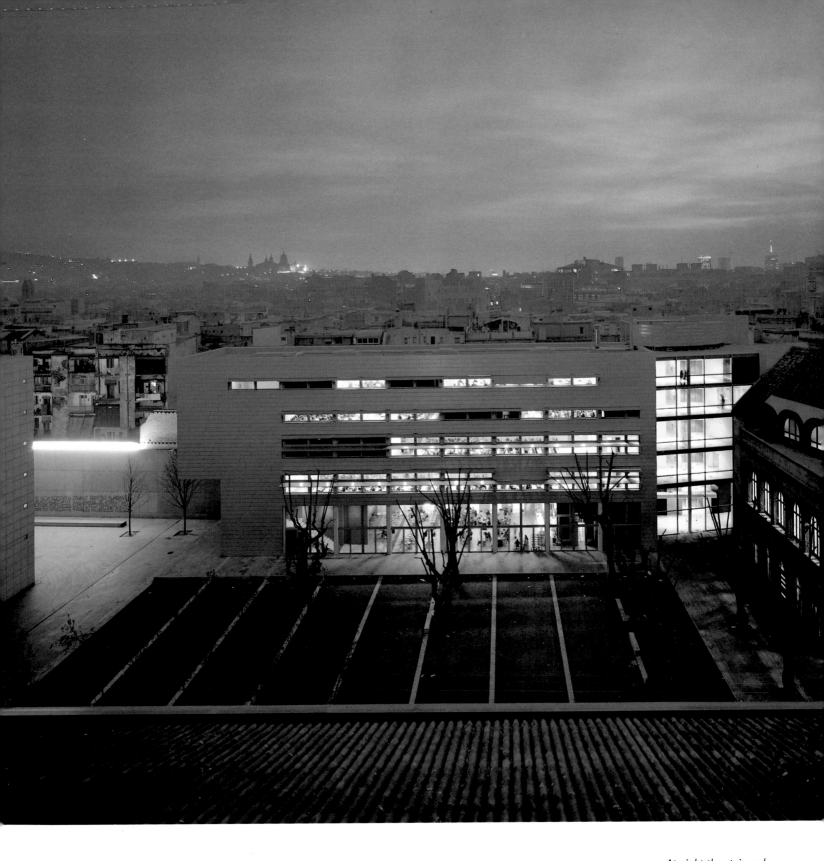

At night the stair and elevator module acts as a huge lantern that lights the plaza. The paved strips dividing the plaza are the orthogonal continuation of the building's structure.

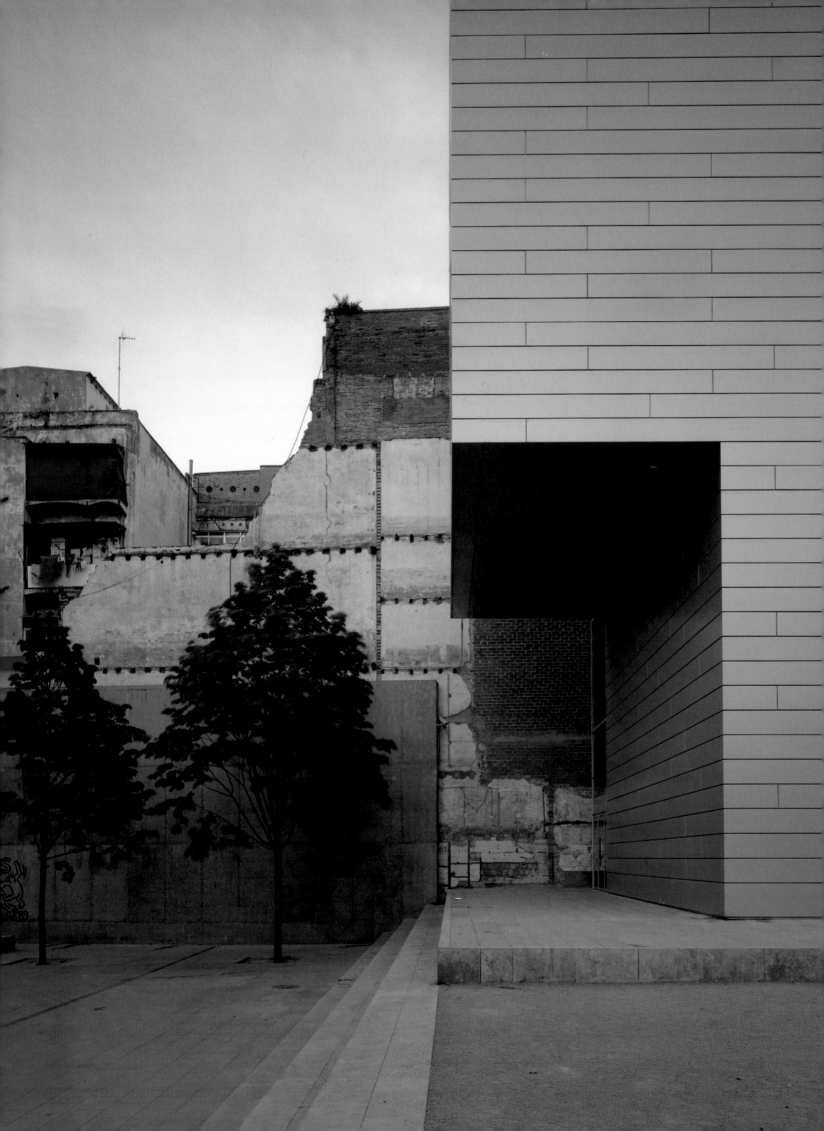

Two views of the main façade with the shutters in open and closed position.

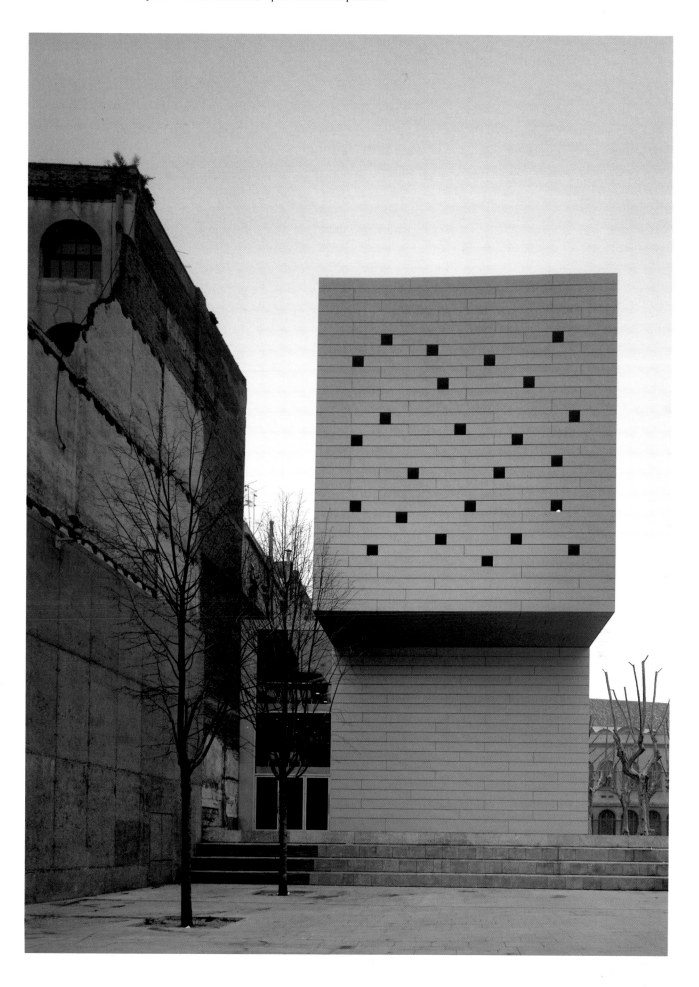

Rear façade. The Faculty building acts as a curtain that conceals the rear façades of older surrounding tenements.

The Valdonzella street façade juts into the surrounding neighborhood in Barcelona's old quarter and together with the two very different adjacent buildings, an apartment block and the Antic Teatre, constitut an example of eclectic architecture.

Except for the transparent entry door through which the foyer is visible, the façade is entirely of white translucent glass. During the day the façade is a broad white face separating the two buildings, while at night it is like a screen onto which the activities taking place inside are projected like Chinese shadows.

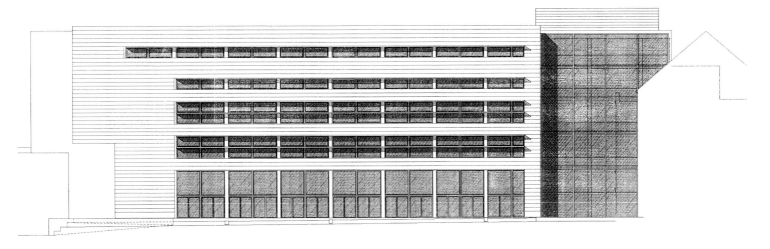

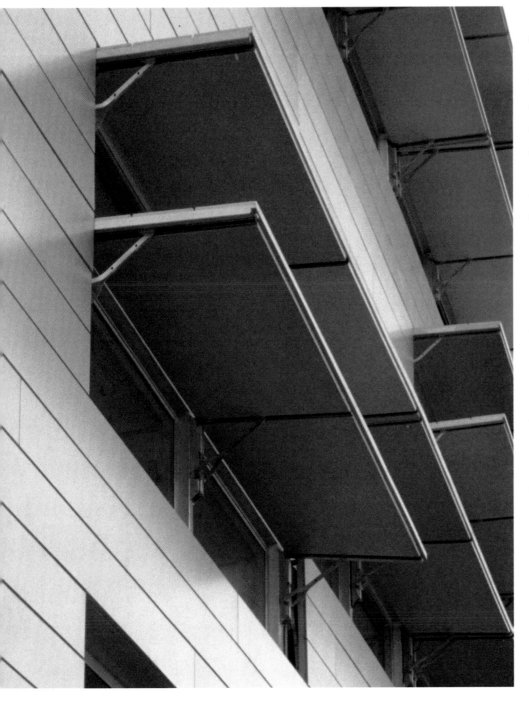

The Communications Sciences Faculty stands in the old quarter of Barcelona. Immersed in a high-density housing district, the building forms part of a complex of recently constructed cultural and educational facilities whose function is to enrich the zone.

The Faculty building constitutes the fourth façade of a plaza, the remaining three being the Contemporary Art Museum (MACBA), designed by Richard Meyer, the Barcelona Center of Contemporary Culture, a former convent refurbished by Viaplana and Piñón, and the old Casa de la Caritat theater.

The project by Varis Arquitectes actually encompasses both the Faculty building itself and the urbanization of the plaza. Consequently, another fundamental theme of the project is the building's relationship to the surrounding fabric of the city.

The Faculty constitutes one of the plaza façades, while also acting as a curtain separating this space from the patios and rear façades of the older blocks surrounding the new cultural complex. The end wall of the aluminum-covered volume is similarly one of the protagonists of a small lateral plaza that

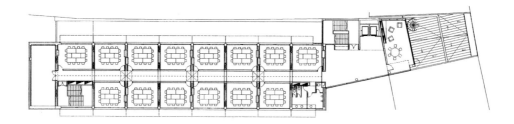

Fifth floor.

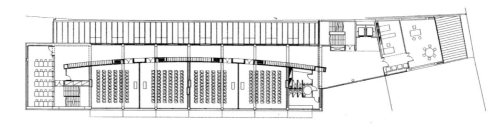

Fourth floor.

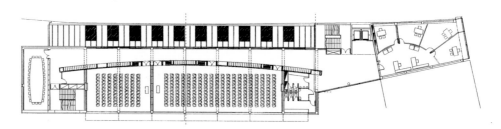

Third floor.

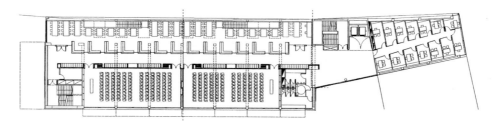

Second floor.

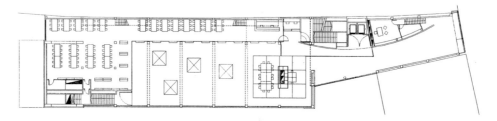

Loft.

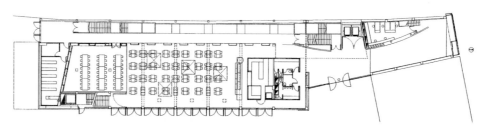

Ground Floor.

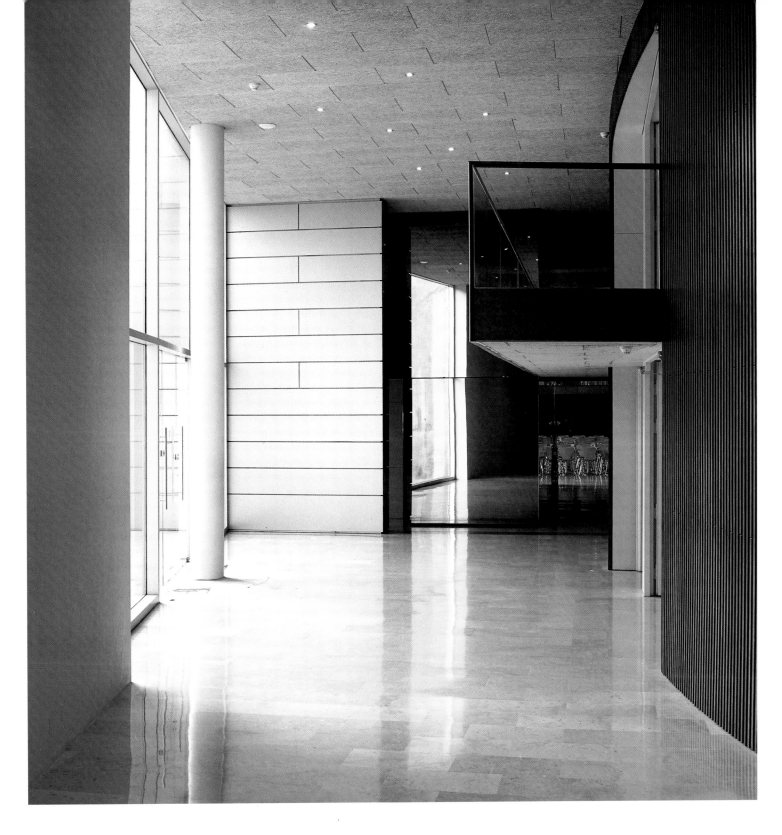

Detail of the entry and reception area.

also contains a large mural by the American artist Keith Haring.

From the volumetric point of view, the building can be read as a compact aluminum body slightly separated from adjacent constructions by stretches of glass, suture elements containing the stairs and elevators.

The ground floor accommodates the café-restaurant with wide windows overlooking the plaza. The bar is the build-

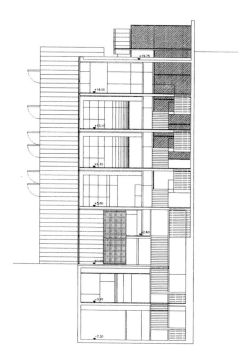

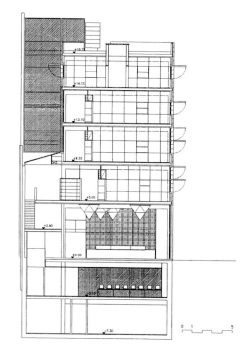

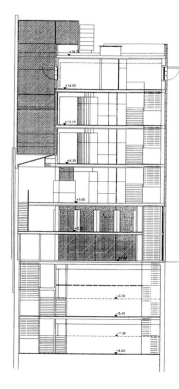

Cross sections.

View of the bar. The ceiling
lights were also designed by
Varis Arquitectes.

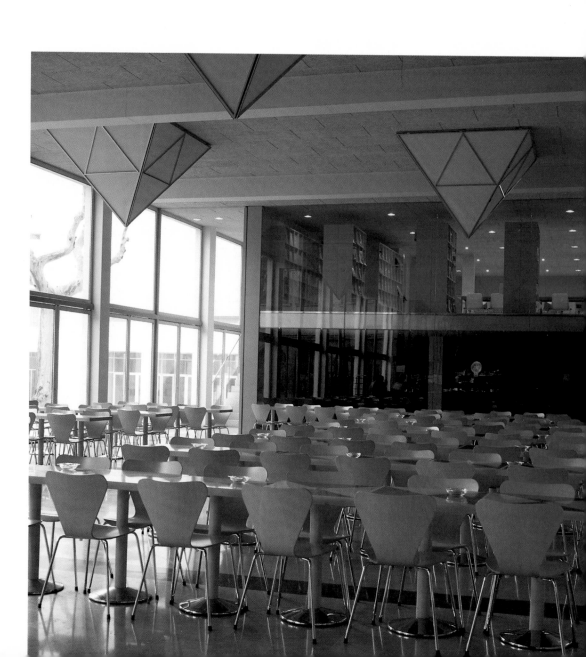

Two views of the corridors that provide access to the lecture rooms. Thanks to their curved form, the ends can be used as impromptu rest and waiting areas.

ing's main social area and meeting place for students. It is a brightly-lit, two-story open space with rudimentary, mostly beechwood furniture. The mezzanine half-floor above the café contains the library, conveniently soundproofed, although a visual link has been maintained between the café and the area with periodicals and audiovisuals.

The basement contains the multimedia technical rooms: film set, control room, makeup room, computer rooms, radio studios, and photography and video laboratories.

The upper floors of the main building contain the lecture rooms, while the administrative offices are in the wing that juts into the surrounding neighborhood. Both are separated by the stairs and elevators.

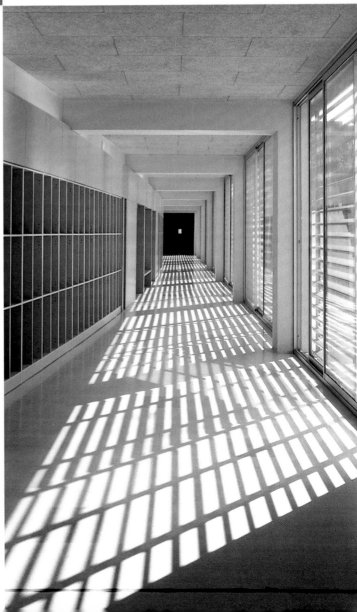

Faculty of Journalism

Ignacio Vicens/José Antonio Ramos

The relationship between mass and void is what gives this building its form. From the point of view of the skin that is, the image the volumes that stand out against the sky and the hollows that carry light into the concrete mass are equally important.

Studying the decisions that gave rise to this form reveals a twofold strategy. First, the various functional areas were to be split off into separate volumes. Therefore, as the functions of certain elements such as the ground floor main auditorium or the block containing the audio-video library became increasingly independent, they would tend to emerge as autonomous pieces. The second was that the architects were to endow each space with a specific kind of lighting and its own way of relating to the exterior. The exterior was to consist of openings and patios, as if the building had been constructed in negative from the roof downwards.

Consistent with the first strategy, Vicens and Ramos chose a homogeneous finish for the whole building (in concrete, a simple yet noble material) and they designed the windows as incisions or holes so as to lose their identity as windows. These decisions not only avoid contaminating the building's appearance with trivial details but also they are absolutely necessary if the observer is to fully appreciate the guiding principle of restraint.

Location: *Pamplona, Spain.*
Design date: *1994.*
Completion date: *1996.*
Architect: *Ignacio Vicens, José Antonio Ramos.*
Collaborators: *Fernando Gil, Adam Blesnick.*
Photography: *Eugeni Pons.*

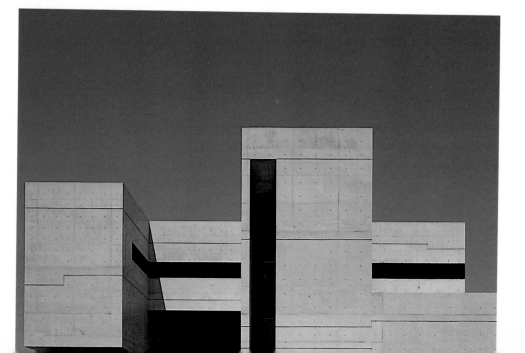

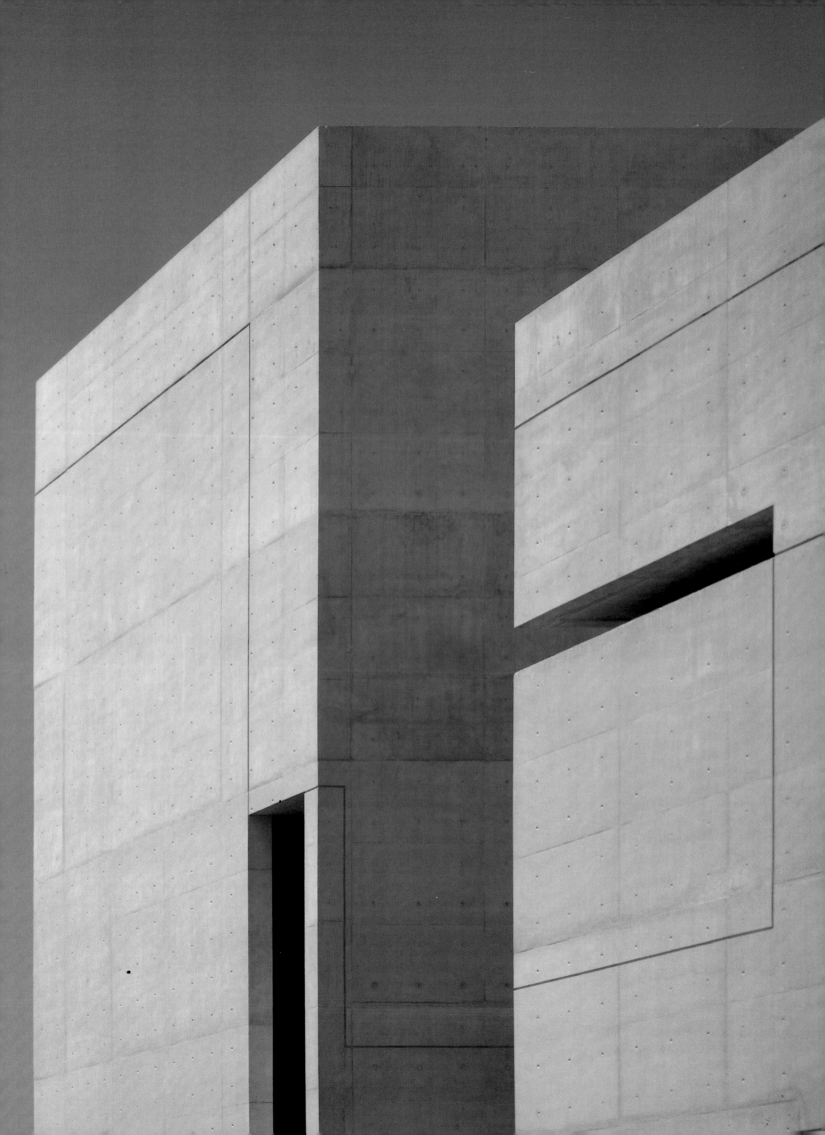

This page: *view of the east façade. Following page: the south façade, overlooking the plaza.*
"The deep, narrow incisions corresponding to the stairs reveal equivalent though not identical situations: perpendicular to the façade there is a horizontal opening; parallel to it, a vertical opening. Thus, perception of the exterior on the part of the observer is in both cases instantaneous and ephemeral."

Preliminary sketch.

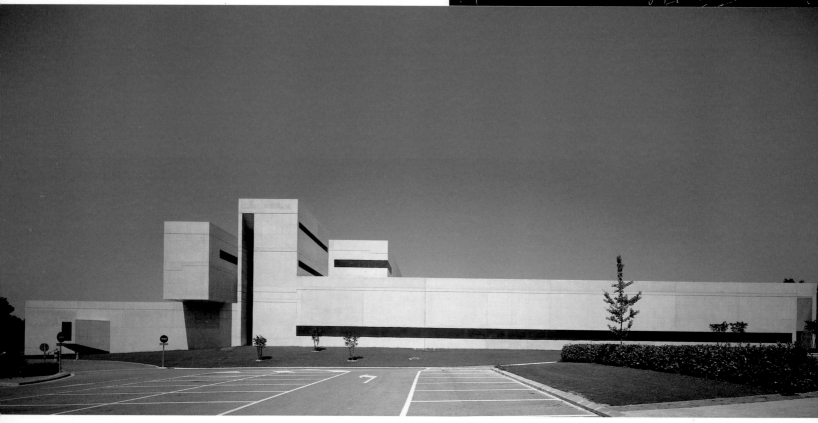

The Social Sciences Faculty is located in an important part of the University of Navarra campus, next to the Library and the Law and Economics faculties. This is the center of gravity of university life, and for this very reason the architects were required to include a central plaza in their design. While the building was designed mainly to house the Faculty of Journalism, some of its lecture rooms were to be made available to students from other disciplines.

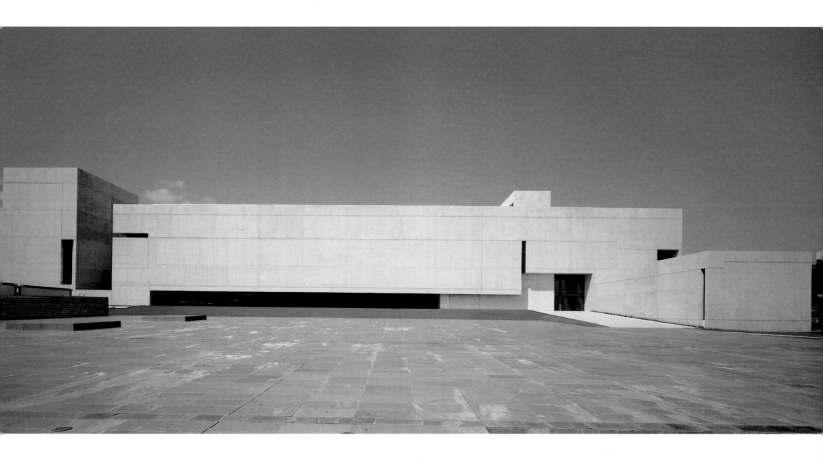

Site plan.

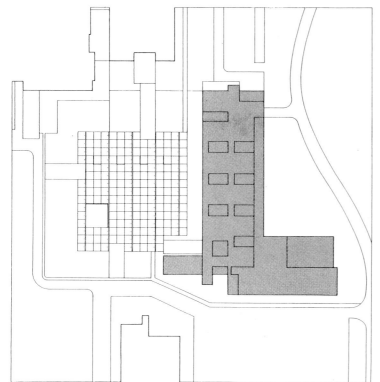

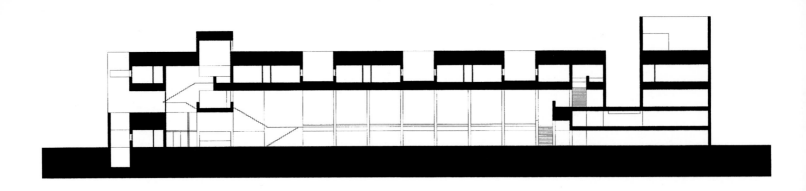

Longitudinal and cross sections.

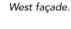

West façade.

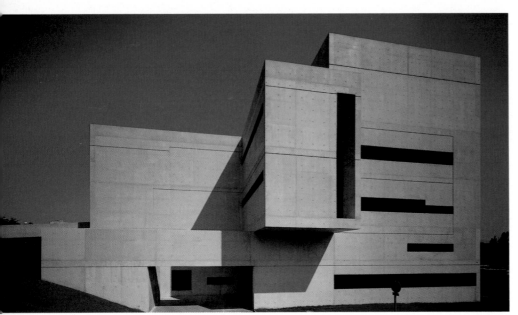

The functional program includes theoretical and practical workshops, radio and television studios, seminar rooms, an audio-video library, offices and a cafeteria. A clear division was needed between the corridors linking the spaces belonging exclusively to the journalism department and those shared by the other schools, which were all located on the ground floor.

The building layout lends to the overall design what in the opinion of the architects constitute the three fundamental activities of any university: research, transmission of knowledge, and living together.

Research, conducted by small groups in quiet rooms isolated from the rest of the institution, is an activity that the architects have designated for the fourth floor, structured according to a system of interior

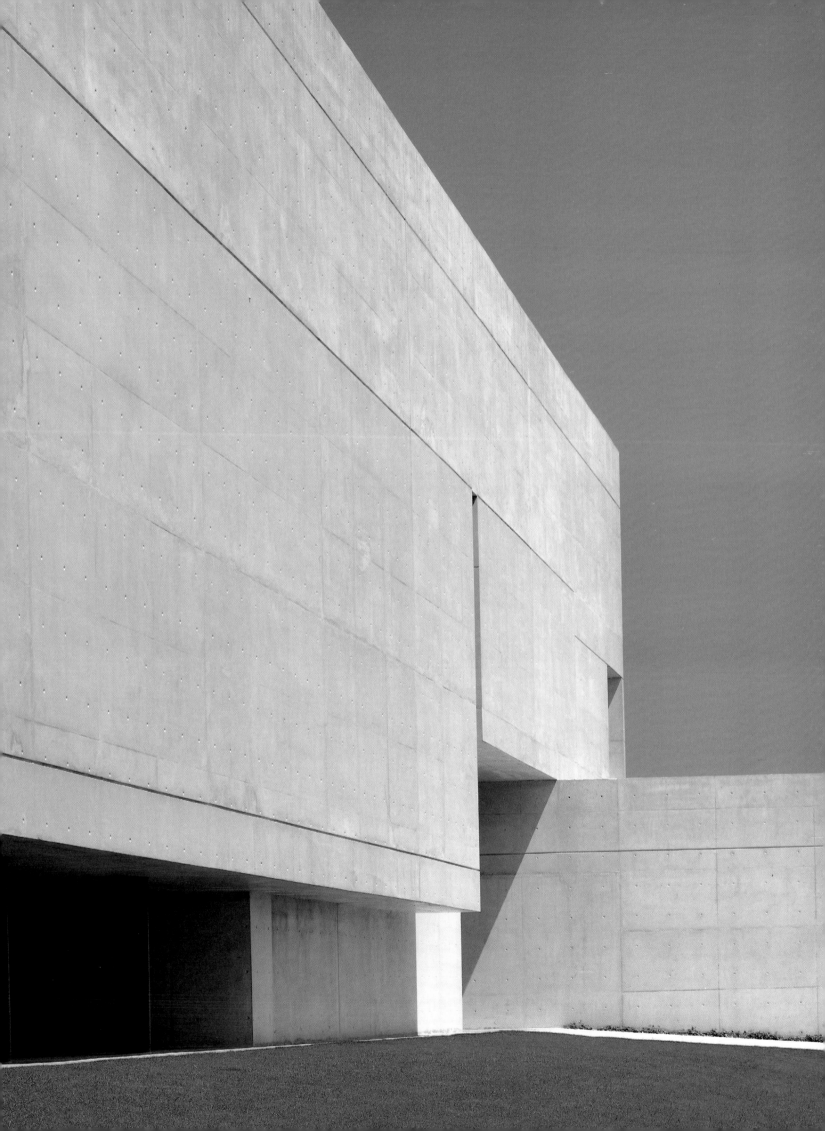

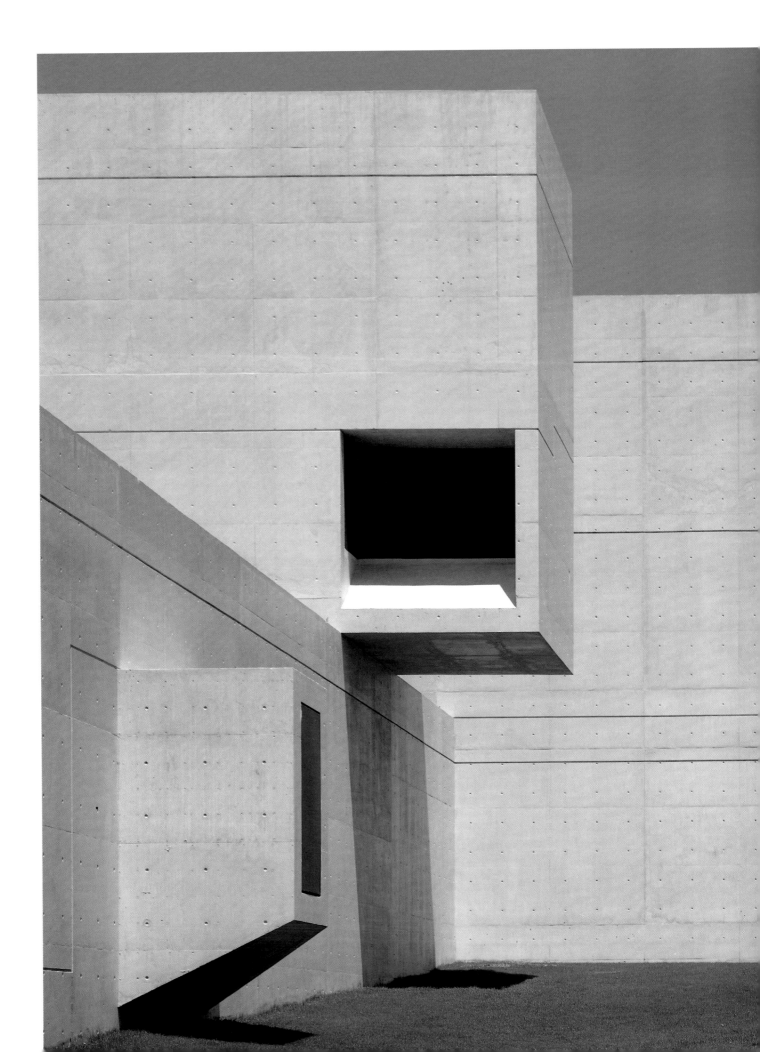

patios, paved with pebbles and empty except for an Acer japonica palmatum tree whose leaves change color.

For the second fundamental activity, the transmission of knowledge, lecture rooms are concentrated on the ground and second floors, oriented toward the north, with classroom facilities designed to accommodate theoretical and practical instruction.

Finally, the architects took into consideration a third activity that is often overlooked: living together with others. Chance encounters, informal conversations and relationships established outside of class hours are sometimes as important as the classes themselves. While professors and university authorities can do little to foster this activity, the architect can do much, since it is his or her responsibility to create the spaces in which it can take place.

For Ignacio Vicens and José Antonio Ramos, the faculty's main space is the multi-storied atrium leading to the lecture rooms. By virtue of its dimensions, its lighting, its links with the plaza, its visual relationships and the traffic patterns it establishes, this space constitutes the building's main social center.

Two views of the main atrium.

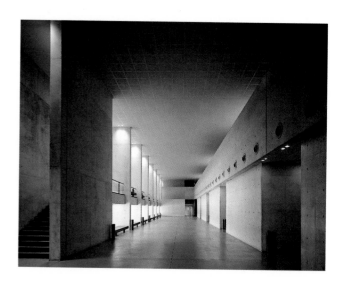

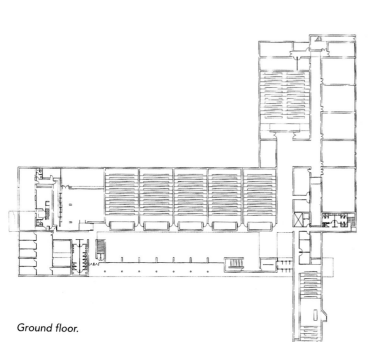

Ground floor.

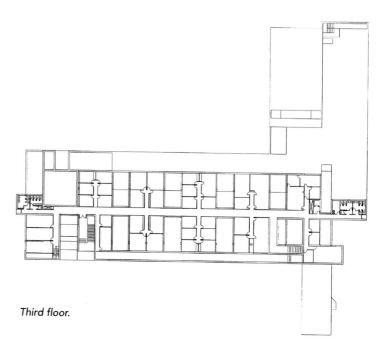

Third floor.

The whole building, both inside and out, is bare concrete. The flooring is of polished concrete except in the plaza, which is paved with gray quartzite. The openings are protected by perforated sheet-metal lattices flush with the exterior surfaces. The exterior frames and profiles are in gray lacquered aluminum, while the interior carpentry is gray formica. The desks, seats, wastepaper cans, ashtrays and noticeboards were also designed by the architects.

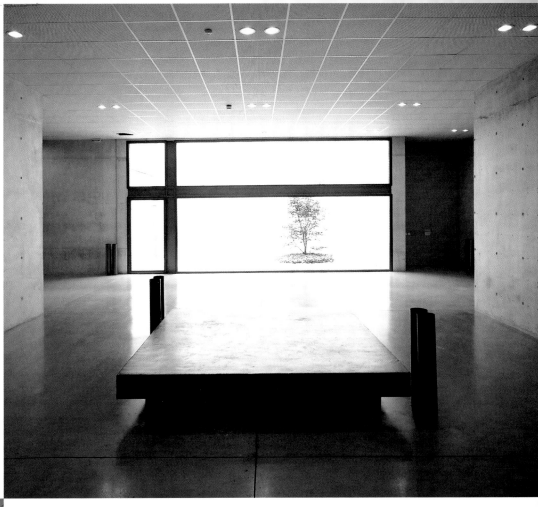

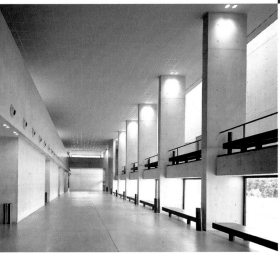

View of the auditorium.

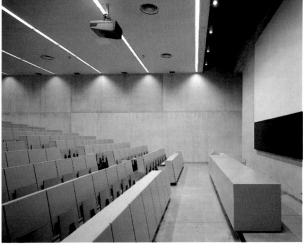

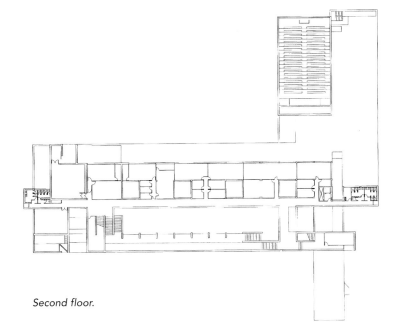

Second floor.

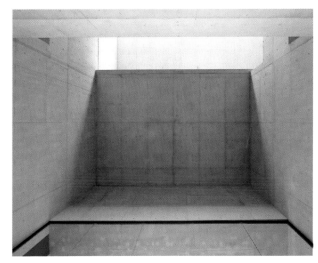

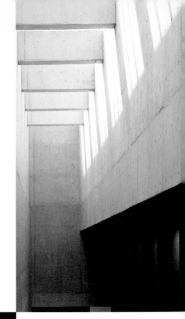

Details of the lighting of the main atrium. The light is almost invariably reflected off the graded concrete walls.

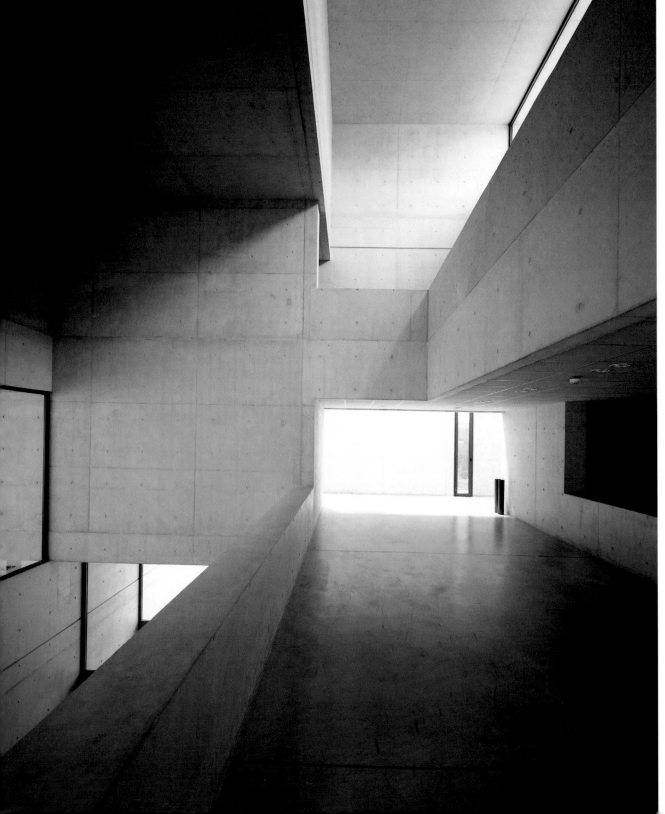

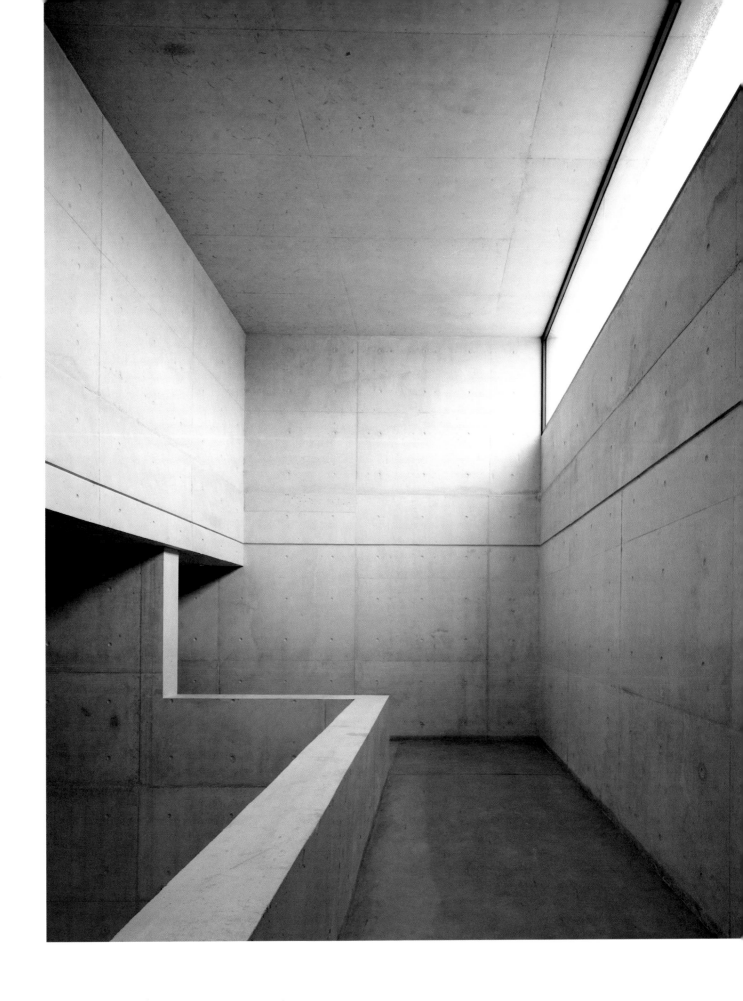

Marne-la-Vallée Technical Center

Dominique Perrault

Despite the fact that most of Perrault's projects are very recent, his work has had huge repercussions in the architectural world, by virtue not only of the magnitude of his commissions but also of the radical nature of his concepts. Projects such as the National Library of France or the Berlin sports complex are based on stringently abstract spaces closed off to the exterior. Although his works are often described as monumental, his smaller-scale projects reveal that this monumentality is the product not of the magnitude of the buildings but rather of the proximity between his concepts and recent sculpture.

The Marne-la-Vallée Technical Center is in the town of Bussy Saint-Georges, near an expressway and a railroad line linking the new city of Marne-la-Vallée with the center of Paris in about a half hour. In this area a dozen or so companies have purchased land.

The building was designed to ensure perfect formal and functional coherence between the new National Library of France, the Library of Tolbiac, and the Marne-la-Vallée Center. As the center

Location: *Bussy-Saint-Georges, France.*
Design date: *1992.*
Completion date: *1995.*
Architect: *Dominique Perrault.*
Collaborators: *Maxime Gasperini, Jérôme Besse (assistants), Daniel Allaire (engineers), Pieffet-Corbin (economist).*
Photography: *Georges Fessy.*

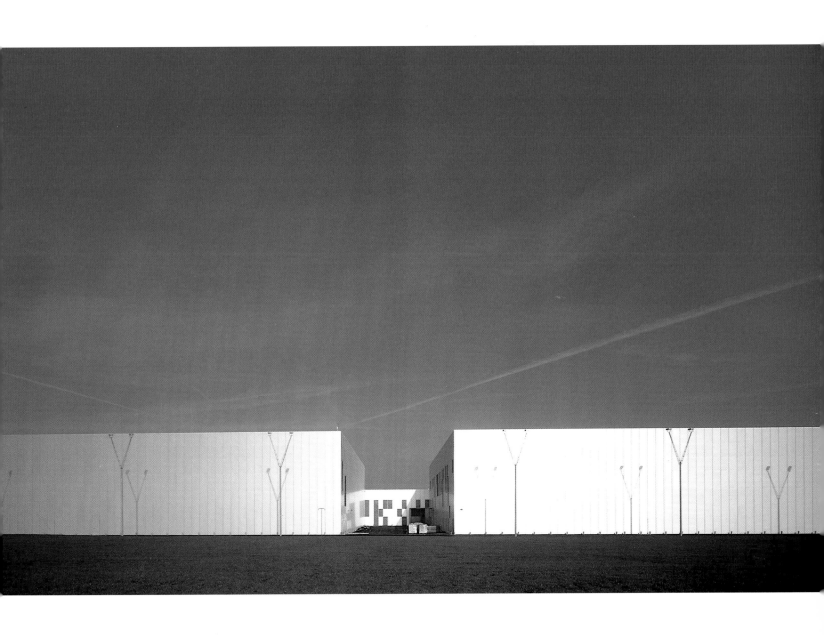

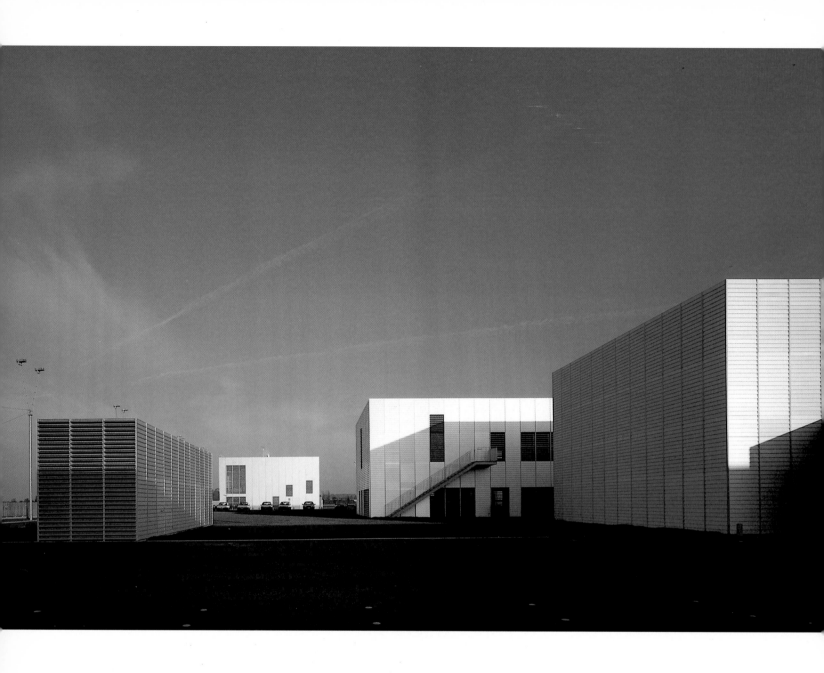

Site plan.

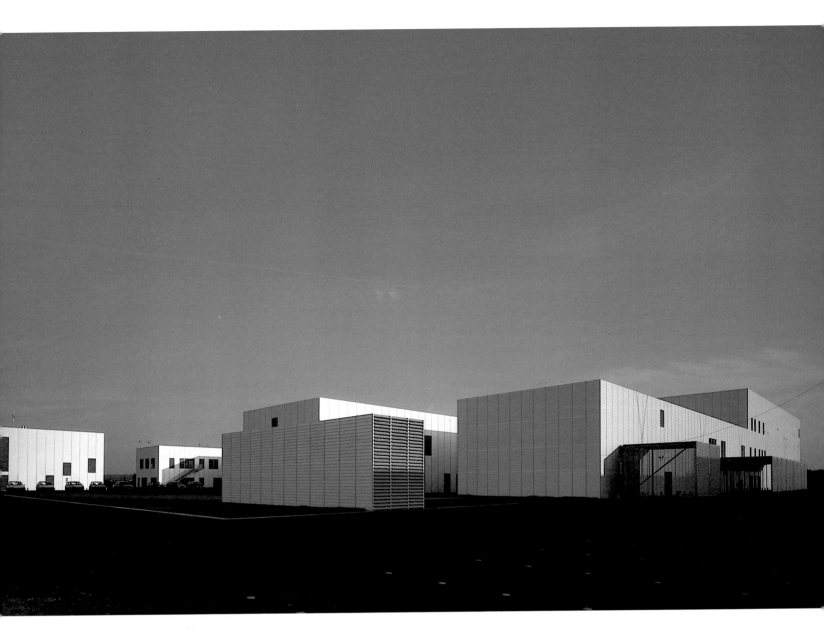

might one day be extended in response to future needs, different phases have been considered, the first of which comprises the current project. The buildings constructed until now are set back against the western edge of the site to allow future enlargements in the remaining three directions: north, south and east.

In this first phase, the set of buildings covers a total square footage of 42,575, of which 15,310 correspond to the Ministry of Higher Education and Research. Future enlargements are planned through enlargement of existing structures and through an arrangement of structures supplementary to the first phase.

The Technical Center is intended for housing rarely-consulted works or collec-

tions in order to leave room in the archives of the higher-education libraries. This means above all that special emphasis is laid on systematically controlling temperature and humidity. The Center is also intended to respond efficiently to users. Requests must either be handled within 24 hours after the placing of an order.

The Center's main axis is a covered interior street linking its different areas and along which workshops and storerooms are arranged. Access is by means of a single entry to the north. On one side of this covered street, buildings are arranged perpendicularly, like the teeth of a comb, and include workshops, offices, confer-

ence and training rooms. The storeroom modules are on the other side.

The workshop and storeroom façades are 30 and 50 feet high, respectively, and are covered in an aluminum skin consisting of fixed opaque sheets and movable panels fixed to the concrete walls by aluminum frames. All panels are the same size: 1.2

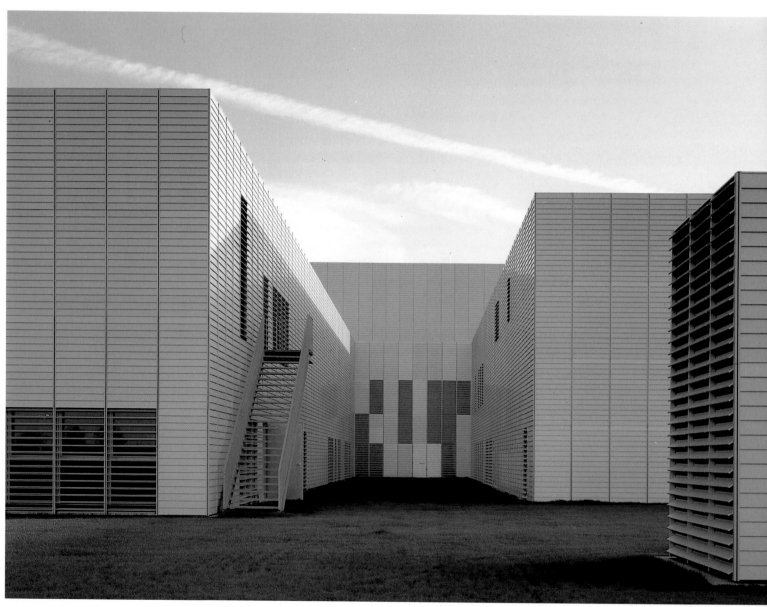

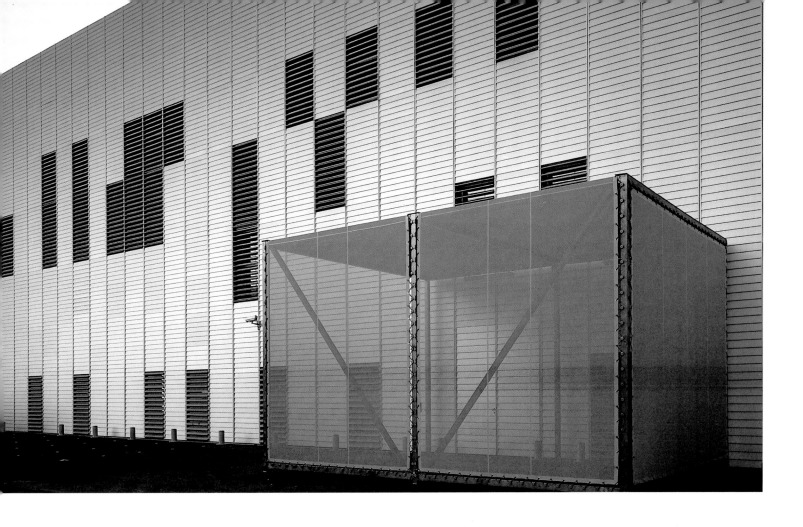

One of the elements characteristic of the project is the absolute levelness of the site and the almost complete absence either of nearby buildings or of any reference foreign to the landscape or the building itself. In this sense, the hermetic volumes of the different modules could be mistaken for examples of landscape art.

Detail of the façade. Section and plan of a window.

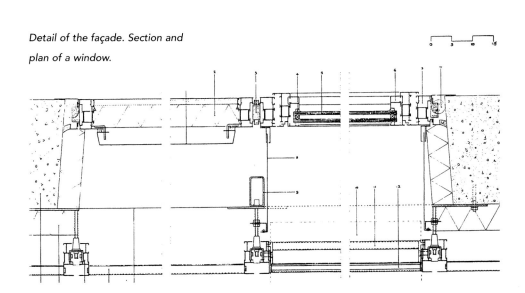

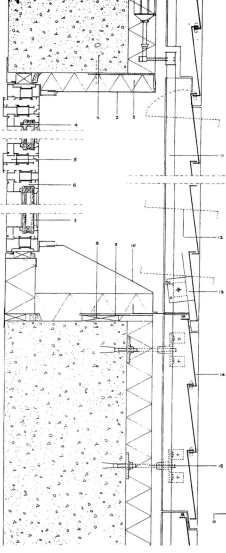

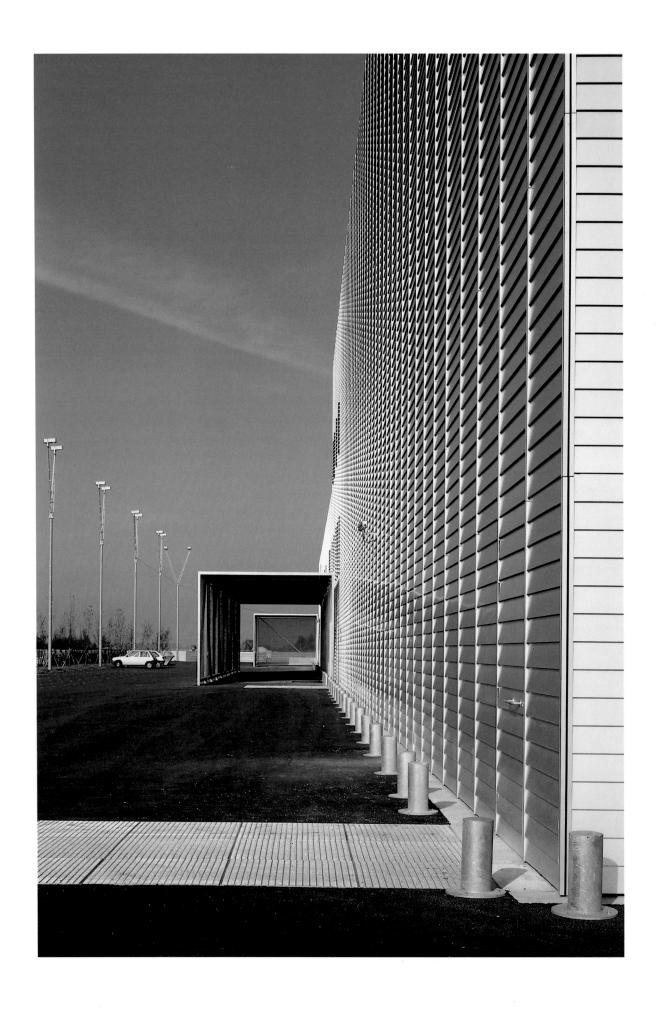

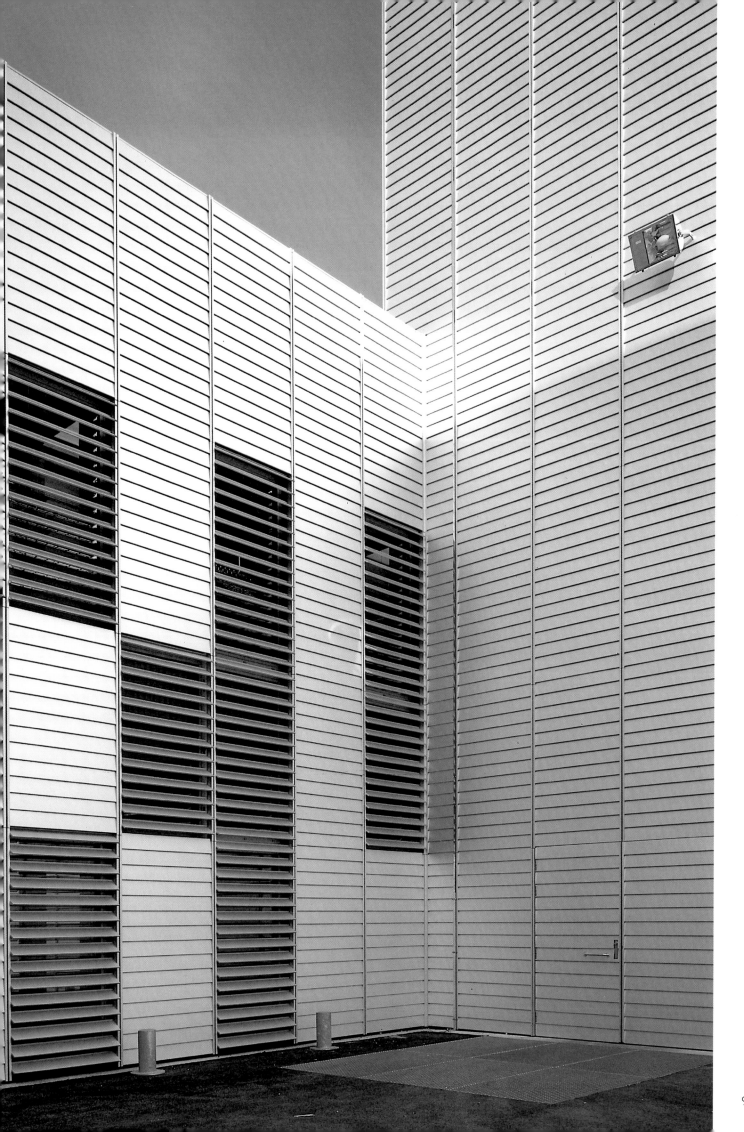

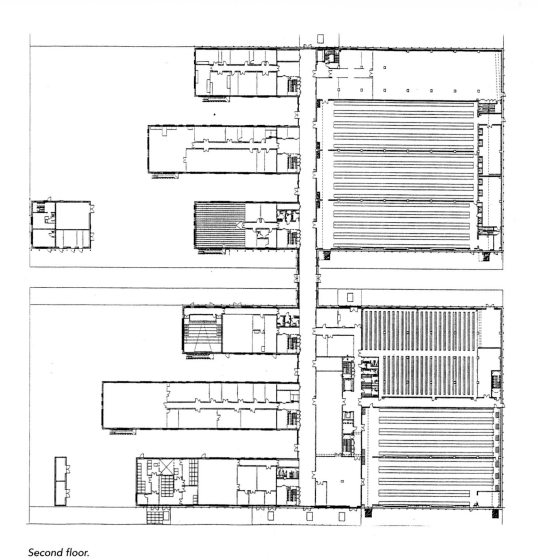

Second floor.

Third floor.

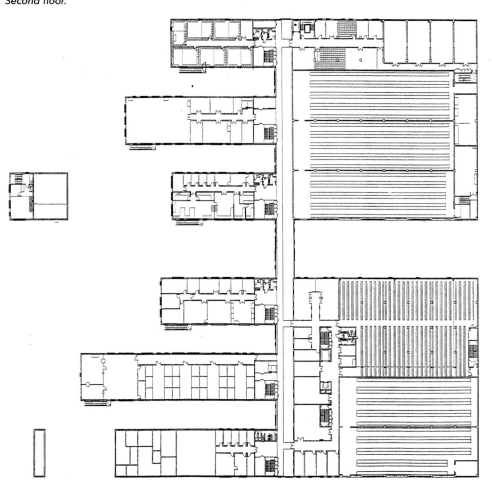

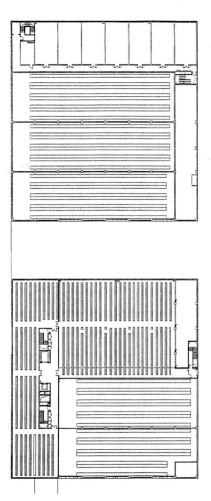

Ground floor.

Fourth floor.

The center is for the storage and preservation of many of the scientific collections, only very sporadically consulted, of the Île de France university libraries. Since 1983, the government had been expressing concern about the saturation suffered by the large university libraries in terms of these kinds of works and documentation and the functional problems such saturation generated. The project for a storage library on the city outskirts which would take into account the need for rapid transmission of data was conceived between 1983 and 1988. In 1990 the idea took shape as a center to complement the National Library of France in order to avoid the redundant use of workshops, to coordinate the preservation of documents, and as far as possible to reduce logistical costs.

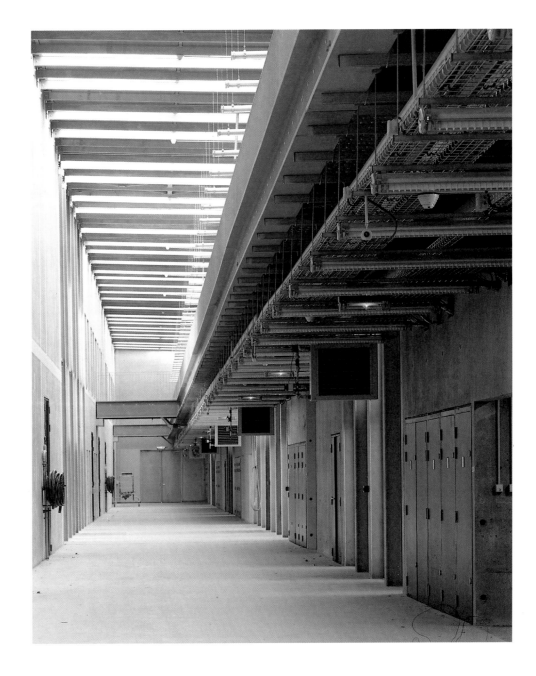

yards long by 6 inches wide and one millimeter thick. Most of these are fixed, while the movable ones are activated by means of an electrical device. The fact that a single material has been used as covering endows the whole building with a unitary character. Though they are slats, most are closed and can never be opened, lending a sense of being sealed off. In some places, when the slats are opened to admit a certain amount of light, they make rectangular shadows on the façades.

The Center's homogeneous surfaces present an image of conceptual clarity. This is an extremely pure, ordered project whose beauty is enhanced by the absence of anything superfluous.

Maison des Arts

Massimiliano Fuksas

Fuksas is not a Minimalist architect in the strict sense. That is, he does not define himself as such. However, the work of this Italian architect now living in Paris is deeply lyrical, something unusual in a discipline linked to space and concreteness.

Late in the eighties, Fuksas designed the cemeteries of Città Castellana, Anagni, and Orvieto, which earned him worldwide renown. The emotive force of these projects surpasses their purely architectural character to such an extent that they can be read as true large-scale art installations. While the poetic element is fruit of these projects' spiritual purpose, Fuksas' entire œuvre is almost invariably informed by a desire to mobilize the observer's emotions.

The mechanisms employed by the architect are different in each case. He might draw on a dreamlike or metaphysical universe, as in the cemeteries, or he might exploit the suggestive capacities of materials, as in projects such as the entry to the Niaux caves or in this one, *the Maison des Arts* in Bordeaux. All share an obvious proximity to the plastic arts, however.

Fuksas is not a minimal architect as John Pawson or Peter Marino are, since while the latter define themselves as Minimalists and theorize on the implications of this definition, Fuksas approaches Minimalism

Location: *Esplanade des Antilles, Bordeaux, France.*
Completion date: *1995.*
Architect: *Massimiliano Fuksas.*
Collaborators: *Patrizia Anania, Mirela Constantin.*
Photography: *Philippe Ruault, Antonio Martinelli.*

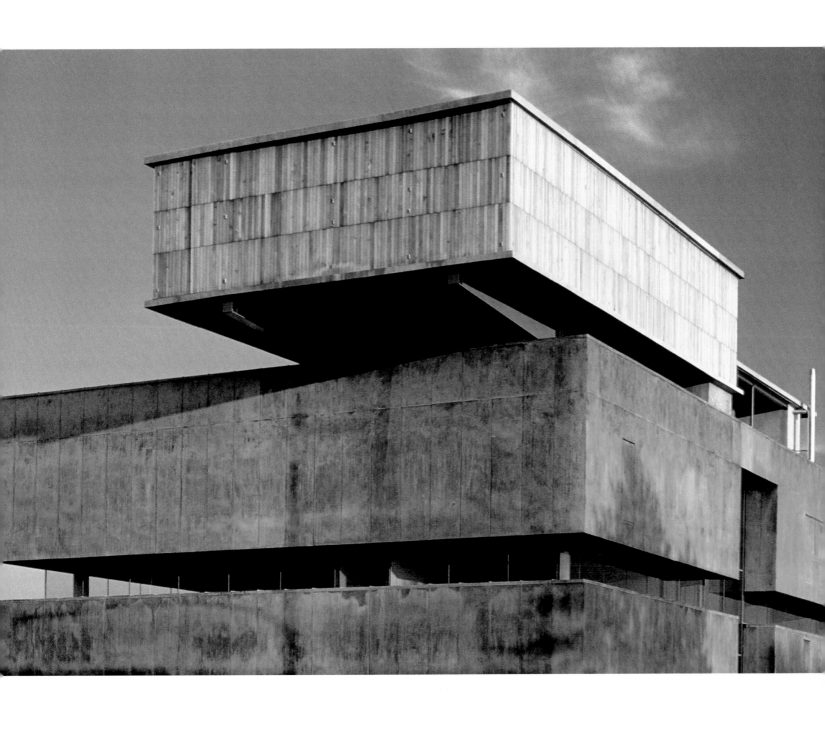

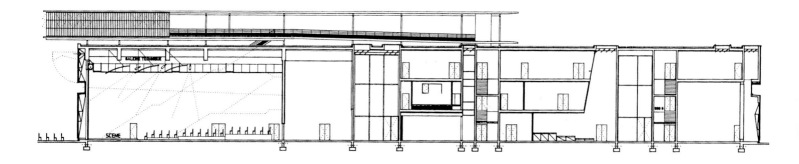

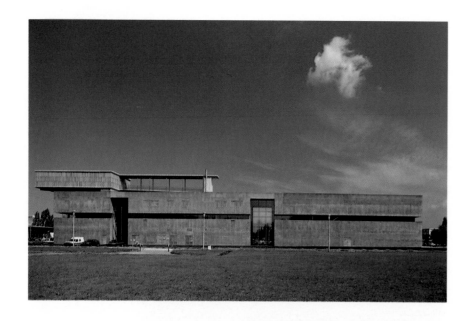

The Maison des Arts *is part of a University Campus surrounded by greenery.*

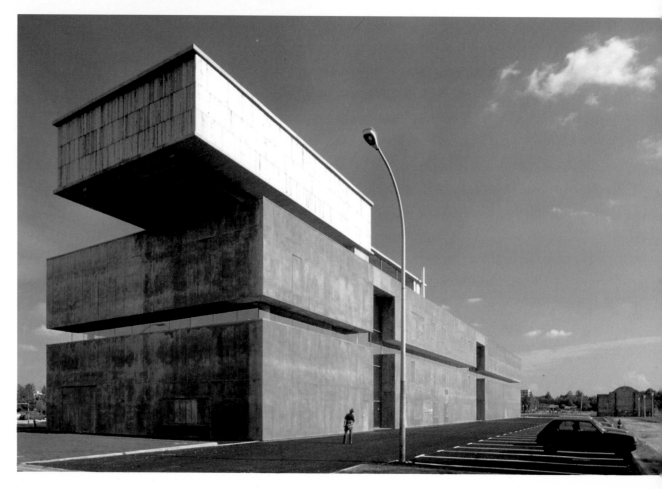

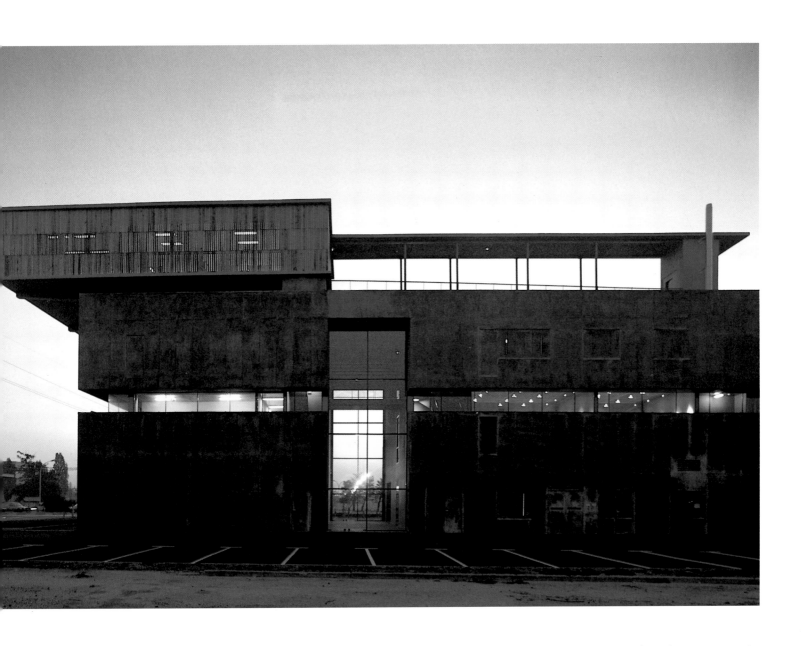

The nighttime image is the equivalent in negative of its daytime counterpart, in the sense that the elements that stand out during the day (copper surfaces and wooden cantilevered box) disappear at night, and vice versa. The windows, almost imperceptible in daylight, assume a leading role in the dark.

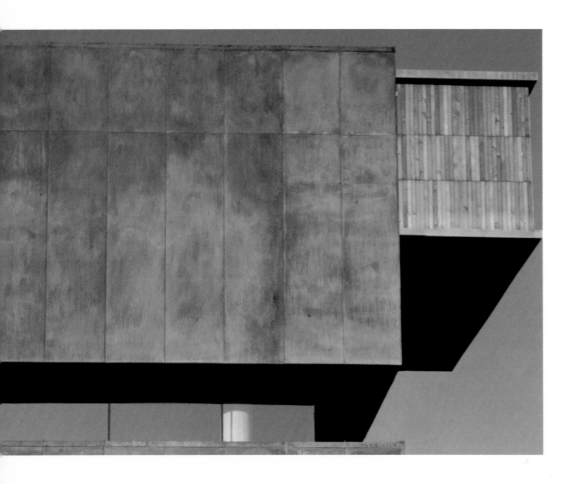

Two aspects of the windows, with the shutters open and closed. The shutters are of the same material as the façade, so that when they are shut, the windows disappear.

Constructional detail of the horizontal glass strip that cuts the façade into two blocks.

Detail of the pre-oxidized copper skin.

tangentially, as he had done previously in the cases of Surrealism or Art Brut.

At the same time, the Maison des Arts does reflect a clearly Minimalist calling. When Fuksas explains the concept behind the project, he does so in the following way: "the departure point is the idea of eliminating structure as far as possible in order to enhance the void and create a simple object, a recipient, endowed with a delicate skin." Indeed, both its exterior appearance and interior spaces are simple and highly restrained. The façade is almost completely hermetic. The distinction of the building lies in its complete covering of oxidized copper, in the light incisions of glass through which the inhabited interior can be seen at night, in the intermittent windows, which appear and disappear (if such a thing is possible in architecture) and in the tim-ber cage balanced on the roof.

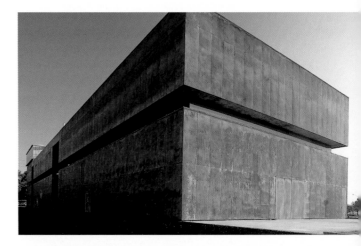

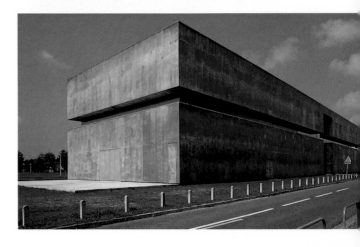

102

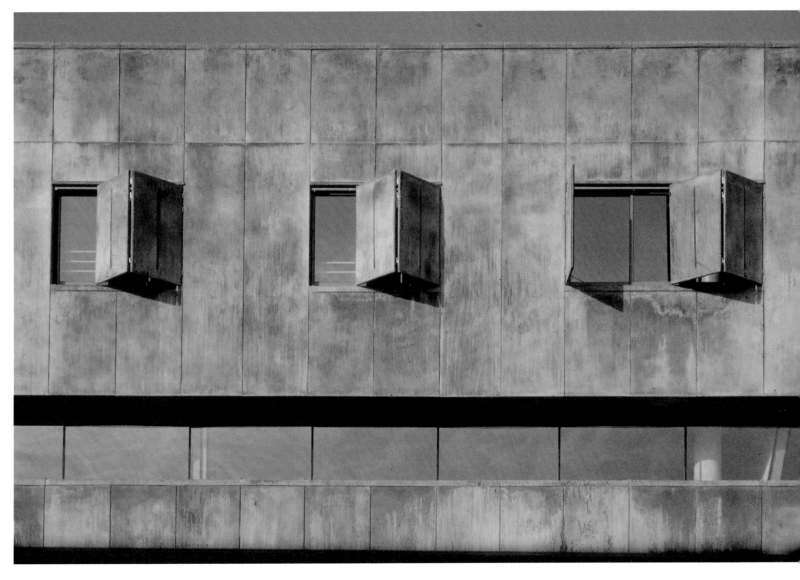

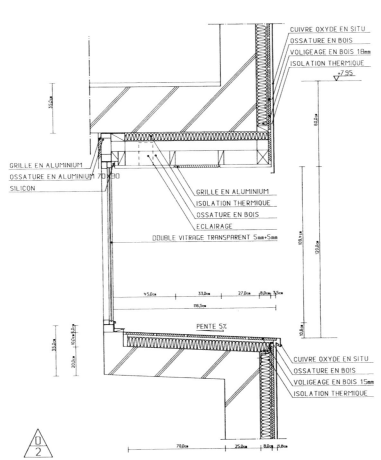

CUIVRE OXYDE EN SITU
OSSATURE EN BOIS
VOLIGEAGE EN BOIS 18mm
ISOLATION THERMIQUE
▽ +7.95

GRILLE EN ALUMINIUM
OSSATURE EN ALUMINIUM 70×80
SILICON

GRILLE EN ALUMINIUM
ISOLATION THERMIQUE
OSSATURE EN BOIS
ECLAIRAGE
DOUBLE VITRAGE TRANSPARENT 5mm+5mm

PENTE 5%

CUIVRE OXYDE EN SITU
OSSATURE EN BOIS
VOLIGEAGE EN BOIS 15mm
ISOLATION THERMIQUE

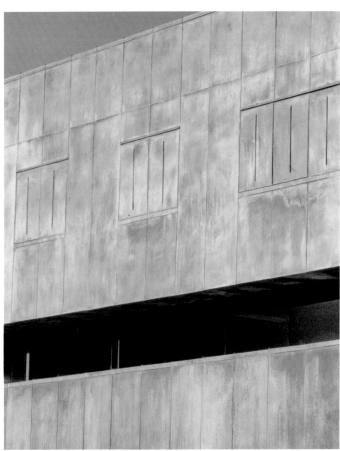

*Different views of the roof and
the radio studio.*

*From the elevator, a catwalk
crosses the roof to the wooden box
containing the radio studios. This is
at once a sculptural element that
stands out against the building's
profile and a ritual itinerary that
leads radio students nearer to the
sky' into which their broadcasts
will be radiated.*

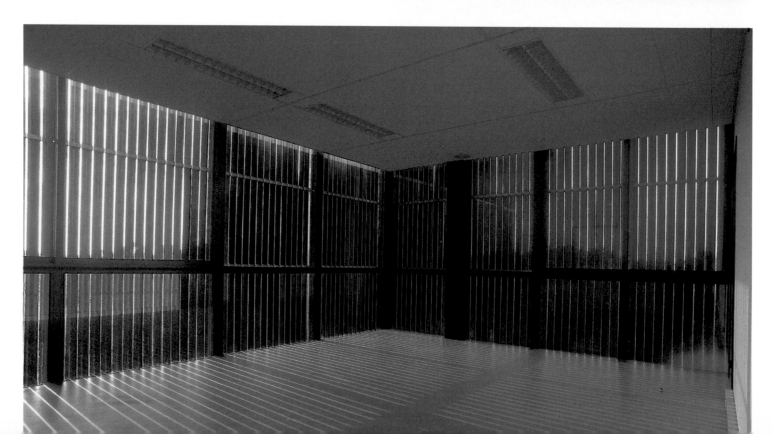

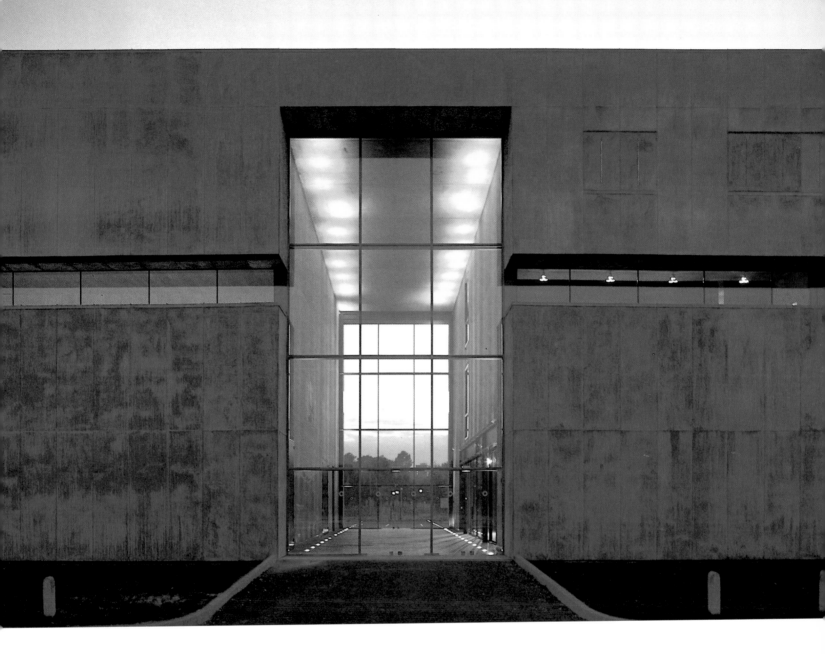

Nighttime view of one of the
transversal vestibules.

Longitudinal section.

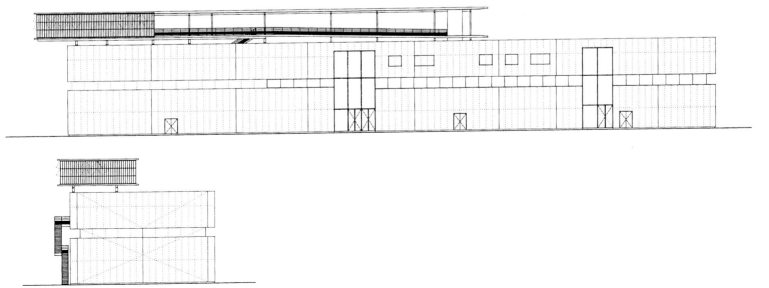

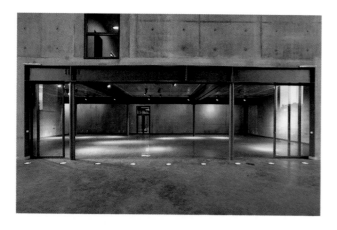

This and the following pages: several interior views of the vestibule.

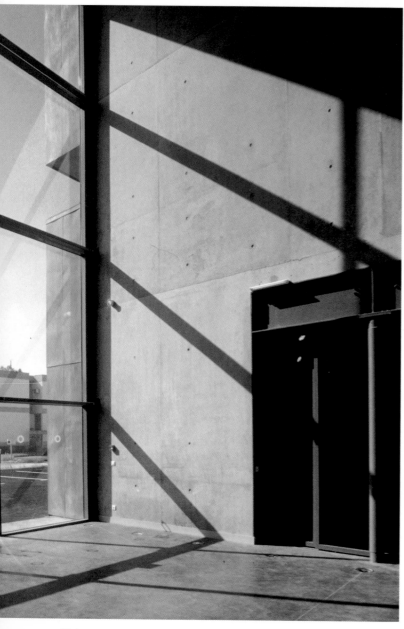

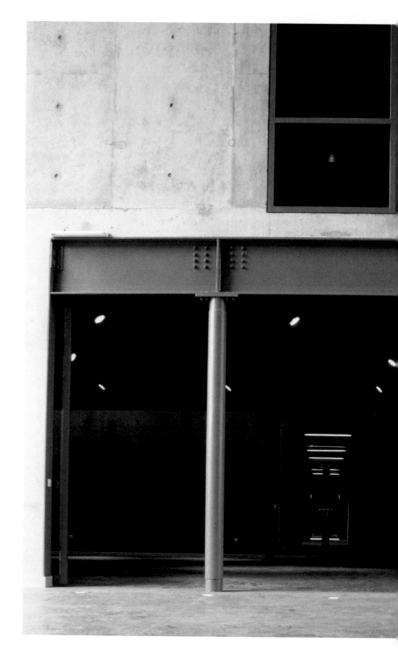

The interiors are stripped bare, the concrete walls are unfaced and light penetrates through cracks. The building has few rooms with a window looking directly outside. The openings are either zenithal or else look onto the two huge vestibules that cut transversally through the building. Most of the rooms are introverted.

Inside the Maison des Arts a variety of activities take place: theater, music, sculpture, radio, and cinema. Despite the building's compact appearance each activity has an independent func-

*The idea lying behind all
the project decisions is that
of simplifying forms to
enhance materials, surfaces,
and textures.*

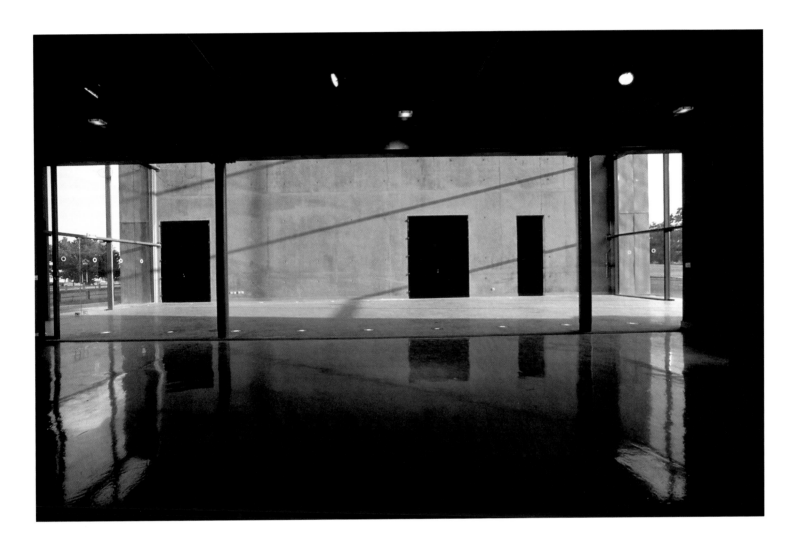

tion and entry. This is thanks to the two three-story-high vestibules that transversally split the building into three separate segments. Each activity occupies either one segment or one of its floors.

The largest module houses the theater with seating for an audience of 350, along with technical fittings, dressing rooms, and spectator boxes. The wall against which the stage rests can actually be opened to allow open-air performances.

On the ground floor there is also a hall for temporary exhibitions which opens into one of the main vestibules. The art-school workshops are also on this floor. Some of these rooms are several stories high to benefit from the light. The administrative offices and the cinema classrooms are on the third floor, while the music school is on the fourth. The wooden cage on the roof houses the radio studio. In Fuksas' own words, this is "an antenna onto the world, underlining the fact that communication with the world may be the only way to bring up the emotions from the depths of the soul."

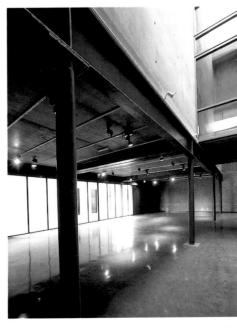

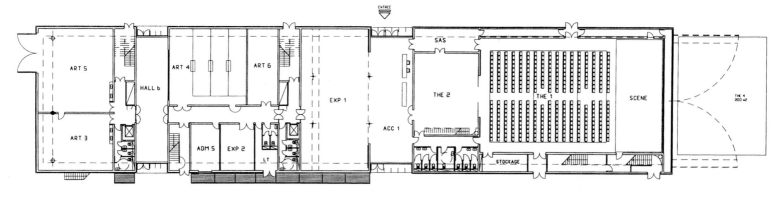

Ground floor.

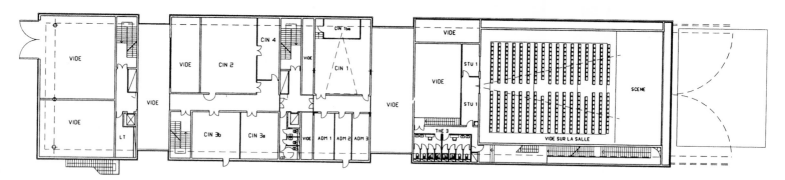

Third floor.

Roof plan.

Detail of the stair.

Theater interior.

Detail of the stair.

Detail of the washrooms.

The art workshops, illuminated
from above.

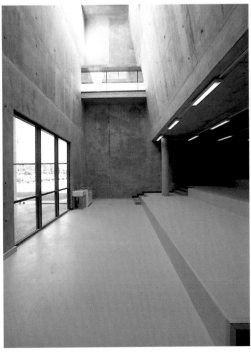

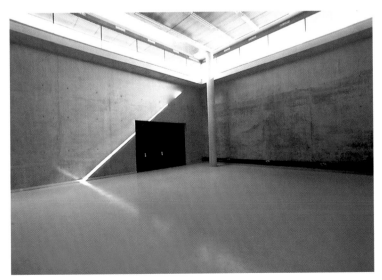

Le Stadium

Rudy Ricciotti

It is often difficult to establish a clear boundary between architecture and sculpture. In the works often located in squares or parks of Richard Serra, Tadashi Kawamata, or Michael van Valkenburgh, for instance, the void the works contain or the division of space they produce are as important as the works themselves. Many themes posed by such sculptures could be encompassed in what we traditionally know as architecture. This same overlapping may occur in reverse, in that some buildings seem to be true, urban-scale sculptures.

A dividing line between activities is difficult to trace and would be a pointless exercise.

The dialogue between different art forms engenders richer works and has always existed, as in Michelangelo or Bernini.

This is especially applicable to Le Stadium in Vitrolles, because few cases exist where a building is so clearly the product of a sculptural vocation. Le Stadium is a kind of huge monolith that stands out disturbingly against the landscape. A building so hermetic that it is impossible to guess its function from outside.

Indeed, the exterior appearance of Le Stadium is conceived in the same way as the great landscape works of Donald Judd and Serra. The object and its surroundings are

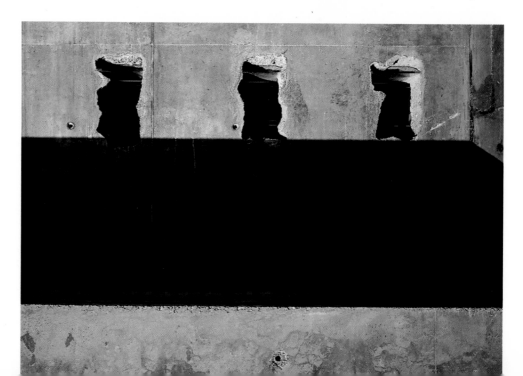

Location: *Vitrolles, France.*
Completion date: *1995.*
Architect: *Rudy Riccioti*
Photography: *Philippe Ruault.*

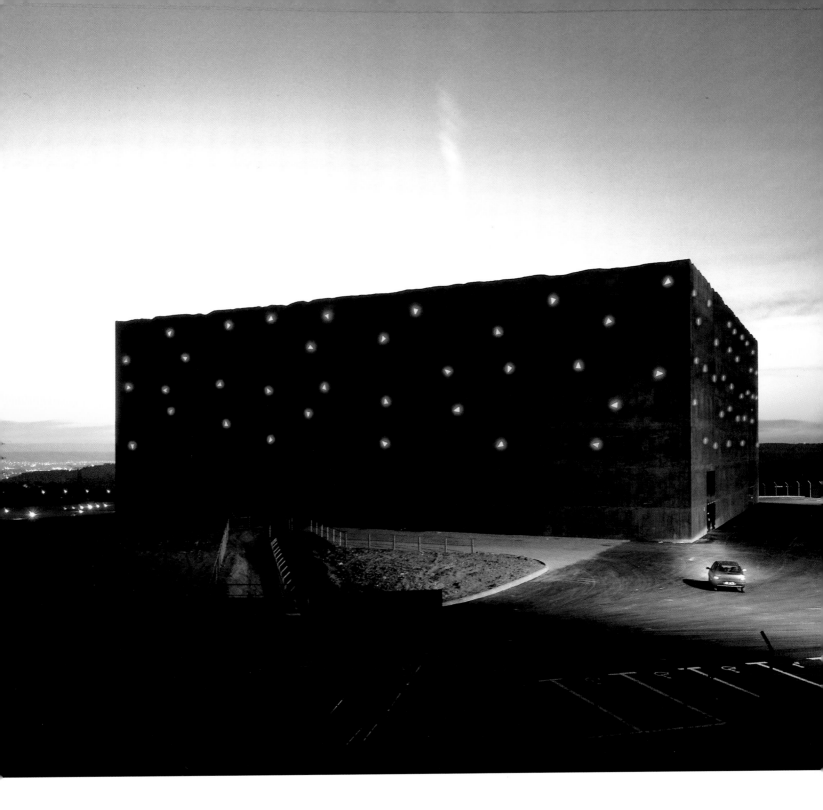

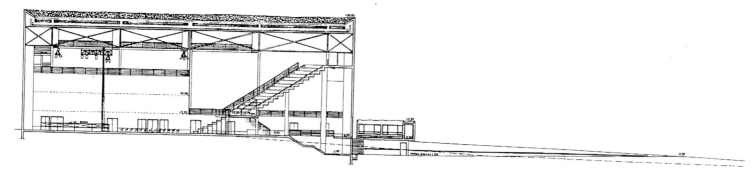

Section through the access ramp.

given equal importance. The landscape is transformed, acquires gravity, is intellectualized, and constrained. As in the case of Palaeolithic menhirs, the first step to be taken in the creation of a work of art is to determine the place where it is to be produced. Perhaps the artist will be content with little more than this. By virtue of its radical simplicity the object' or the monolithic-looking building in this case changes constantly depending on the light, weather, or time of day.

A study of Rudy Ricciotti's œuvre as a whole leads to the conclusion that this particular work is an isolated case. Ricciotti is a deeply Mediterranean architect. He has his studio in Bandol, a small village near Marseille. "How could I carry on buil-

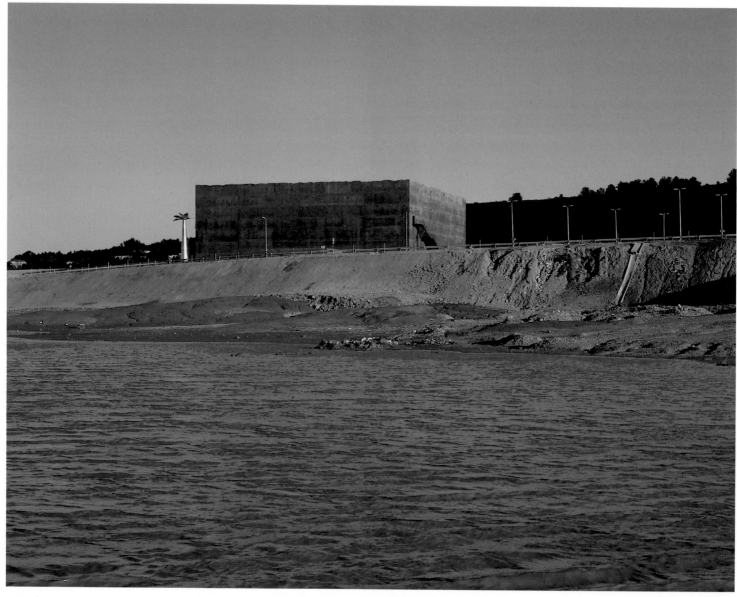

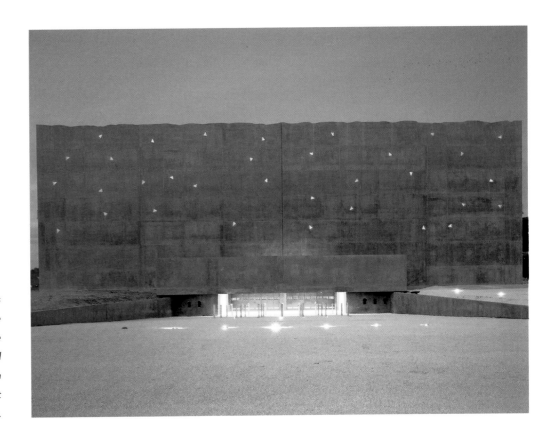

Two views of the entry. Le Stadium is completely hermetic; above the surface, at least, there is no visible opening. The entry is below ground level and the only window, which illuminates the foyer, is hidden just behind the office building.

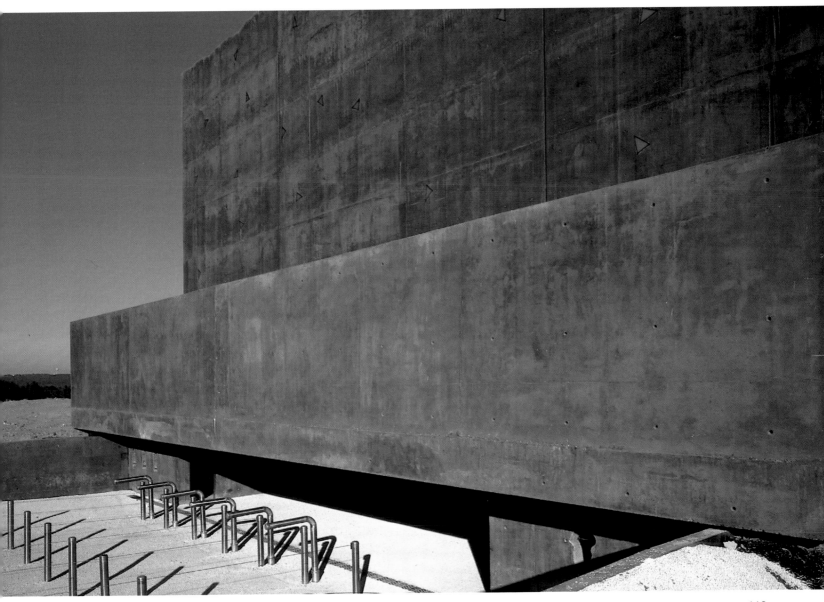

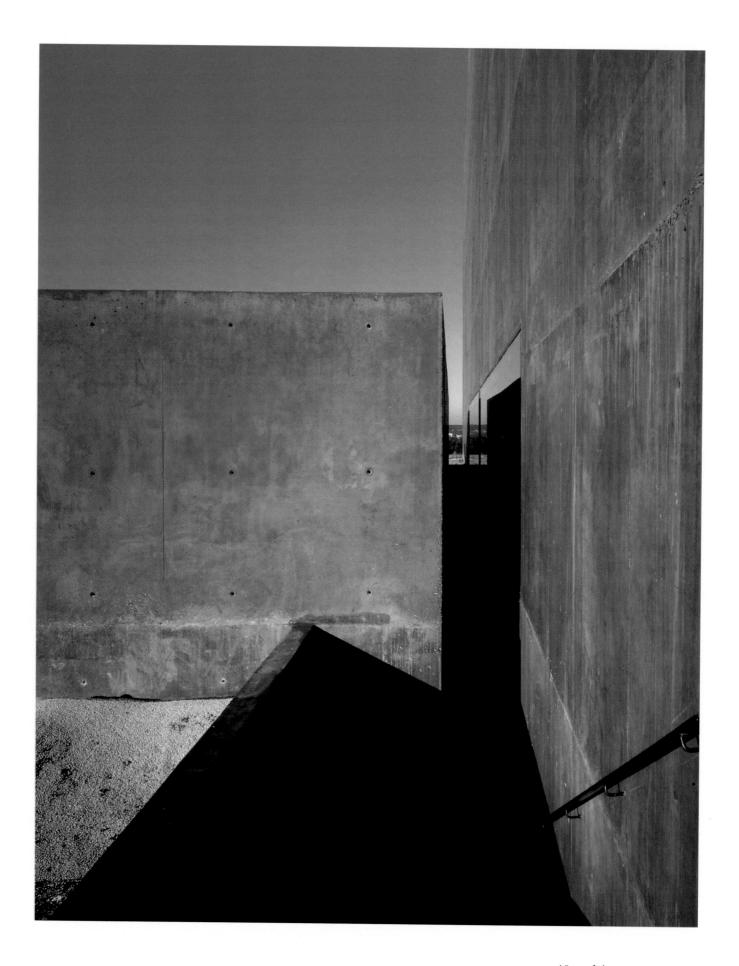

View of the emergency stairs.

The stairs that descend to the entry,
behind the office block.

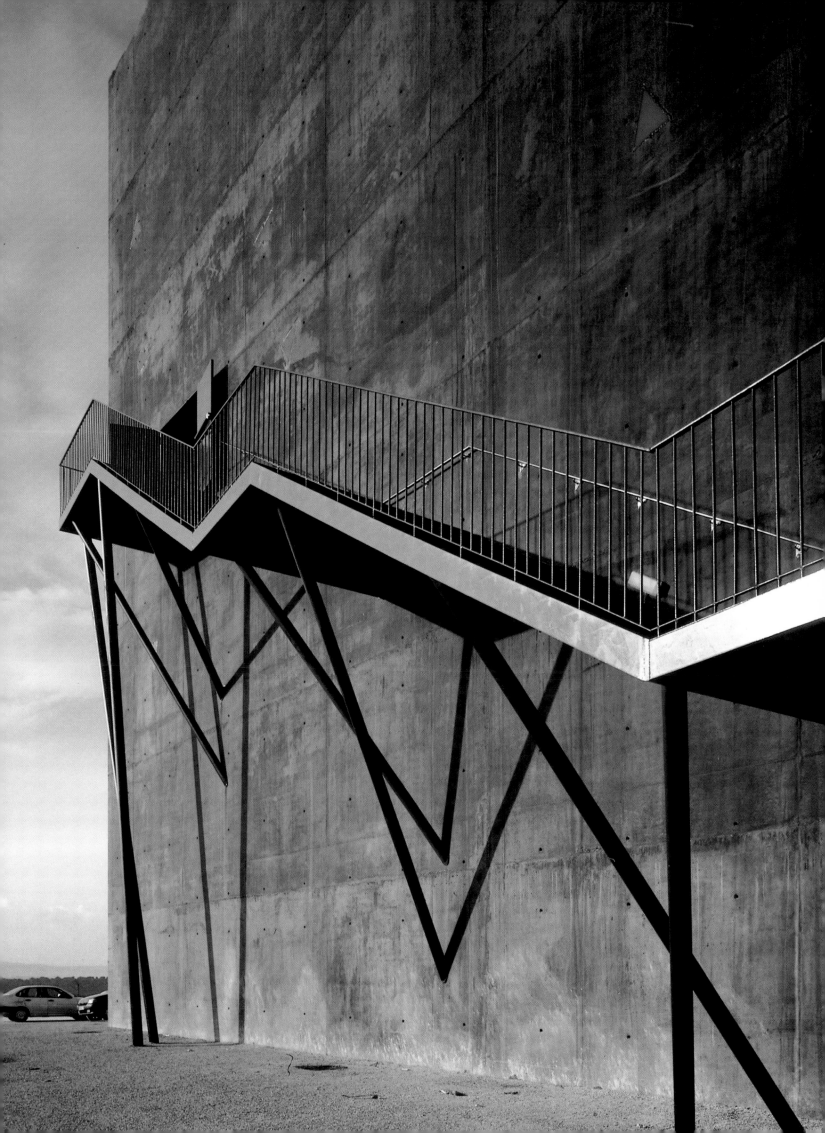

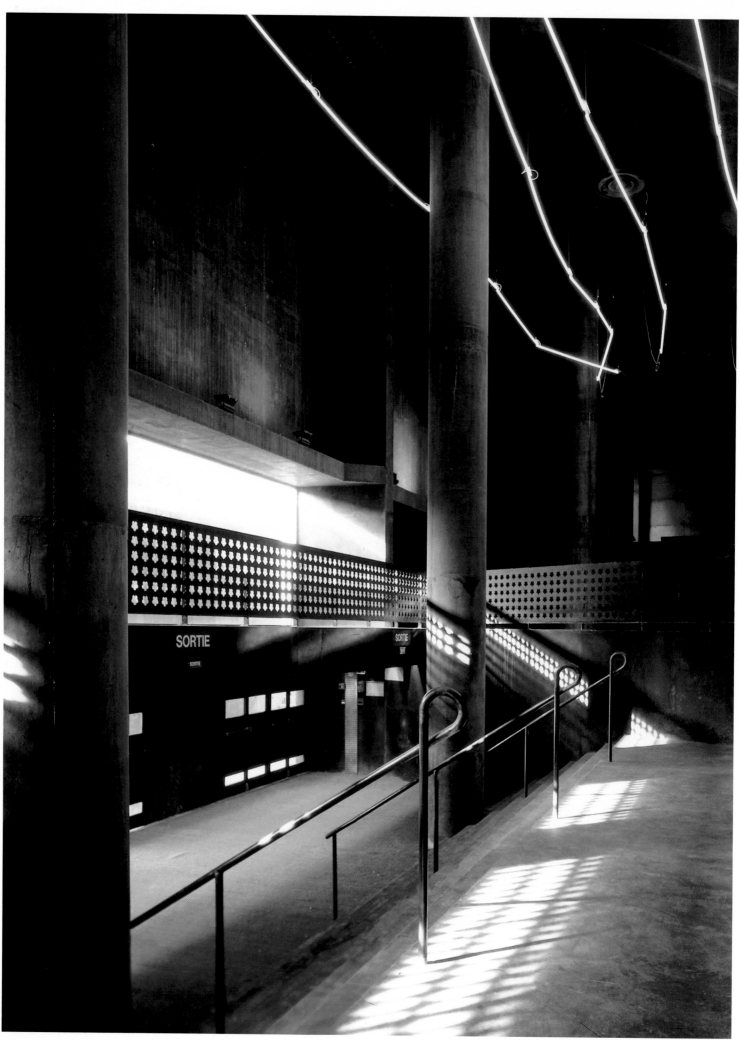

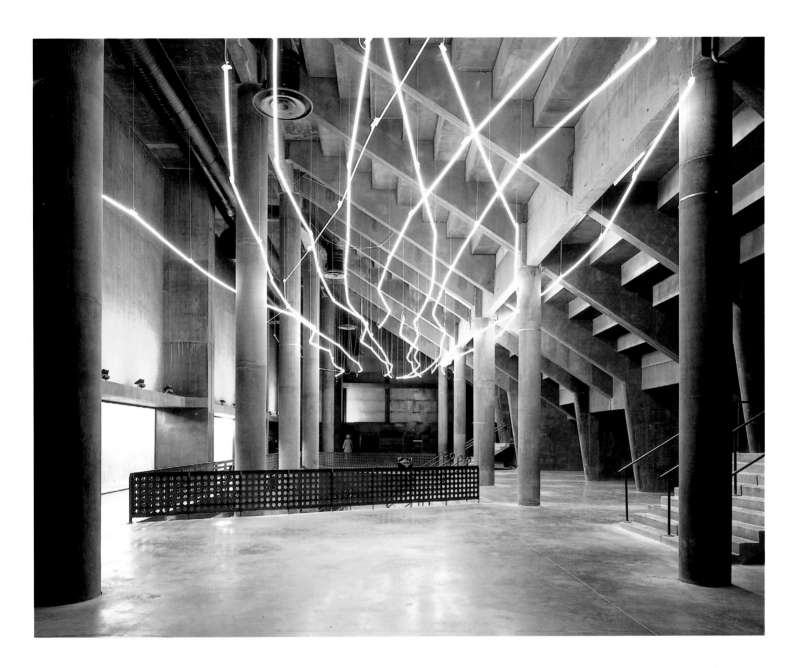

This and previous pages: two views of the foyer. The interior finishes are dark and industrial in appearance.

ding if I forgot my origins?" he asks. "I realized that what's most important for me is to know what I'm talking about. Why can't the Mediterranean have its own, autonomous culture? I began to resist the temptation to adopt international models, perhaps at first purely as a reaction, through arrogance, rather than as the result of true conviction." Indeed, practically all his other projects, villas beside the Mediterranean or public buildings, are open to the sun and light of the region.

Such a radical change from Ricciotti's usual approach may possibly come from the fact that the building was required to be the venue for sporting events or rock concerts. In both cases attention is centered on the stage.

Le Stadium reveals a clear division between exterior and interior. Thus while the building's exterior makes it seem like an enormous, hermetic, sculpture-like, monolith, we must not forget that life goes on inside. The fact that it is a building, not an

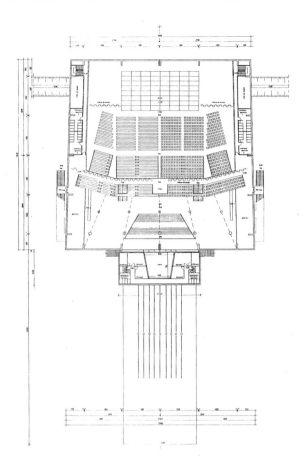

+ 10.5 floor.

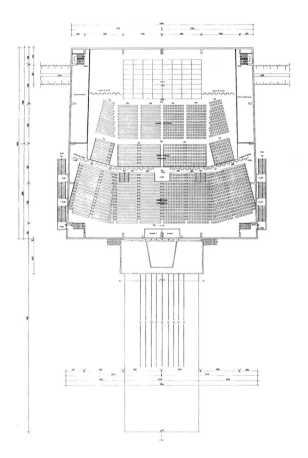

+ 31.5 floor.

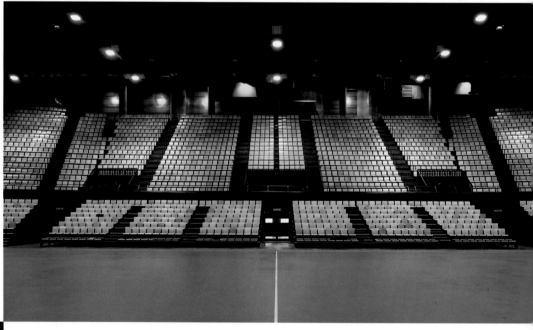

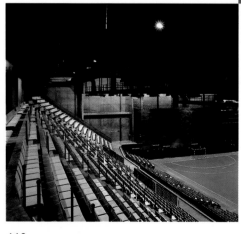

*Two views of the tiers, which
stand only on one of the sides.
The yellow seats stand out
against the black background.*

118

Detail of the bar.

object, endows it with an added value. A passer-by observing Le Stadium, standing out silently among trees against the evening sky, will be astonished to know that there are thousands of people inside.

The interior layout is comprised of tiers on a single side because Le Stadium is often used for rock concerts and, to a lesser extent, for sporting events. The ground plan is an almost perfect square of 190 x 184 feet. A ramp over 21 yards wide with metal handrails lead to the entry doors. The entry is just below a one-story office block independent from the main building (although finished in the same material), which sits beside the walls of the ramp.

Once inside the building, spectators climb stairs back to ground level. The ramp and entry have a ritual rather than functional purpose. People go down into the earth before re-emerging where the concert will take place. The division between exterior and interior is thus further emphasized. The foyer is located just below the tiers, the lavatories and other services are on the sides and the stage immediately opposite.

Lager Technik Wolfurt Office and Garage Building

Baumschlager & Eberle

The form given to the building was determined by factors relating to the site, costs, and to the need for possible future enlargements. The site is defined by strongly differentiated traits, such as dense housing estates to the south, the highway to the north, the freeway overpass to the east, and cultivated fields to the west. The project was required to respond formally to such sharp contrasts, which means, in terms of the appearance and texture of the building, that each façade had to echo its immediate surroundings. Each part of the project thus reacts almost independently to its context.

The compactness of the volume, together with the system of hanging façades, was a favorable basis from a budgetary point of view. The south façade, which can be dismantled, and its corresponding static pre-dimensioning will make it easy to extend the building toward the back of the site, if desired. The concrete structure follows a clear, orthogonal layout. Furthermore, the spans allow for maximum flexibility of use. The dimensions of the units and their relationships are clearly defined, while at

Location: *Wolfurt, Austria.*
Design date: *1993.*
Completion date: *1994.*
Architect: *Carlo Baumschlager, Dietmar Eberle.*
Collaborators: *Rainer Huchler, Ernst Mader (construction).*
Photography: *Eduard Hueber.*

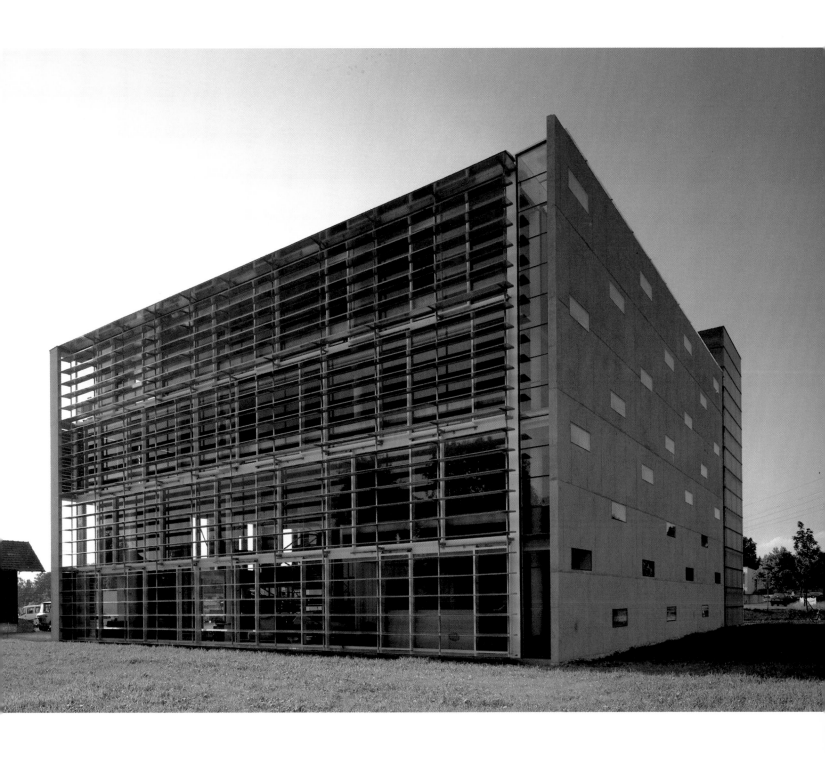

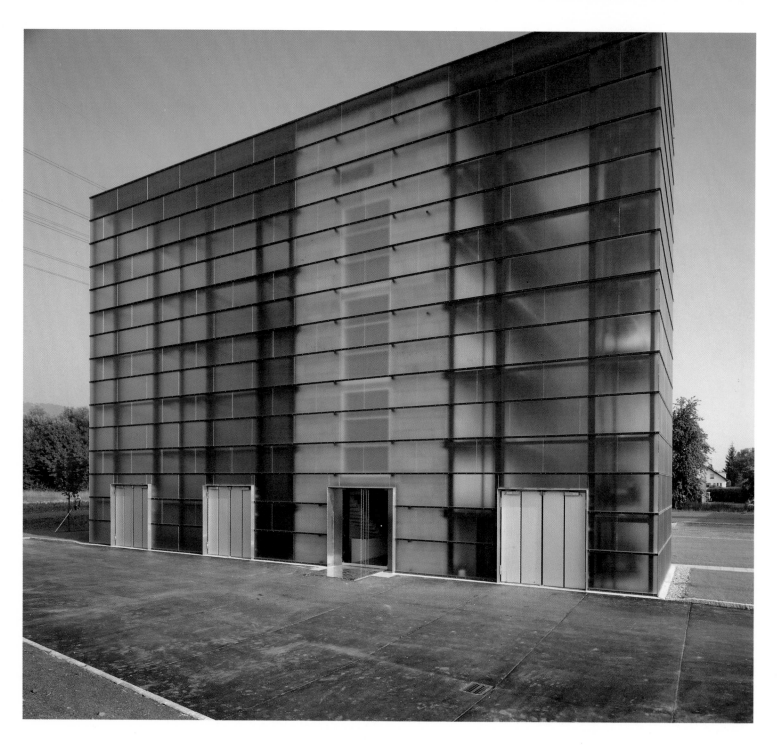

Site plan.

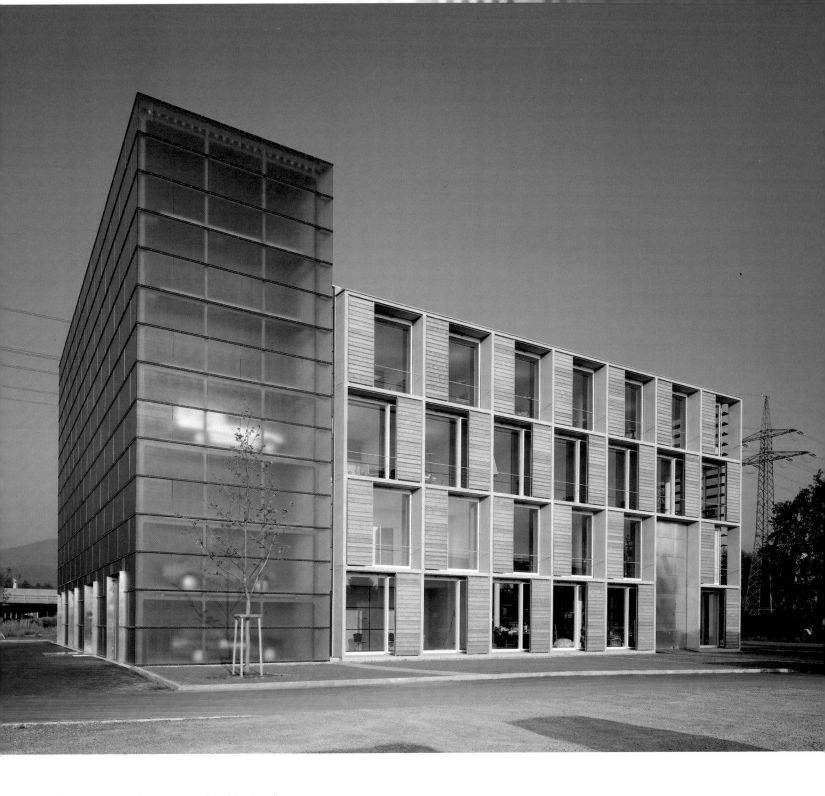

the same time they remain flexible thanks to adequate space.

The building is clearly differentiated from neighboring buildings to the south, which are mostly traditional single-family, gable-roof dwellings that are largely indistinguishable from each other and have no distinct relationship to the landscape. By contrast, the Wolfurt office building is very striking. It consists essentially of two rectangular volumes that reveal the textures of materials such as the gray, unfaced con-

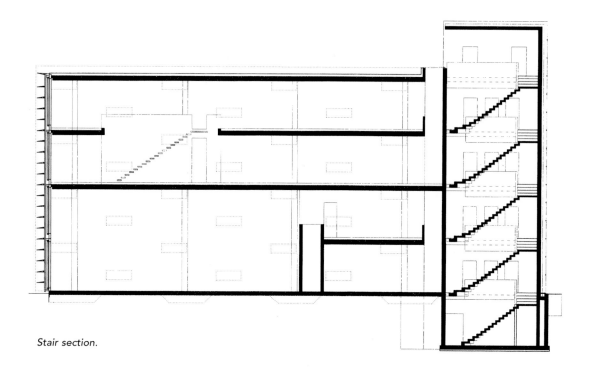

Stair section.

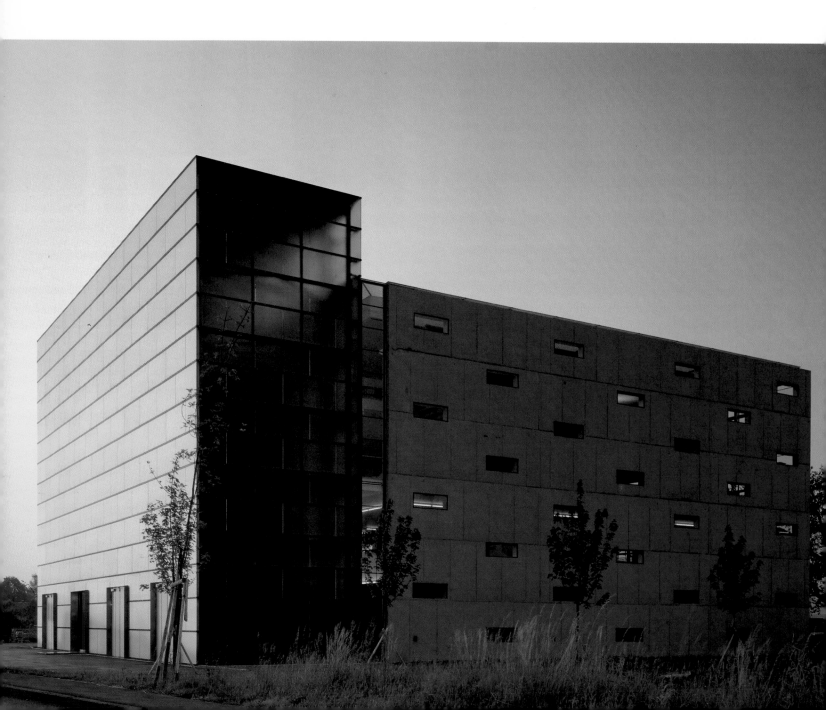

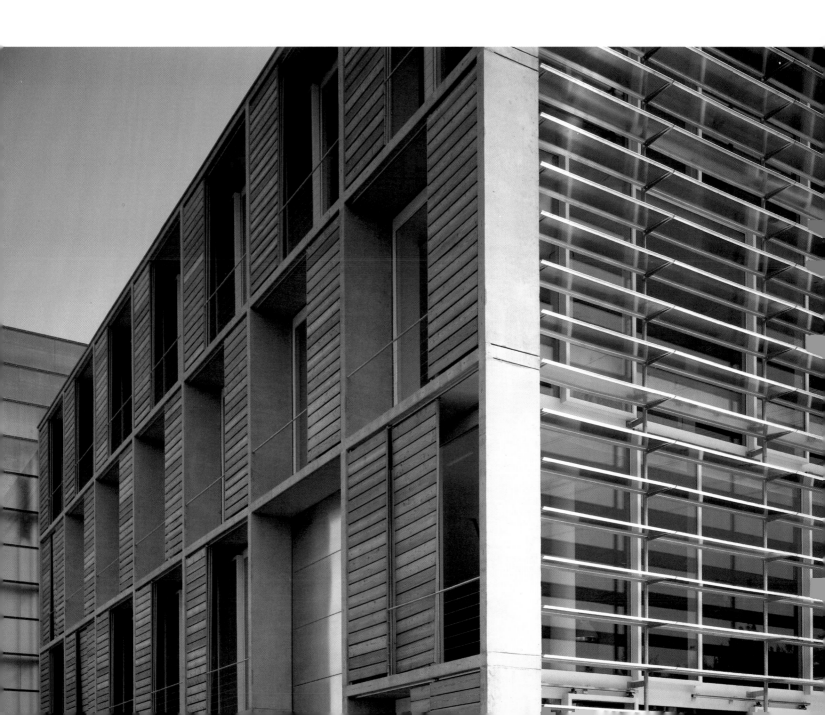

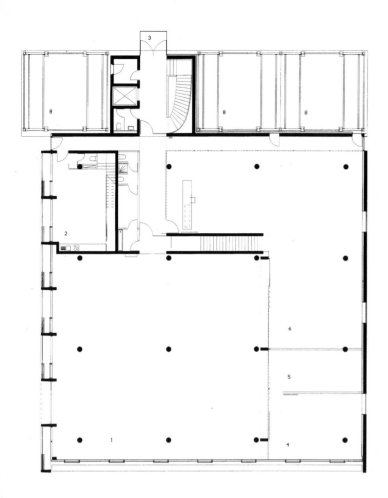

Ground floor.

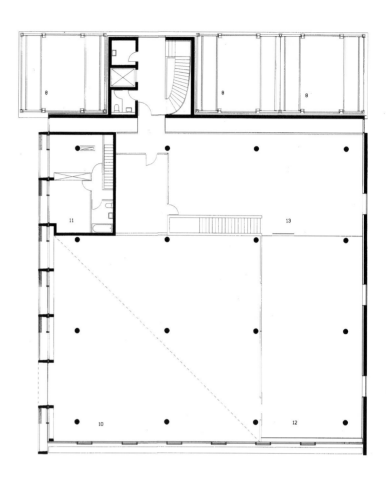

Second floor.

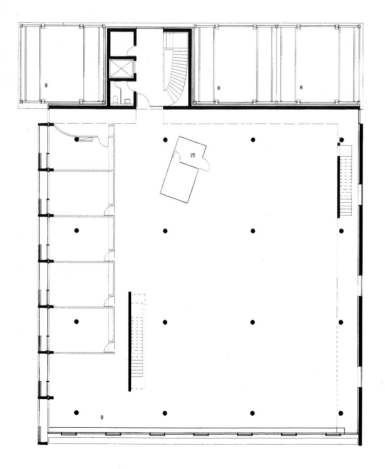

Third floor.

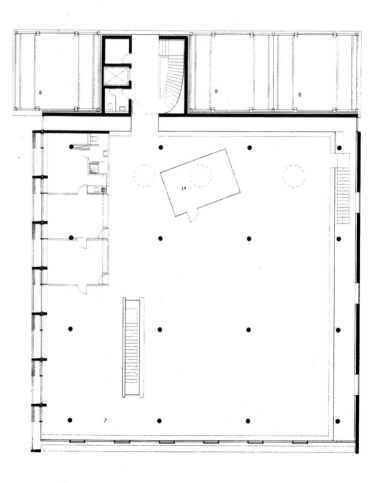

Fourth floor.

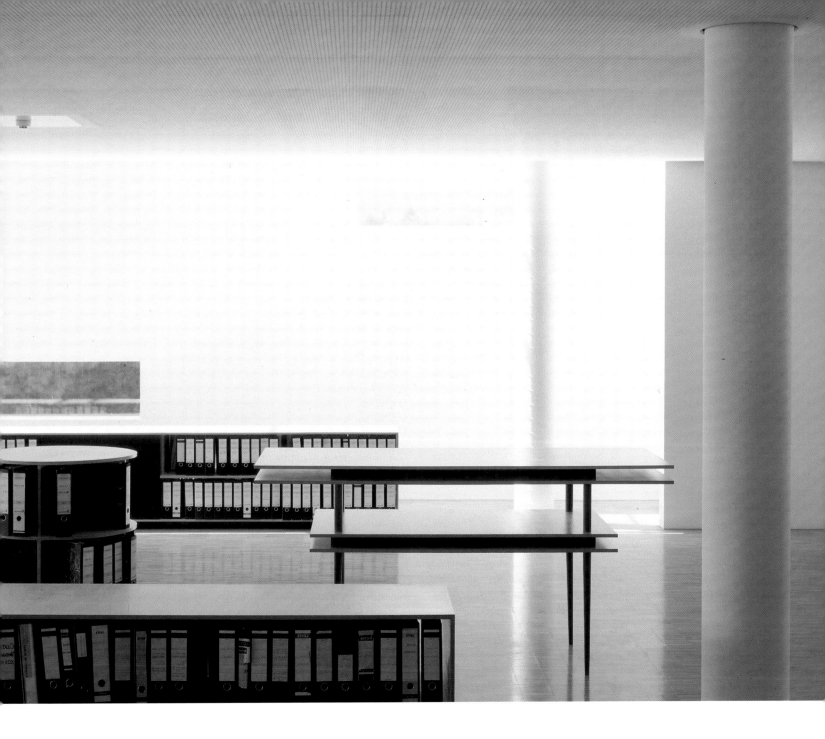

crete, unpainted wooden blinds, slats, and translucent glass.

The façade overlooking the street marks the two volumes. One is tall and thin, clad in a continuous translucent skin, and contains the vertical parking lot. Through the skin it is possible to see the blurred outlines of the cars. Its color introduces constant variations. Objects are perceptible with greater or lesser clarity depending on the time of day and the light. The other volume is a stretch of concrete that defines solid areas and hollows thanks to light-colored timber sliding doors. This façade is composed of a regular concrete

umes-with a stretch of timber into which long, narrow, horizontal openings have been cut. The carpentry is flush with the façade surface.

The relationship between interior and exterior is interesting in that the building itself reflects one kind of relationship or another with the exterior. The project shows different faces to different observers. This happens not only in terms of orientation and its effect on light, but also regarding the way in which the visitor approaches the building. The project responds to the differing situations on its four sides, involving changing rhythms and different forms of perception, sometimes slow and deliberate and sometimes from inside a fast-moving car.

structure that establishes a uniform rhythm. The general layout of the openings creates a sensation of transparency without upsetting the balance of the façades' dual interplay of opacity and translucence.

The façade opposite the overpass is, by contrast, entirely translucent. Because it contains the parking lot, it acts as a barrier between the fast-moving cars on the freeway and the offices, which are contained in the other, adjacent volume. The hanging façade looks southwest, its slats acting as protection against the sun's rays. Finally, the northeast façade also expresses the difference between two contrasting vol-

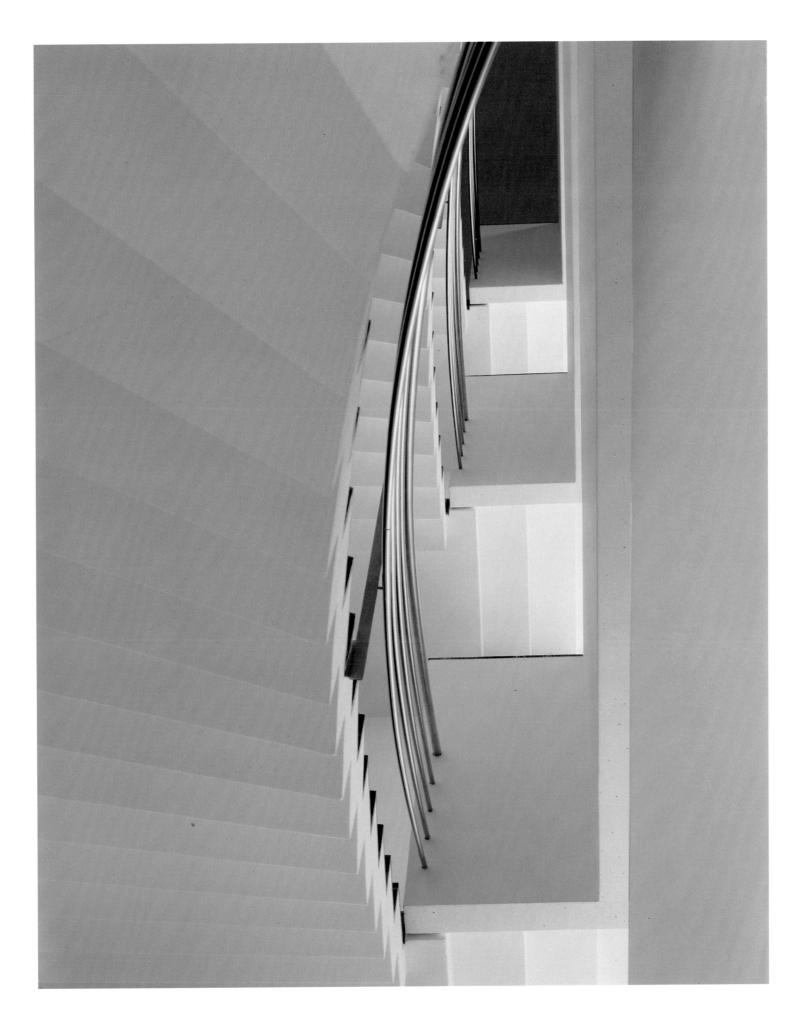

Various views of the stairway.

House for a Flower Artist

Hiroshi Nakao

A house is a grave. It is an outside injected into the world, turned indoors and then closed. In short, it is a grave in reverse. Its outer walls are wrapped in steel which changes color dramatically, from black to red, as erosion sets in. Then, ever so subtly, it returns slowly to black.

A house is bathed in the occurrence and recurrence of black. All interior space is stained with black. From a membrane image sealing in the world, black temporarily retreats and silences all substance.

And we just sit and wait. We wait for that which sucks up its deep memory and makes it rumble: light. A ceaseless cycle of fade-ins and fade-outs highlights the contours of matter (flesh), renewing itself at each passing.

A house organizes the dynamics of memory and oblivion. Space, in its center, is either raised or compressed. It is the emergence of both vertical and horizontal depth. In it, our floating and shrinking bodies grasp a new gravity and rhythm.

A house arranges the movement of standing and lying. Memory-Oblivion, Standing-Lying. A house, in short, is a grave. It is a grave that calls to mind life. It is a black box that seeks to arouse life.

Location: *Tokorawa, Japón.*
Completion date: *1996.*
Architect: *Hiroshi Nakao.*
Collaborators: *Hiroko Serizawa.*
Photography: *Nacasa & Partners.*

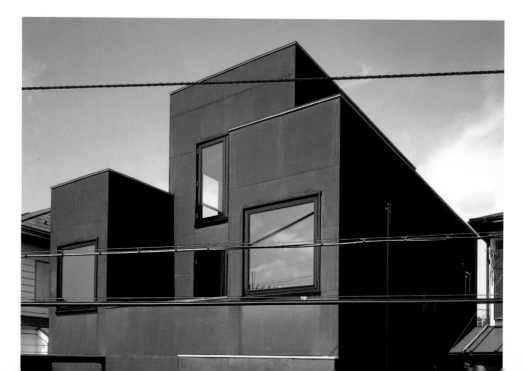

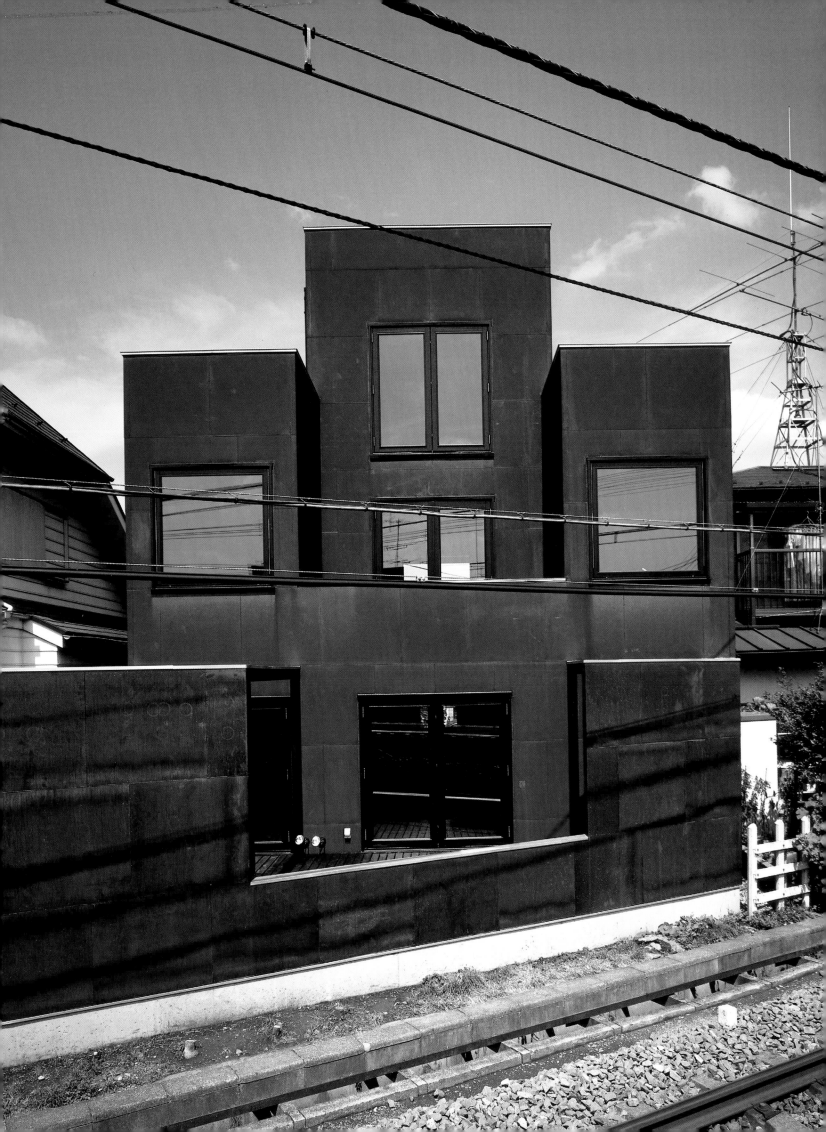

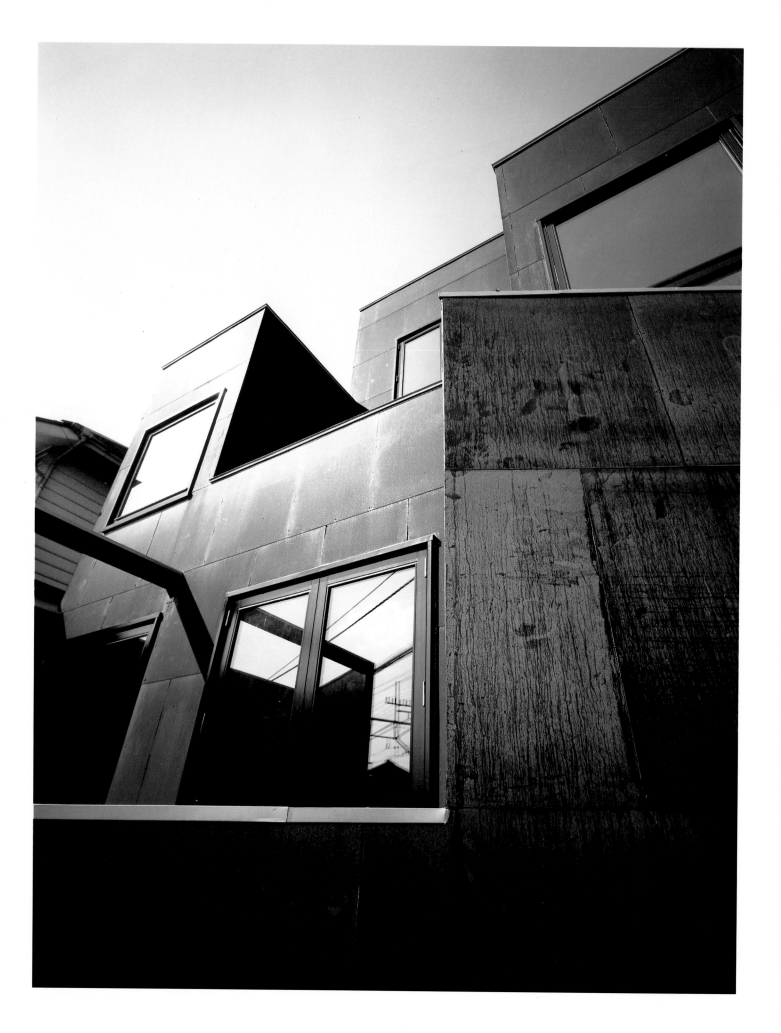

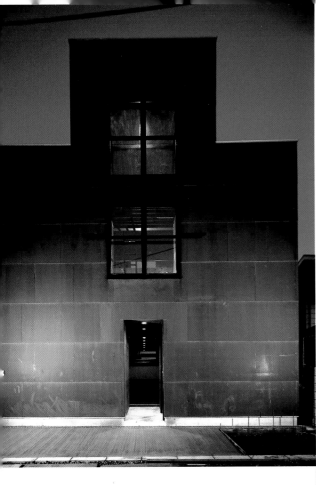

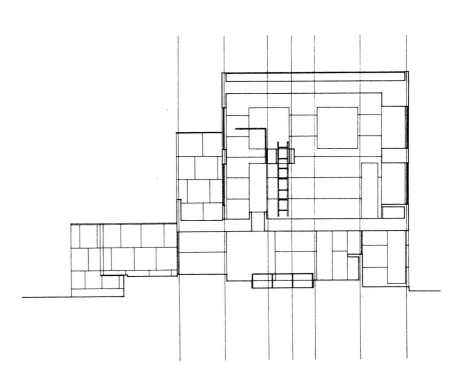

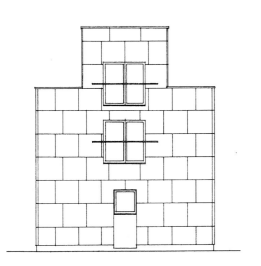

North elevation.

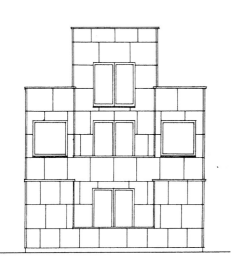

South elevation.

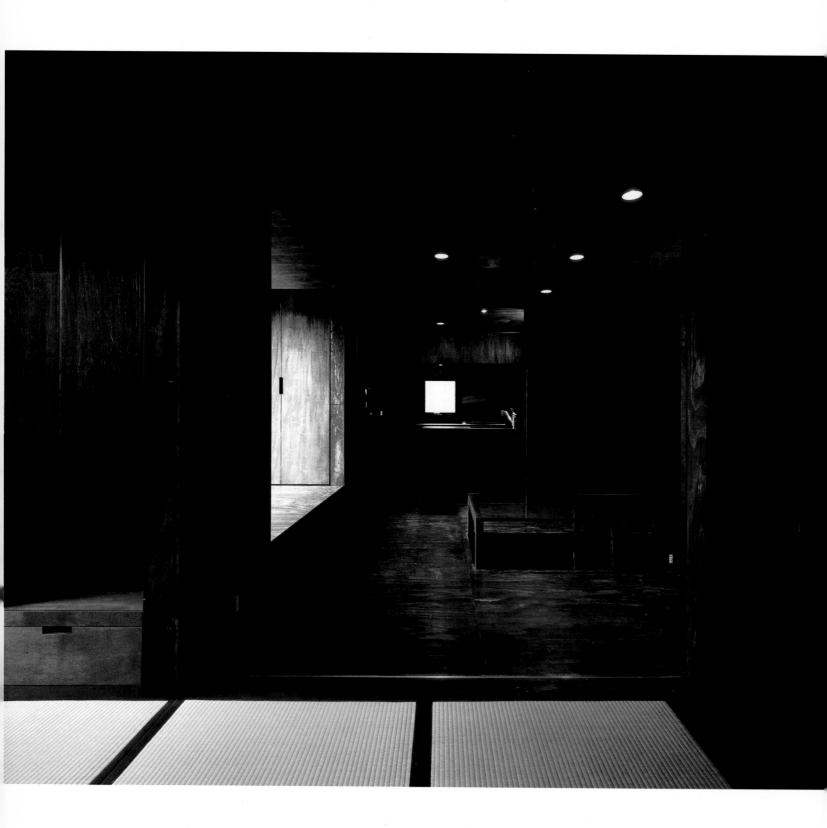

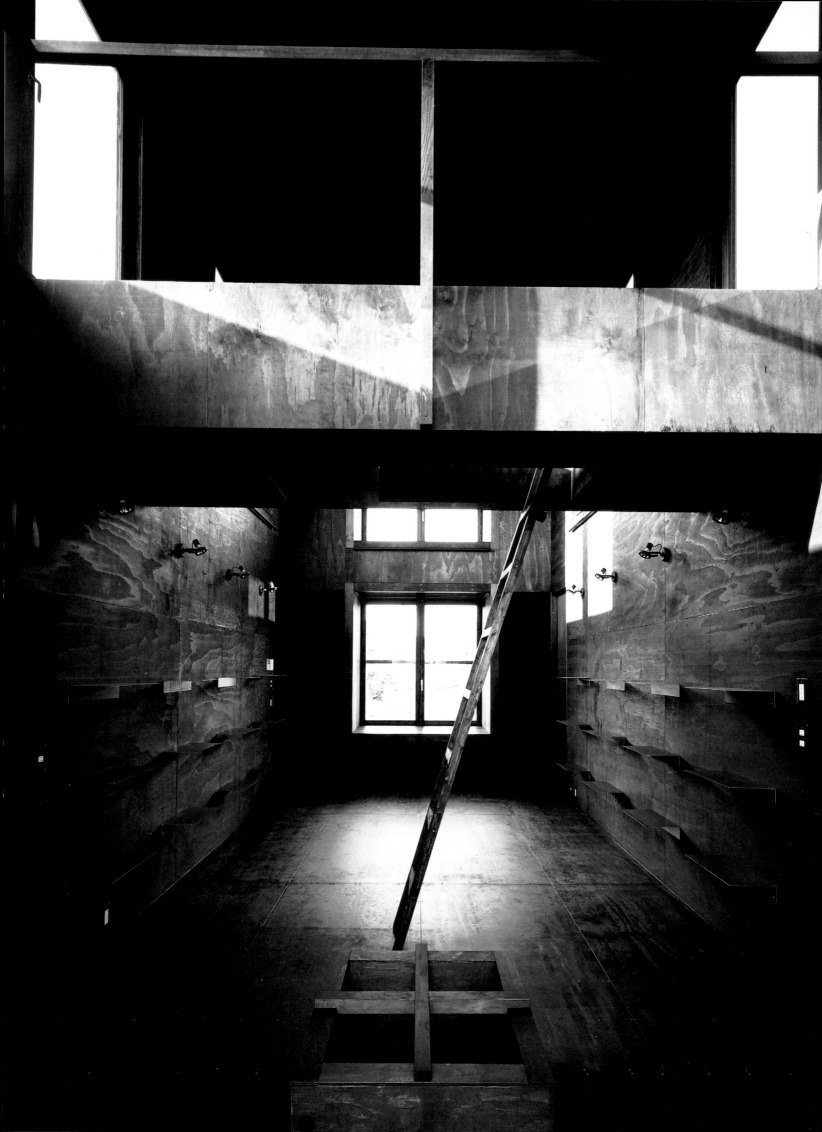

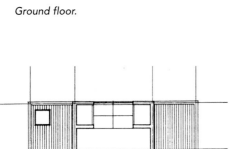

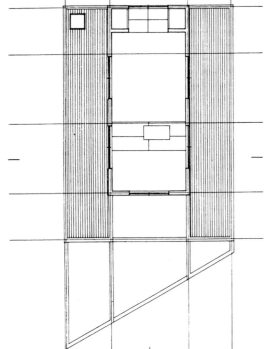

Ground floor.

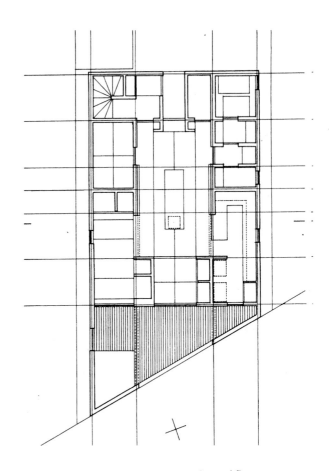

Second floor.

Third floor.

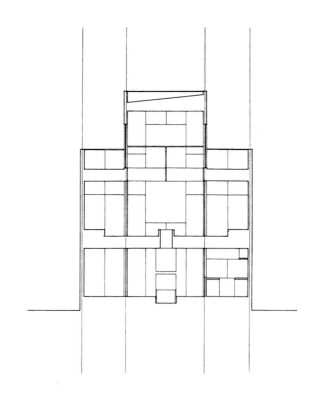

Cross section.

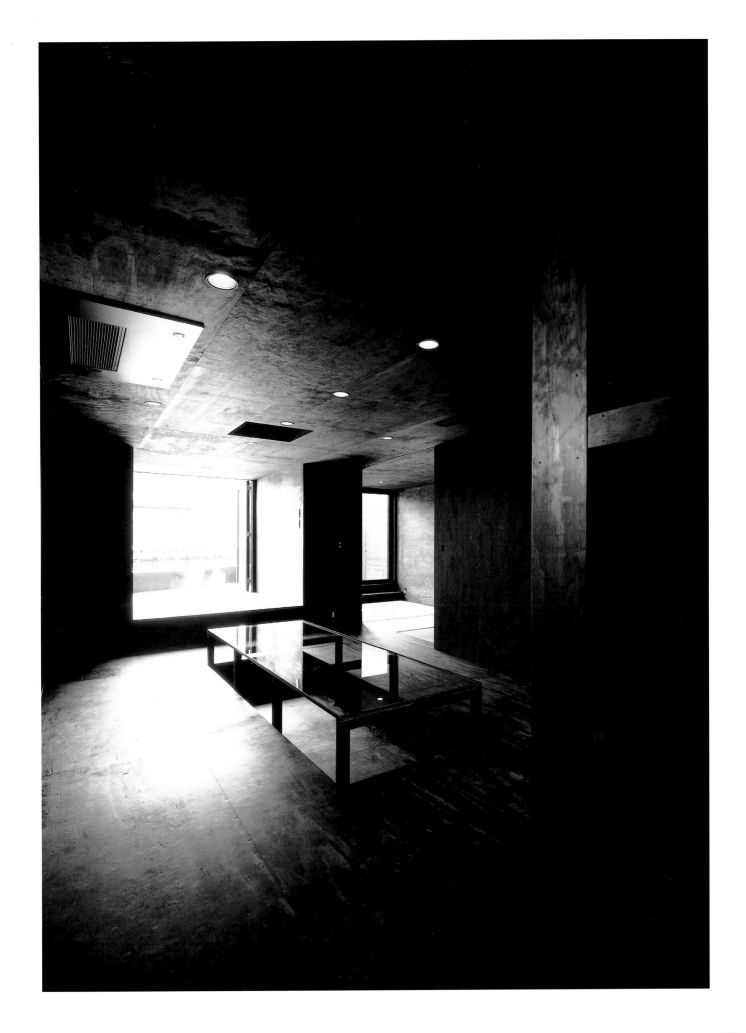

House n.15

Hiroshi Naito

The outstanding feature of Hiroshi Naito's architecture is its sobriety' its plain, simple geometry. His silent spaces of diaphanous structural clarity are created using materials that appear just as they are. His works possibly carry with them more questions and intuitive perceptions than affirmations. Whatever the case, they are questions about architecture's ability to create new values in relation to the dynamics of a rapidly-changing world on the threshold of a new era. One of the most astonishing embodiments of that new era is the chaotic, incredibly congested city of Tokyo. For Naito, the city's autistically inward-looking buildings obstinately insist on isolating themselves from the outside world.

None of Naito's works can be considered a finished product. The completed work is one more step in the complete cycle of architecture, a life cycle that passes through various phases, beginning with the intention to create something that responds to specific objectives and needs, and ending when the building is eventually demolished. Each intervening moment has its own particular meaning. The nuances do not remain constant from creation to extinction; there is no single meaning attached to a building once construction work has been completed.

Location: *Tokyo, Japan.*
Design date: *1992.*
Completion date: *1993.*
Architect: *Hiroshi Naito.*
Photography: *Hiroshi Naito Architect & Associates.*

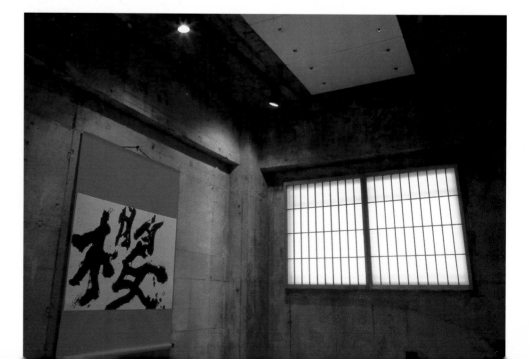

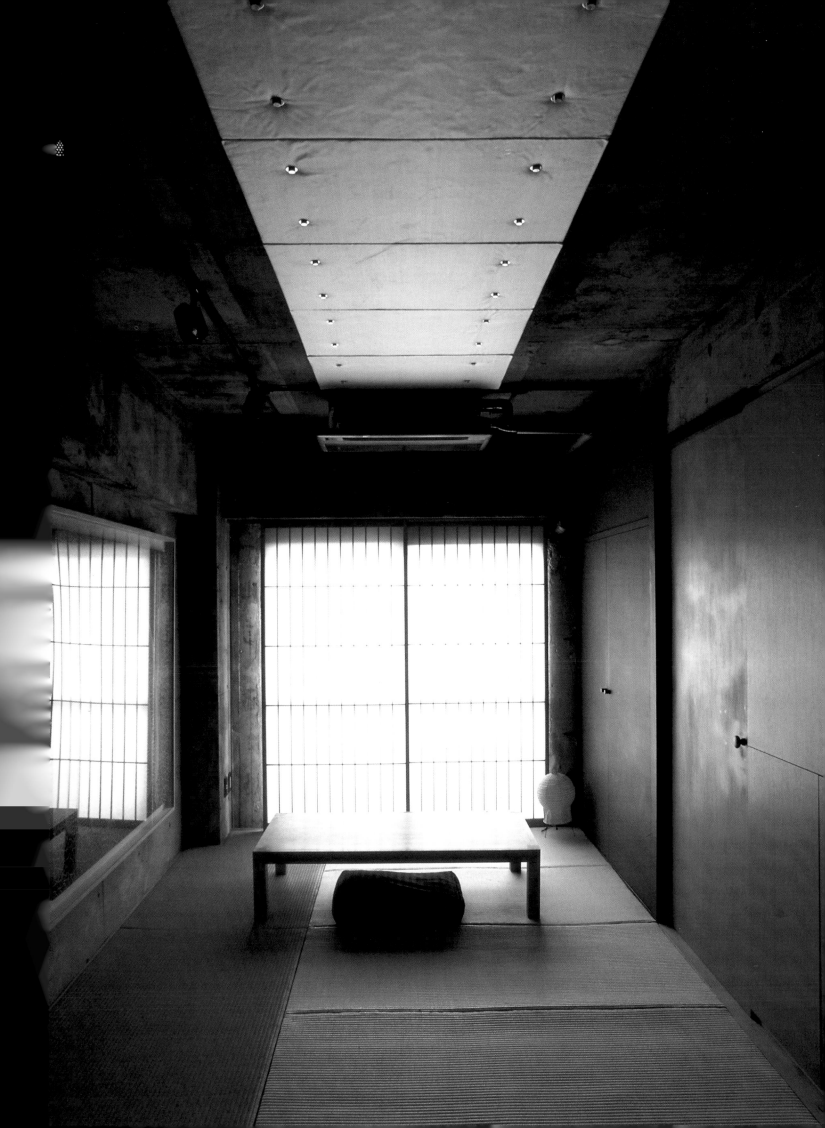

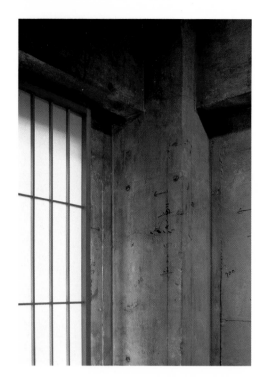

Detail.

mold, and lines and marks that act as signs. The project is a wise exercise in purification. It pays especial attention to what has been uncovered and in revealing what was formerly concealed.

The project has been called *Kuro no Heya*, which means 'room in black'. Although there is actually no black in the apartment, the appearance of the bare walls somehow brings it to mind.

Naito's concern is to broaden the horizon of possibilities derived from considerations of the finished work and to find a method by which to ensure continuity from the creation of architecture to its extinction.

The House No. 15 project consists of the refurbishment of a 118-square-foot apartment in a 6-floor, 20-year old block. It is essentially an operation of discovery in which previously concealed elements are laid bare. Partitions have been pulled down, plaster wall panels removed, and new materials have been added only when absolutely necessary. The washroom has been left where it was, the kitchen has been renovated, and the two tatami rooms have been joined together, separated by cupboards from the entry area.

Although the apartment is very different from what it was, the difference is not striking. It has undergone a change of skin comparable to the removal of makeup, enabling the walls to reveal their true beauty. Now that the plaster is gone, traces of human work can be seen, such as a splinter of wood from the formwork

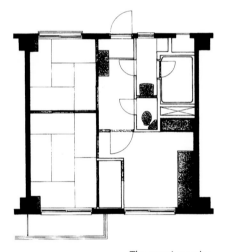
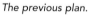

The previous plan.

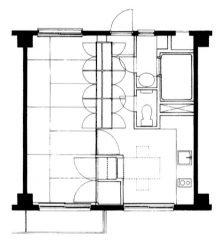

The altered plan.

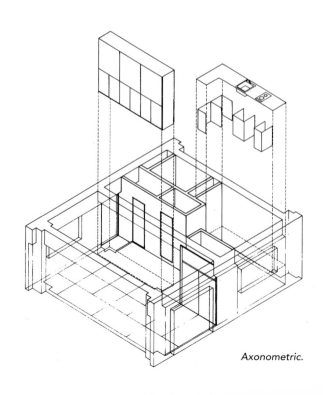

Axonometric.

140

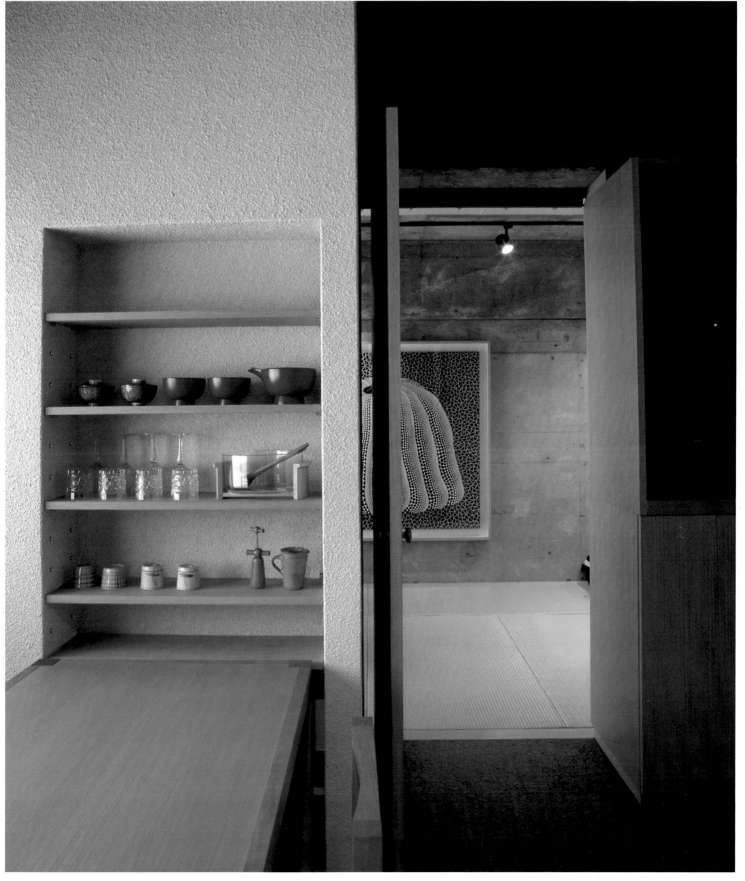

Price/O'Reilly House

Engelen/Moore

Location: *Redfern, Sidney, Australia.*
Completion date: *1996.*
Architects: *Tina Engelen, Ian Moore.*
Photography: *Ross Honeysett.*

"There is no deep philosophy behind our work. We want our buildings to be sensitive and honest. Unfortunately, you don't see many like that. We work on the basic principle that above all we want to create a pleasant atmosphere. In the places we live in, the important things are light, space and ventilation.

We've been called Minimalists. Indeed, some of our works may be described as such. We could also be defined as the continuers of the Modern Movement, but we wonder if this is really important. The term was coined 60 years ago and we're about to enter the next millennium. I prefer to think that there are very different people doing good work, each one rooted in his own way in the Modern Movement". (Ian Moore, Steel Profile, no. 58, interviewed by Peter Hyatt.)

These telling reflections by Ian Moore confirm that the historical perspective has changed. Certain ideas of the Modern Movement have lost their original vigor, above all those having a certain Messianism and need to transform architecture. The renunciation of ornament and the construction of roomy, luminous, geometrically simple spaces are principles already encountered in the work of Adolf Loos, Le Corbusier, Mies van der Rohe, and Richard Neutra.

Nevertheless, while one of the sources of present-day Minimalist architecture is the 1960s art strand of the same name that emerged in New York, the Modern Movement continues to be a point of unavoidable reference.

The two-story Price/O' Reilly house stands on a site formerly occupied by two, traditional flat-roofed houses. The street

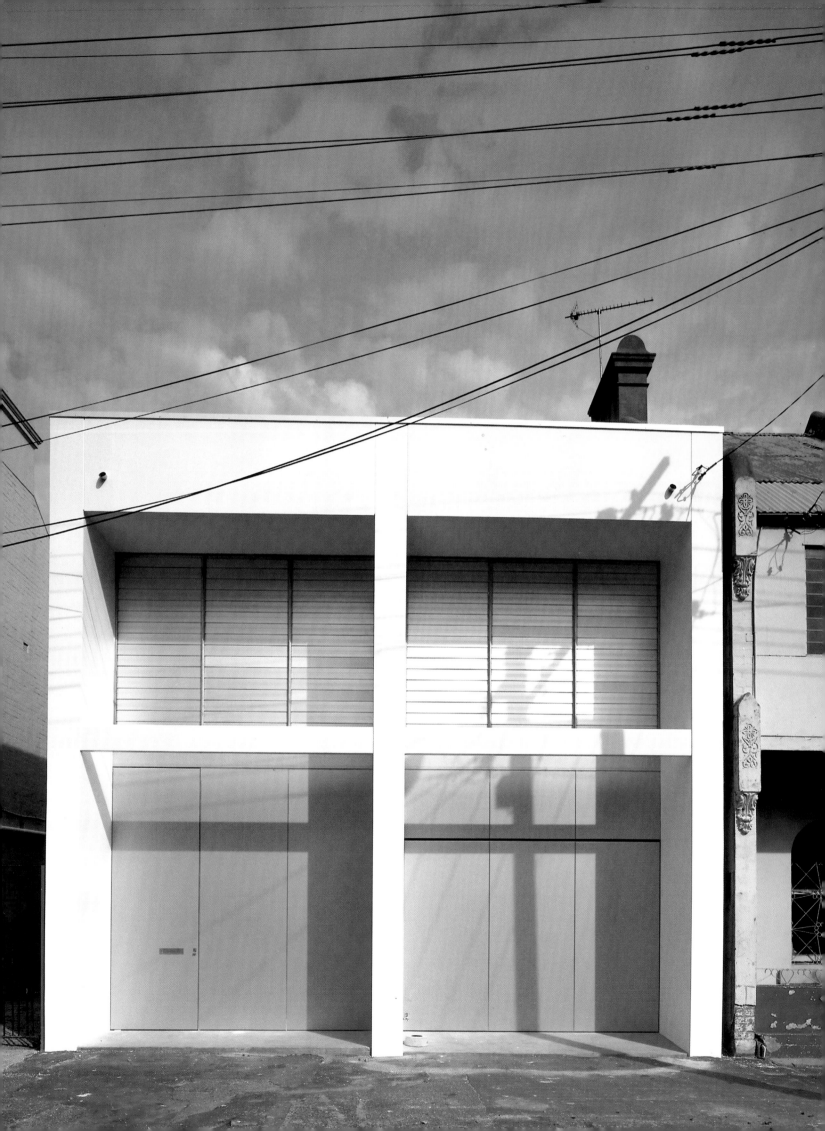

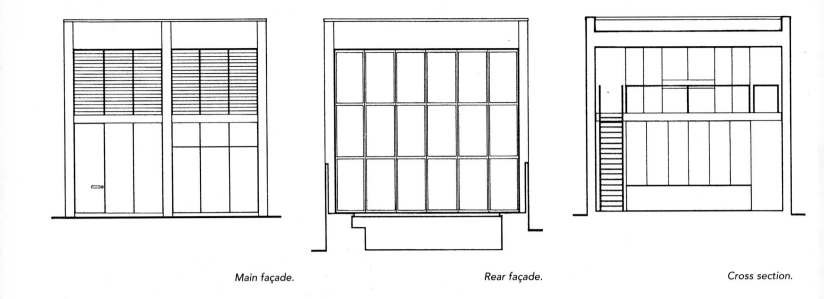

Main façade. Rear façade. Cross section.

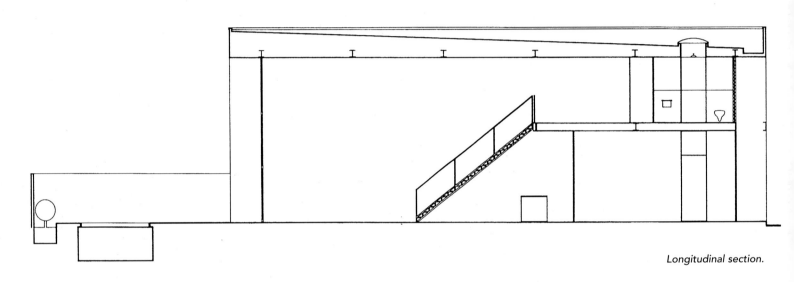

Longitudinal section.

has a mixture of residential and commercial buildings, including single-family dwellings, stores, and apartment blocks of various sizes and periods. Because this was to be a residential building, the local authorities stipulated that it should resemble a traditional house rather than a store.

For that reason, the main façade is divided into two vertical strips, and both the horizontal elements and the proportions of each of these strips have been designed in relation to the adjacent houses. By contrast, the rear façade consists of a single opening 19.5 feet high by 22.5 wide. The interior layout corresponds to

this polarity. Behind the main façade are the smaller rooms of the house on two floors: the garage, storeroom, and lavatory (on the ground floor) and the bedrooms and bathroom on the floor above.

Next to the garden a single, double-height space has been built that functions as the living room, dining room, and the kitchen, and when necessary, as a photographer's studio. Since the budget was rather low, the architects opted for a simple structure of steel porticoes with a mezzanine half-floor. The side walls are concrete blocks plastered on the inside. The rear fence, the strips on the main façade and the partition walls

View of the rear façade.

"There are three words I always use: research, refinement and rigor. I believe they can be found in everything we do."

144

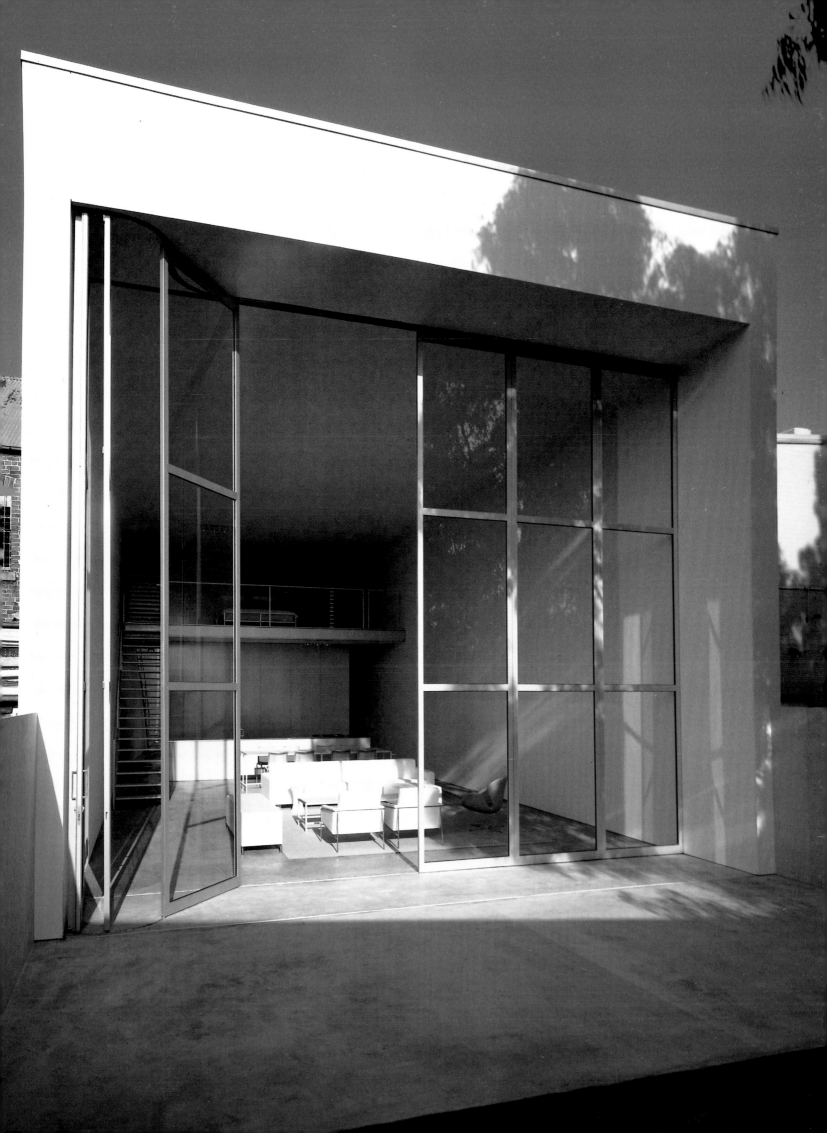

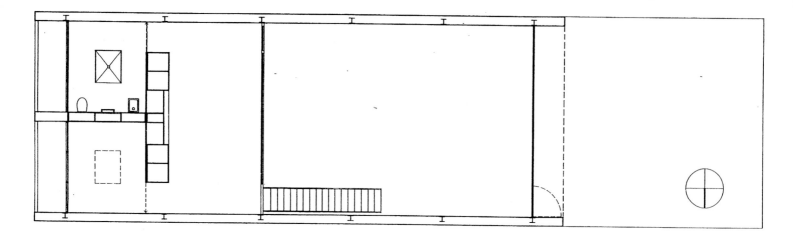

Loft.

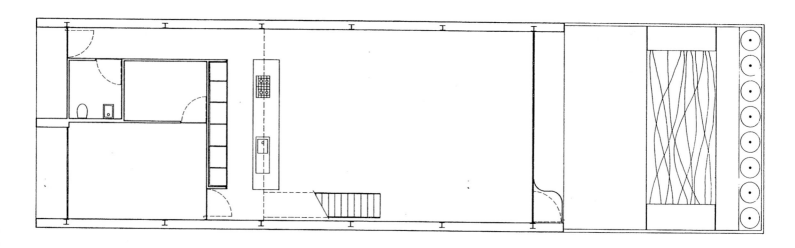

Ground floor.

are pressed fiber-cement sheets. All the walls were subsequently painted white, while the remaining elements have been treated with a more refined, detailed finish, mostly in matte aluminum.

The rear façade is composed of six 19.5-foot-high sliding glass doors that can be folded up completely against one of the side walls. This not only makes it possible to extend the house to the patio but also to efficiently control ventilation in summer and heat the house in winter by taking full advantage of the sunlight. The eucalyptus that grows on the adjoining edge of the next-door site further protects the house from the afternoon sun in summer.

The kitchen is a single piece of furniture beneath the mezzanine half-floor. The remaining furniture had to be proportionate to the room; thus, for example, a 10-foot-long sofa was chosen. Not only the dining- and living-room tables but also the base of the bed and the towel-rail in the lavatory were designed by the architects.

146

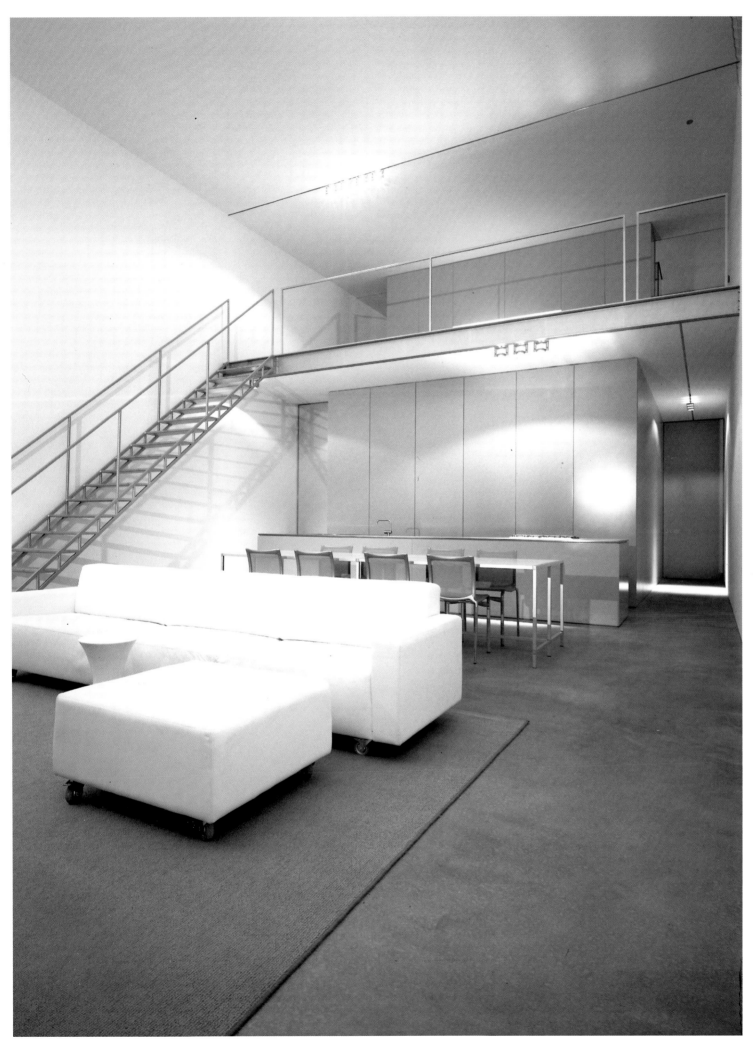

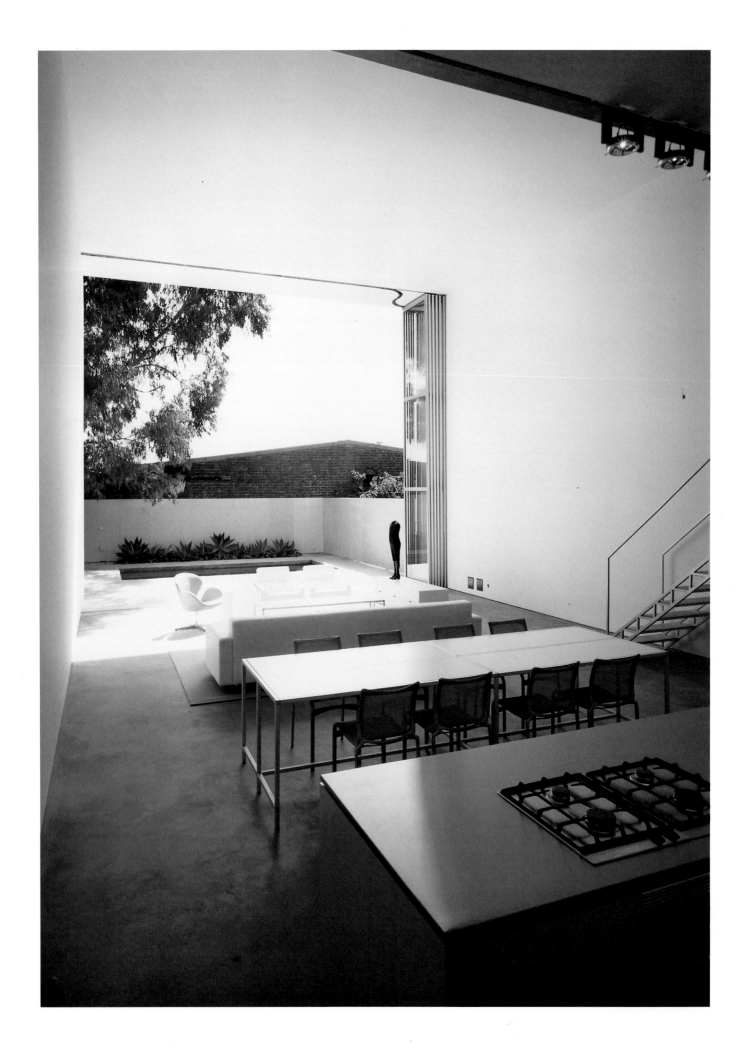

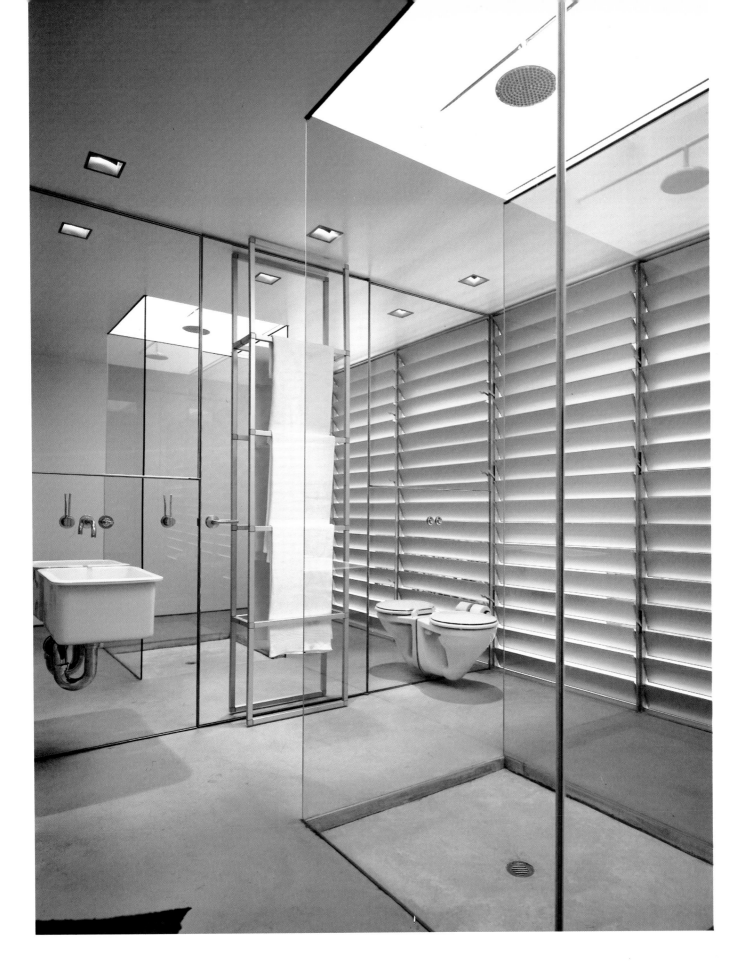

All the furniture had to be lightweight, or else mounted on casters, so that it could easily be put aside to transform the house into a photographer's studio.

View of the main bathroom. The treatment of the finishes and the light endow what is otherwise a very simple geometric space with a whole wealth of nuances.

Dr. Baeltz

Shigeru Uchida

The two cosmetic shops designed by Shigeru Uchida for Dr. Baeltz represent a different approach in the design of shop premises with spaces of reduced dimensions. The number of components of the shops has been reduced to a minimum in a process of analysis which results in a unitary design, where aesthetics blend with function.

The philosophy behind the brand of Dr. Baeltz cosmetics is based on the natural properties of their products, and so a different approach is required than in shops where product choice depends on factors such as image or fashion. In Dr. Baeltz shops, a beauty consultant attends the client personally and advises him or her on which type of cosmetic is appropriate in each case. This approach means that the two shops studied here are not retail display spaces, but rather places in which to relate the product to the client. The crucial factor lies in enhancing the virtues of the product by means of personal attention to the user rather than in showing off the colors and textures of the product.

Both shop premises are of reduced dimensions (29.8 m and 38 m) and have a

Location: *Kitazawa y Hiroo, Tokyo, Japan.*
Completion date: *1995.*
Architect: *Shigeru Uchida.*
Photography: *Nacasa & Partners.*

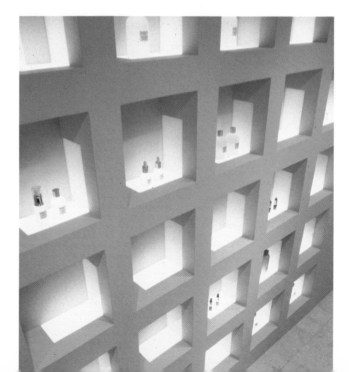

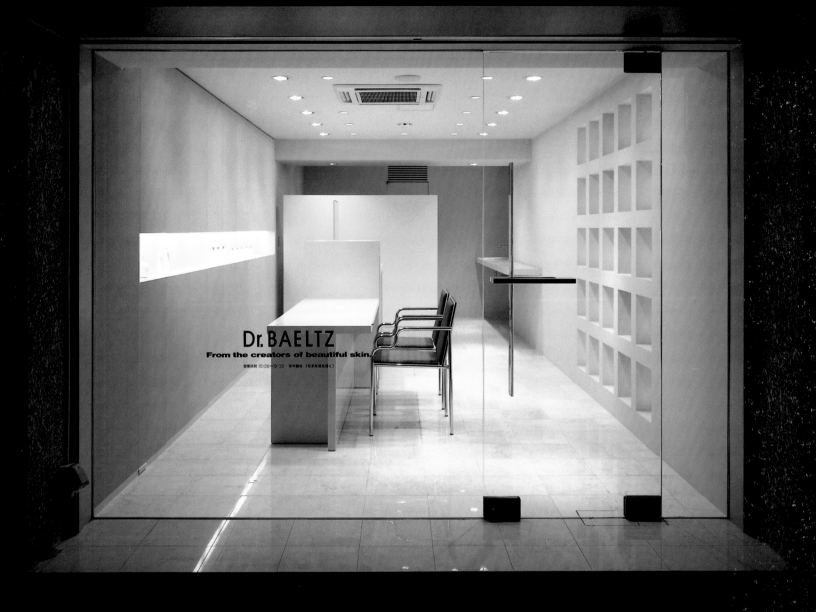

Facing the counter of the
larger shop, a rectangular
layout built into the wall
creates a composition of
shelves with their own lighting
to set off their content.

shop from outside.

only item which

the overall beige

ground, the

parates the facial

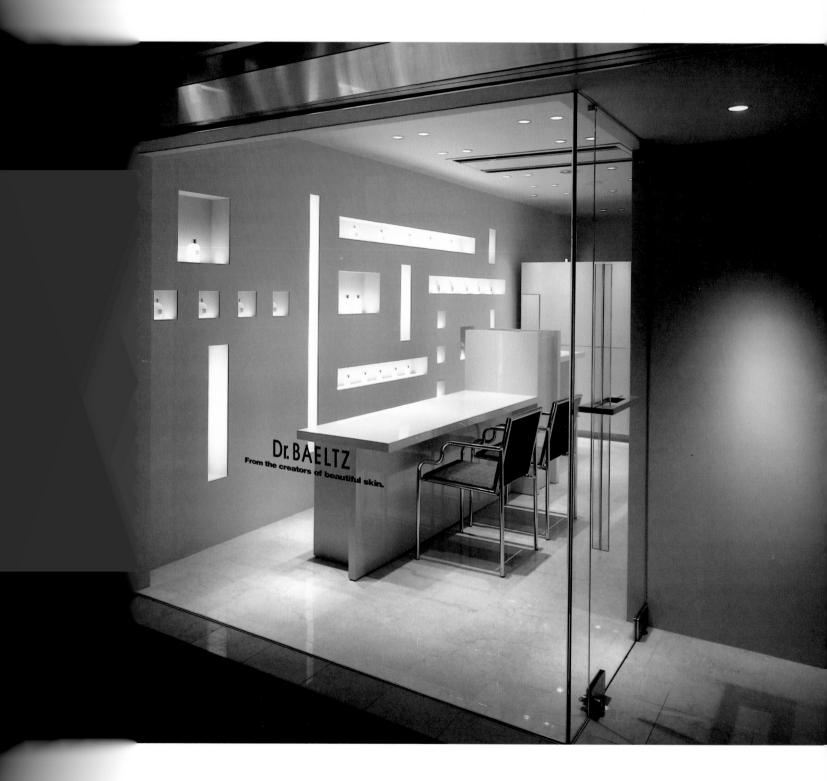

or plan. The entrance forms tinuous glass façade facing shopping center where the ted. This gives a complete view of the interior space. The floorspace is divided into three sections: the shop, the customer service counter, and the facial treatment area at the back of the shop. The counter, located along the length of the shop and complemented by steel-structured armchairs upholstered in blue, is the only item that invades the

The abstract composition formed by the openings of different sizes in the wall behind the customer service counter uses containers of the Dr. Baeltz brand as decorative elements.

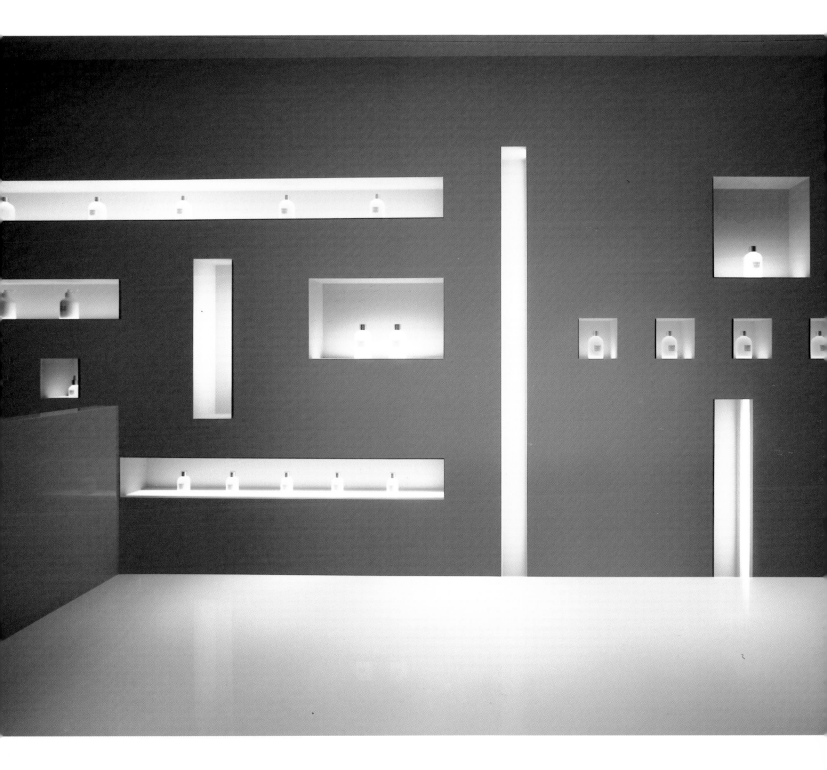

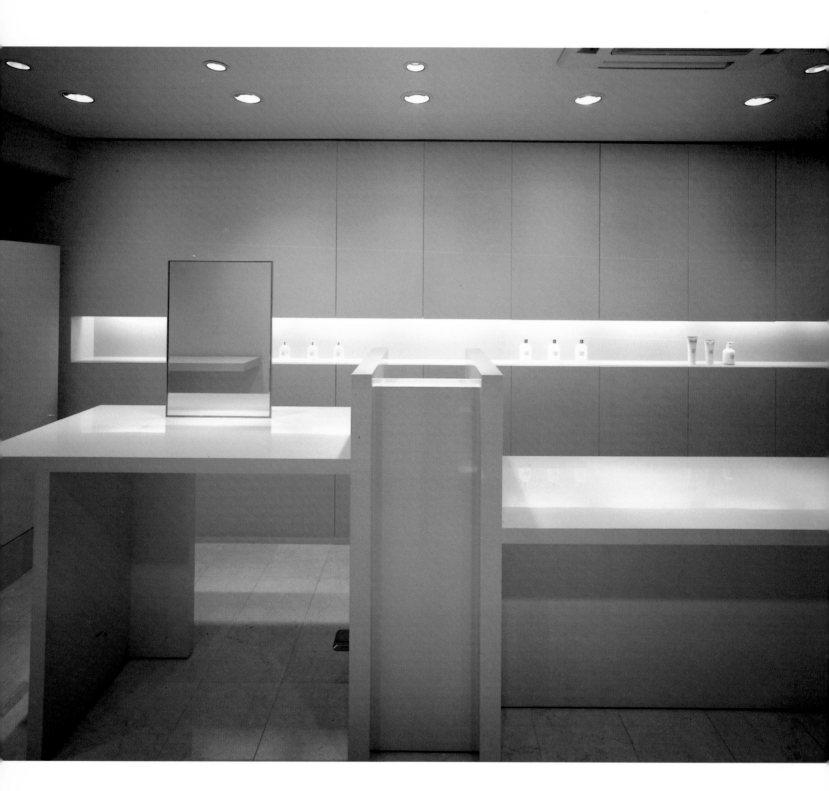

The longitudinal display case built
into the wall acts as a background
for the customer service counter.
It is made up of two parts of a
different height and is situated
lengthwise in the shop.

154

space of the premises. The products are displayed along the walls of the shop. The facial treatment area is separated from the rest of the shop by means of a partition which does not reach the ceiling, thus allowing physical and visual continuity of the space.

All of the branded products are contained in plain bottles or jars laid out either in display cases or on shelves built into the longer walls. The display cases thus blend in with the vertical fittings. In the larger shop, a continuous narrow display case behind the counter faces a rectangular layout of shelves which takes up all of the wall. In the other shop, a random distribution of shelves of various sizes and shapes creates an abstract composition on the larger wall.

The layout of the fittings within the walls is reinforced with their own lighting to show off the displayed products in various sizes of containers. Display cases and products combine to produce an overall aesthetic effect.

The use of beige as the predominant color follows a desire to enlarge the reduced space of the shops. The painted finish of the walls and ceiling, the polished marble flooring, the wavy wood finish on the panel which holds the display case in the larger shop combine to create a complementary series of tones. Likewise, the glossy resin finish of the counter are complemented by the indirect light from the display cases.

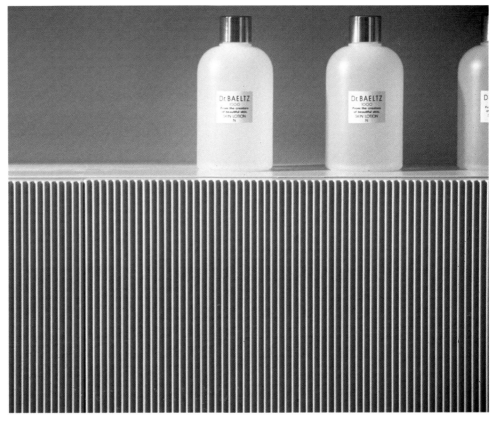

Detail of the longitudinal display case in the larger shop. The case is built into a panel with a wavy wood finish, in which the plain bottles and jars of the brand stand out.

Bottega Veneta

François de Menil

The architecture of François de Menil for the two Bottega Veneta stores is based on geometry, color, and space. It attempts to carry the meaningful aesthetic experience until it reaches the insignificant and the obvious. This is an architecture that ventures toward degree zero in terms of geometric and spatial composition. It is an architecture that imposes itself through the strict physical presence of its volumes and materials. On these are inscribed the occasional slight gesture or casual distortion to fracture the geometric form.

In this particular context, the physical spaces where daily transactions take place acquire decisive importance and must be treated with utmost care. Such a space becomes an object to be admired in its own right, inside of which the elements for sale are displayed in small, almost insignificant quantities against a suitable background.

De Menil has developed a twofold strategy by which to arrange the exhibits. On one hand, the leather articles appear as jewels in display cases, idealized objects in wall niches, points where color and attention are concentrated. On the other, they constitute compositional material, texture, contributing in the same way as wood or glass to the store architecture.

Location: *Bloomingdale´s, New York; Short Hills, New Jersey, USA.*
Completion date: *1996.*
Architect: *François de Menil.*
Collaborators: *Jan Greben, James Moustafellos, Viken Arslanian.*
Photography: *David Cardelús.*

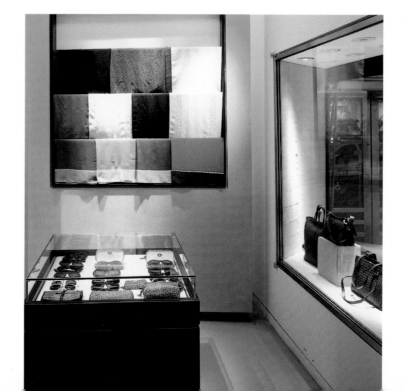

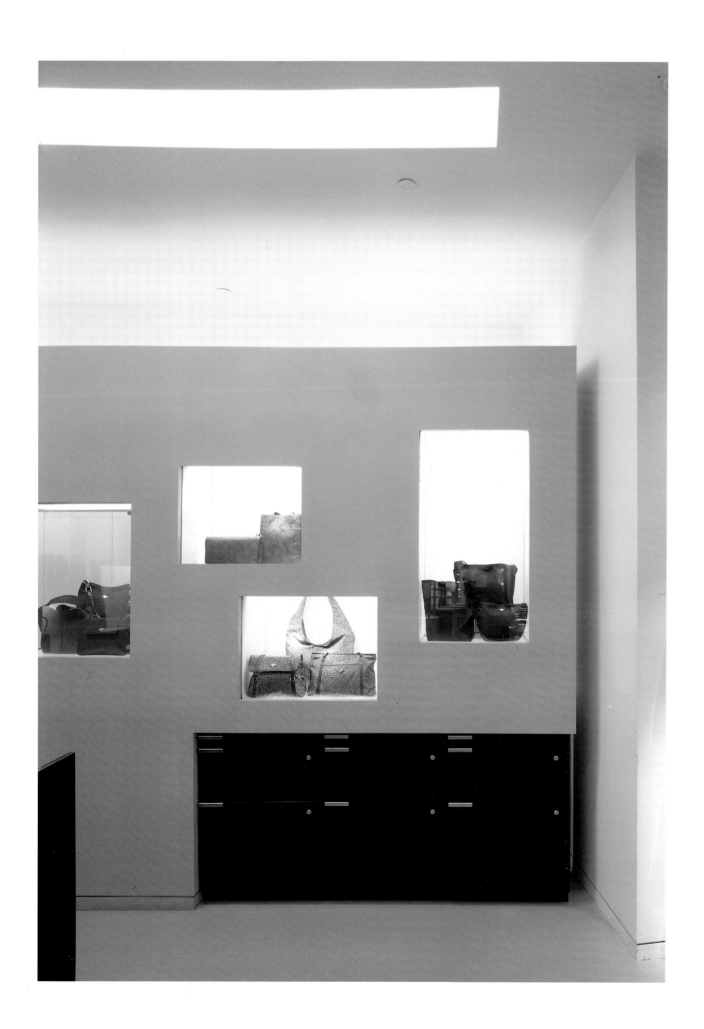

Entry to the Bottega
Veneta store in
Bloomingdale' s, New York.

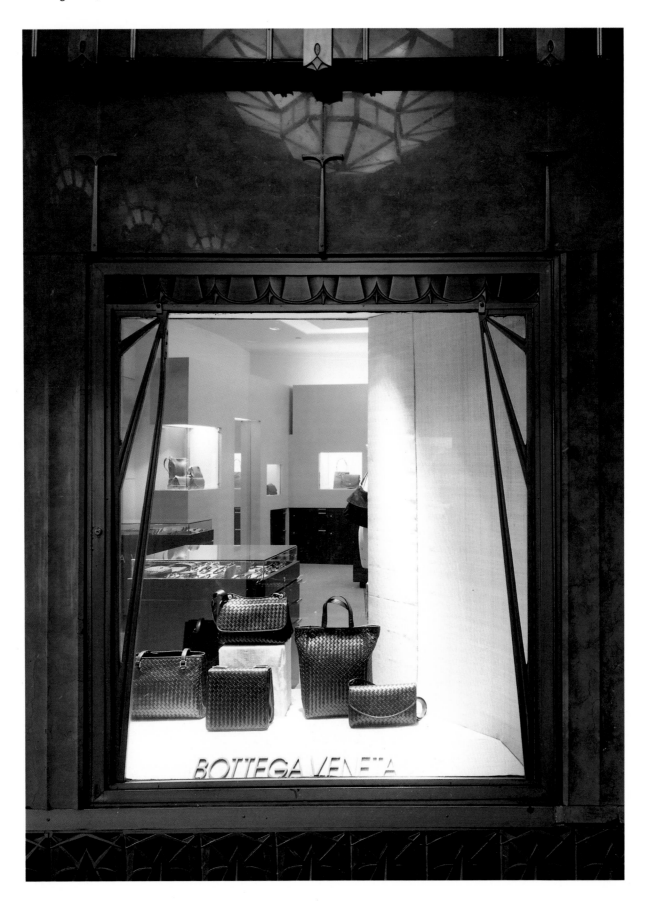

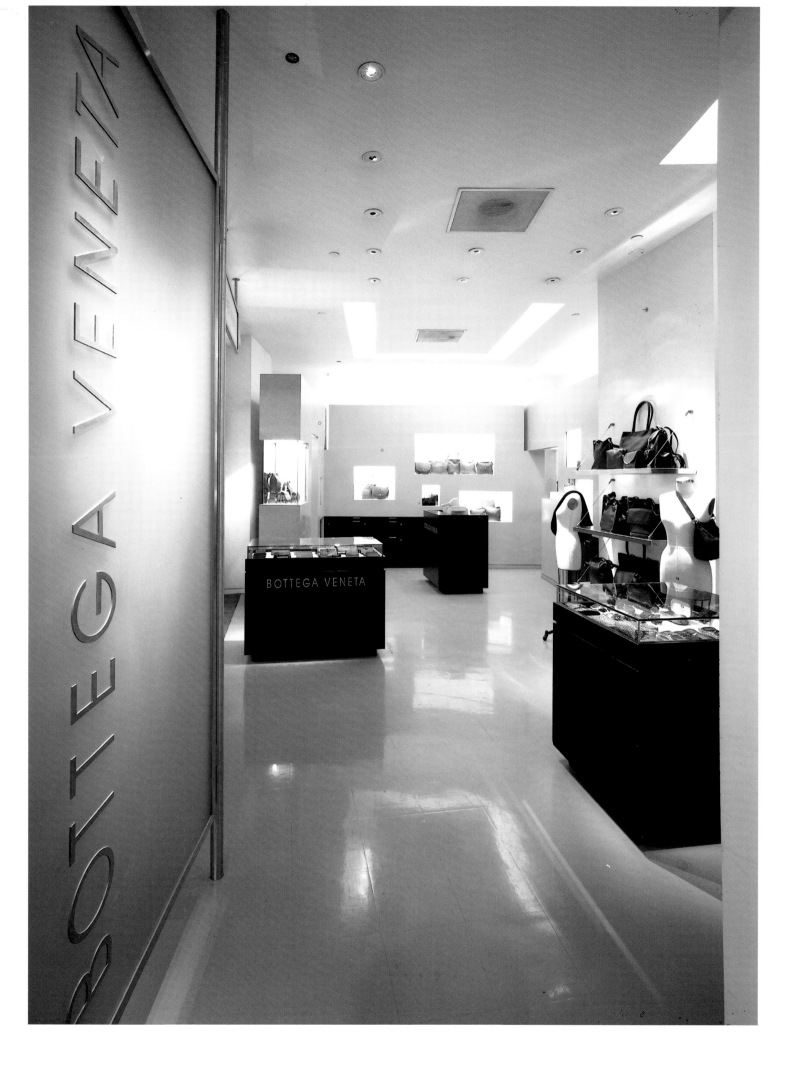

BUILDING VESTIBULE

LEXINGTON AVENUE

59TH STREET

The store is arranged around a J-shaped display window-wall that orients the interior toward the main corridor.

Overall plan.

1. Sign post.
2. Display cabinet.
3. Display wall.
4. Storage area.
5. Storage area.
6. Storage cabinet.
7. Cash register cabinet.
8. Pivoting display wall.
9. Display cabinet.

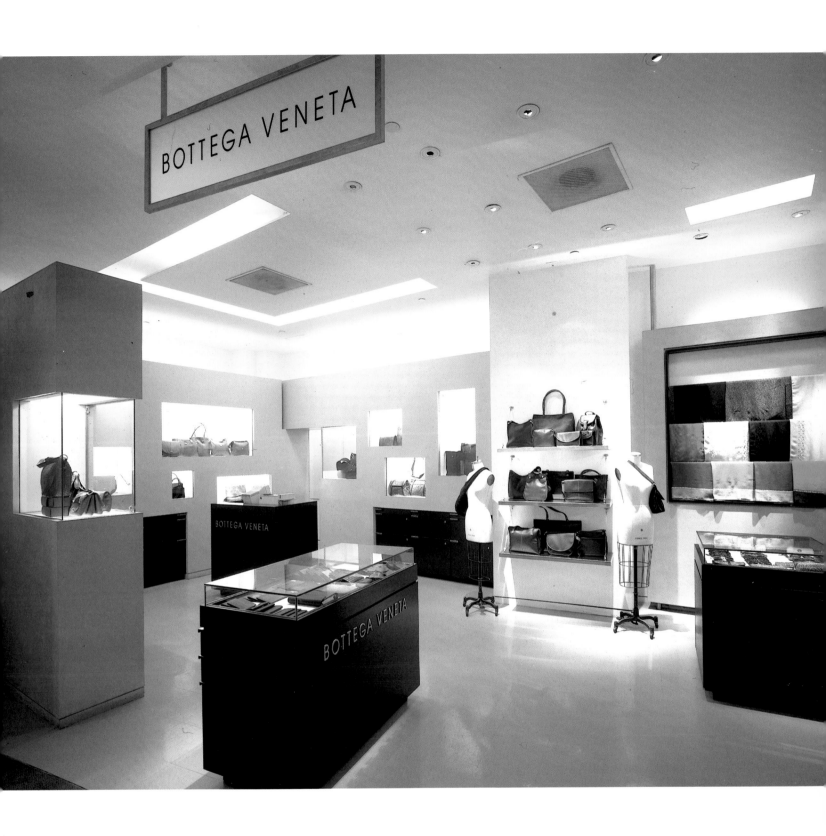

The experience of shopping is ritualized in stages of increasing contact with the merchandise, from contemplation of the products as objects in display cases to hands-on contact with them on the pullout shelves where it is possible to appreciate their texture, design, and craftsmanship. This experience progressively transforms the article from an idealized abstraction into a personal possession.

The classic shop window disappears and the area it formerly occupied becomes a space through which we perceive the interior. This is an example of the new window-store concept: the whole interior is in full view from the street and products and customers are equally on display. Architecture and exhibition work hand-in-hand to create a strong visual identity. Planar cabinetry elements and lighting are used to manipulate the relationship between floor, walls and ceiling, breaking preconceived spatial boundaries.

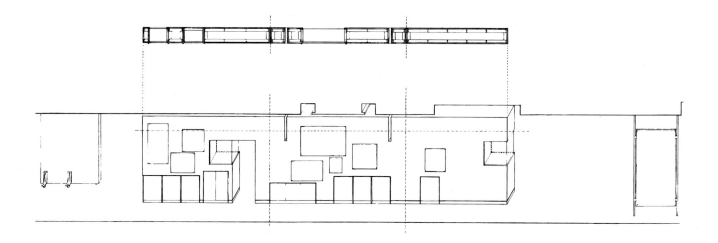

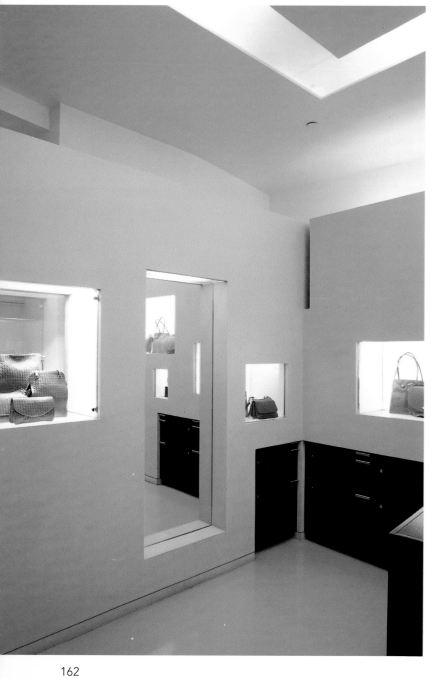

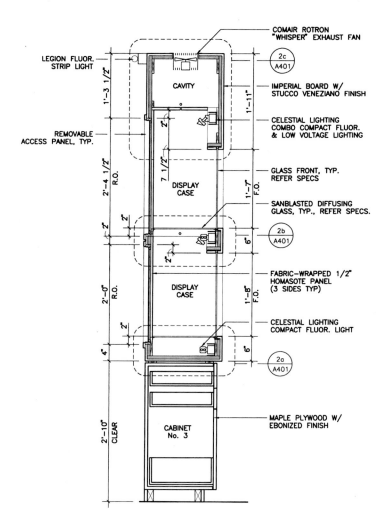

COMAIR ROTRON "WHISPER" EXHAUST FAN

LEGION FLUOR. STRIP LIGHT

IMPERIAL BOARD W/ STUCCO VENEZIANO FINISH

CAVITY

CELESTIAL LIGHTING COMBO COMPACT FLUOR. & LOW VOLTAGE LIGHTING

REMOVABLE ACCESS PANEL, TYP.

GLASS FRONT, TYP. REFER SPECS

DISPLAY CASE

SANBLASTED DIFFUSING GLASS, TYP., REFER SPECS.

FABRIC-WRAPPED 1/2" HOMASOTE PANEL (3 SIDES TYP)

DISPLAY CASE

CELESTIAL LIGHTING COMPACT FLUOR. LIGHT

MAPLE PLYWOOD W/ EBONIZED FINISH

CABINET No. 3

Elevation and cross-section of the display window-wall, divided into several display cabinets containing either one or just a few objects.

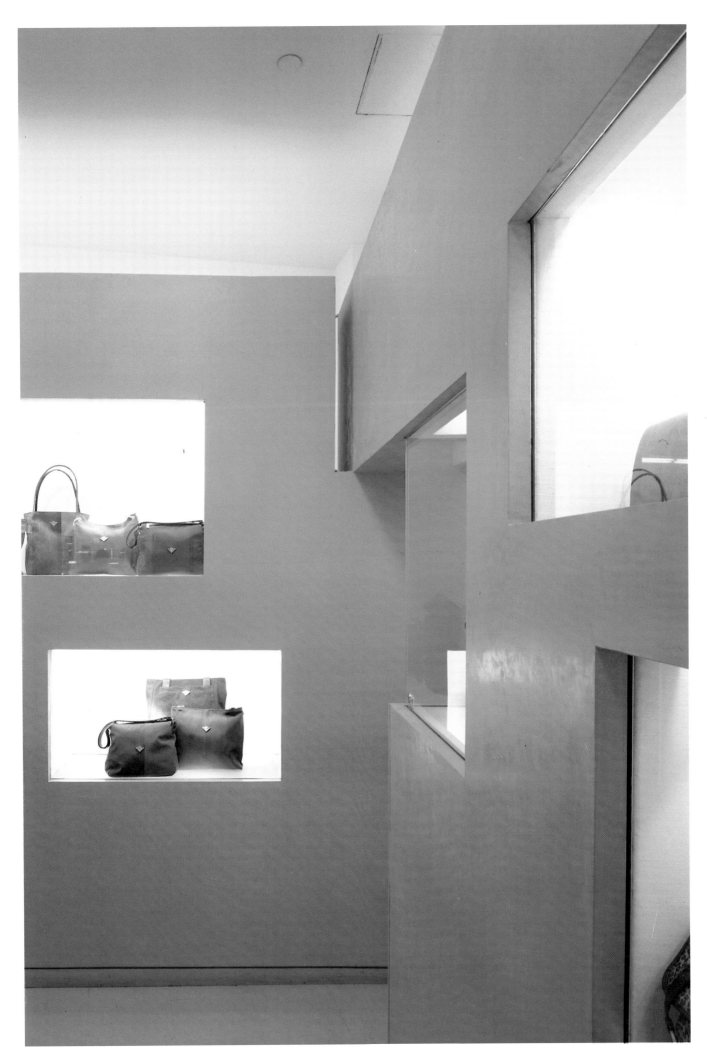

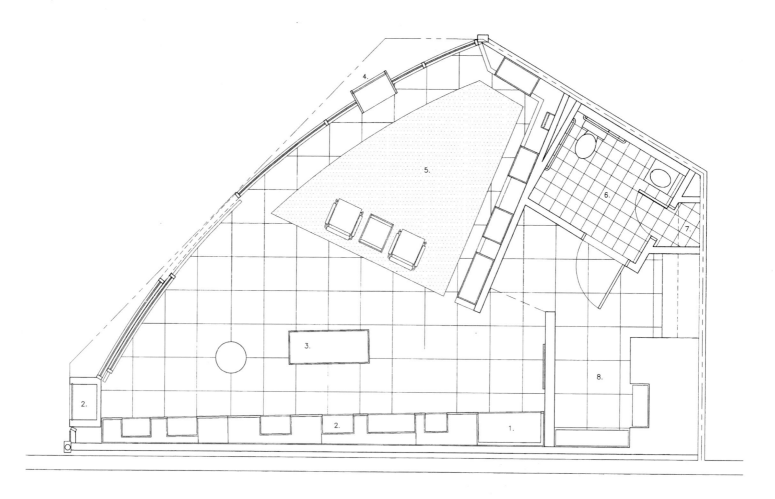

*Plan and overall view of
the Bottega Veneta store
on The Mall at Short Hills,
New Jersey.*

Tenuous artificial lighting is used to create a warm, welcoming atmosphere that invites potential customers to pause at specific, more precisely lit points. Soft, harmonious color tones, glass, and metal all combine to create a store-object, a store-symbol, the essential emblem for the product. Elegance and simplicity act as the ideal backdrop for the merchandise on display.

The products are advertised in such a way that they are associated not with an ideal, such as efficiency or reliability, but rather with an image: the product is young or distinguished. Aspiration toward an ideal is thus replaced by identification with an image; we may project ourselves toward an ideal, while images project us or are projected onto us. Extreme care has therefore been lavished on the design not only of the articles on sale but also of everything concerning them: the graphics, the color and texture of shopping bags and wrapping paper, the trade-mark logotype, and even the appearance and demeanor of the store assistants.

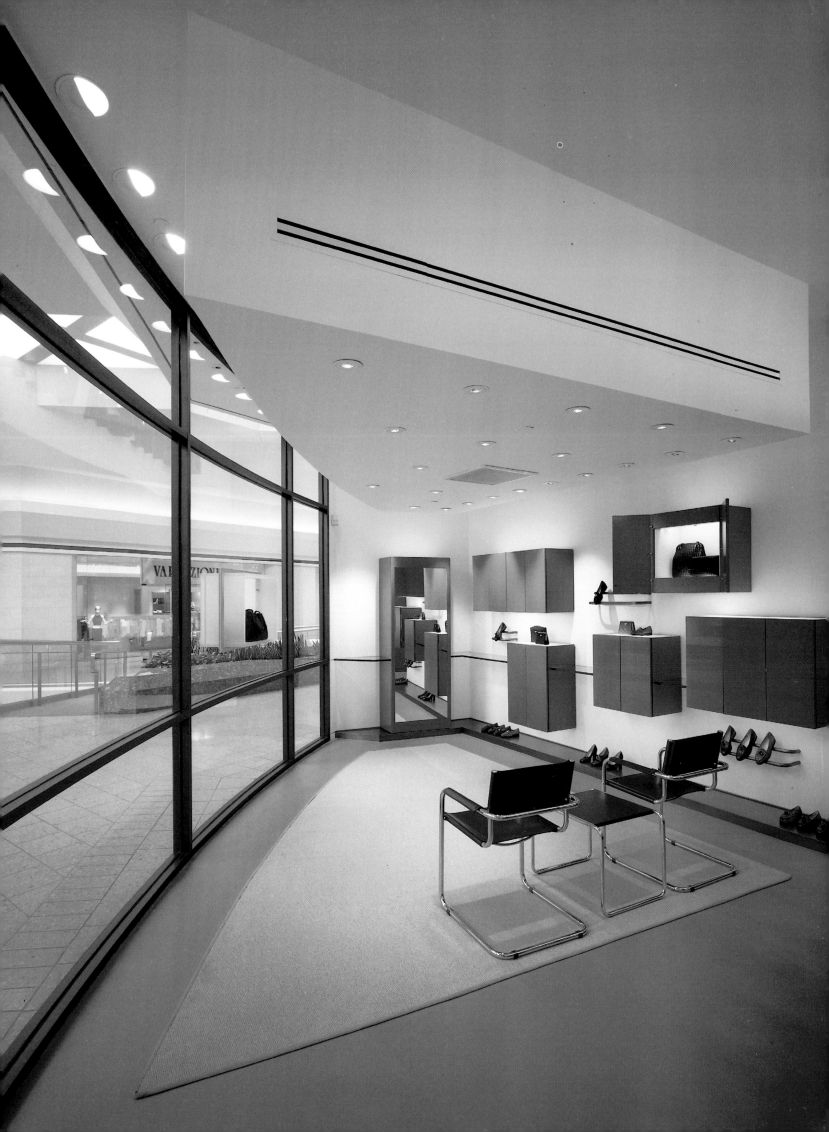

Elevation of the display cabinets.

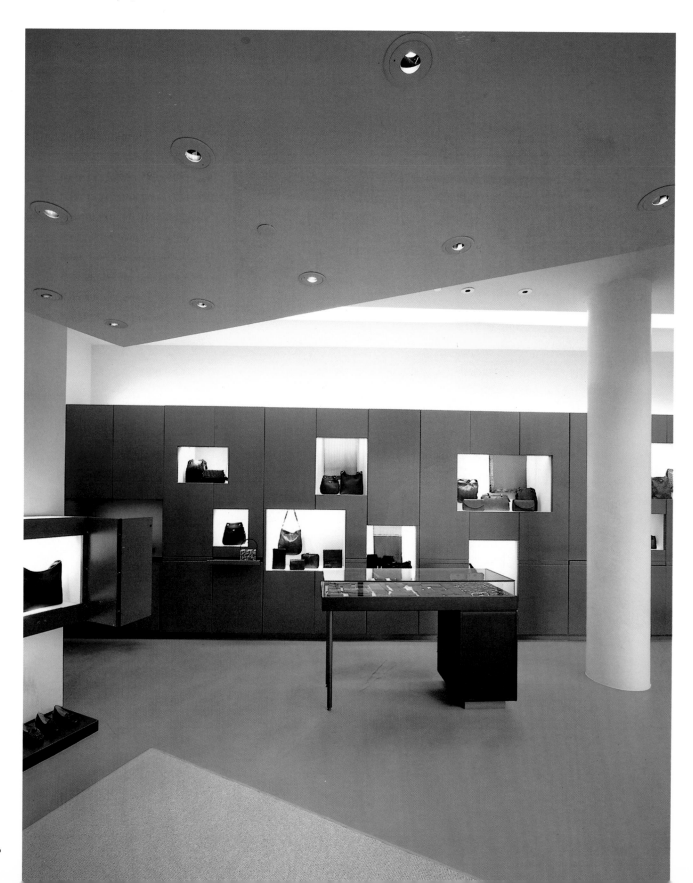

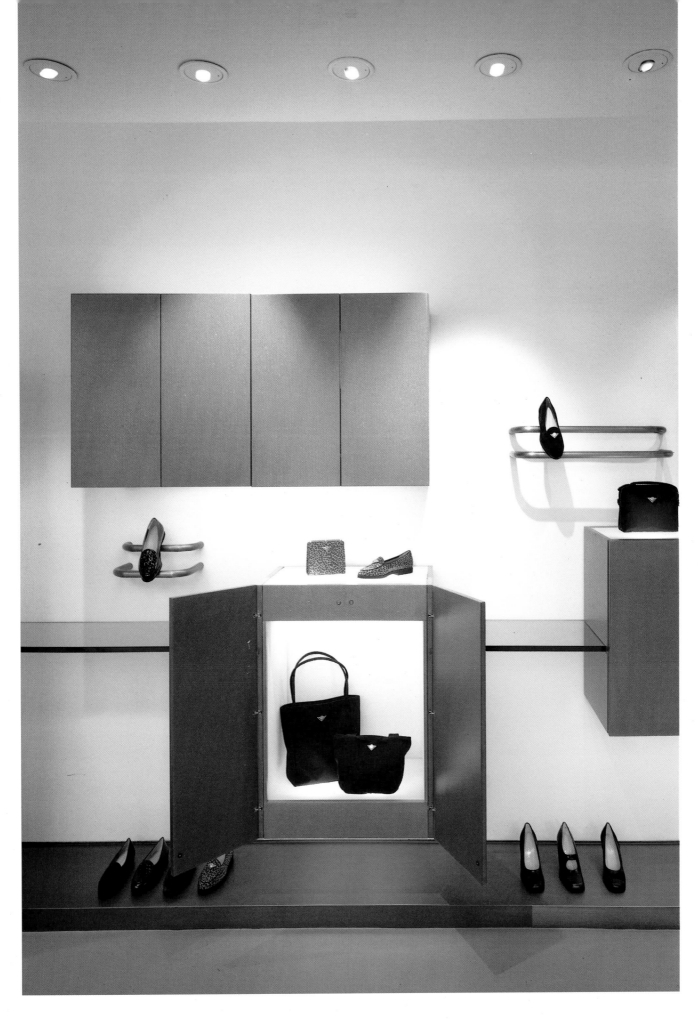

The store is divided into two zones: footwear and bags.

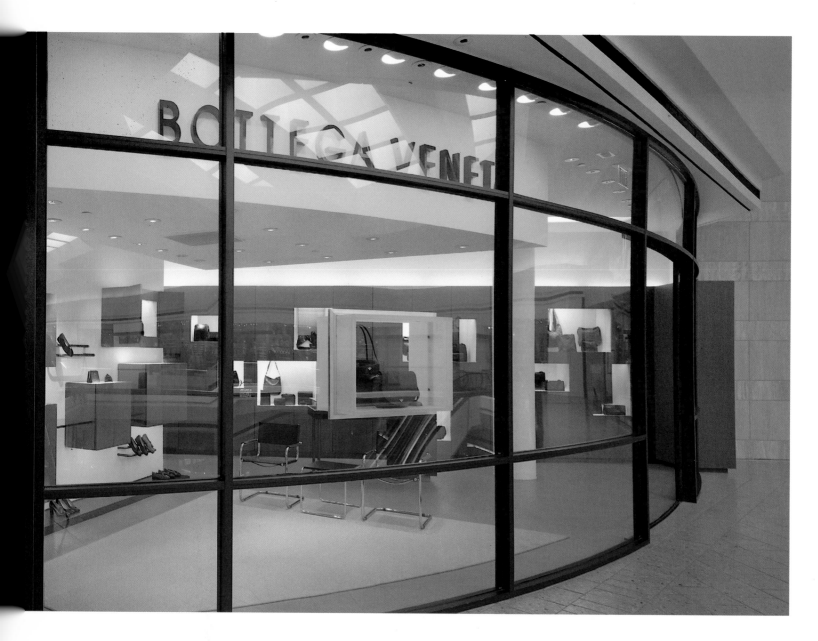

The glass wall has a twofold function. On the one hand, passers-by on the Mall have a perfect view of the products from outside the store. On the other, it creates an expanding sense of space beyond the store's actual limits.

3/4" STOREFRONT
LAMINATED GLASS

SHIM SPACE & SETTING BLOCK

3/4" SANDBLASTED
TEMPERED, GLASS
DISPLAY BOX

LOCK-TITE
U-V CURVE
JOINT TYP.

3/8" TEMPERED
CLEAR GLASS
FRONT

STRUCTURAL SILICON
COORD. W/ ARCHITECT

ALUM. CHANNEL
1 1/4" X 1" X 1/8" TH.

ALUMINUM
BLOCK 3/4" X 1/4" TH.

ALUM. BLOCK 1 3/4" X 3/8" TH.
W/ OVERSIZED HOLE

"SLIP" BUSHING
TYPICAL.

3/8" DIA. COUNTER-SUNK
ALLEN BOLT, SUBMIT SAMPLE
FOR ARCH.'S APPROVAL

3/8" TEMPERED
CLEAR GLASS
FRONT

LOCK-TITE
U-V CURVE
JOINT TYP.

3/4" SANDBLASTED
TEMPERED, GLASS
DISPLAY BOX

3/8" DIA. COUNTER-SUNK
ALLEN BOLT, SUBMIT SAMPLE
FOR ARCH.'S APPROVAL

"SLIP" BUSHING
TYPICAL.

CLEAR VYNAL SPACER

ALUM. BLOCK 1 3/4" X 3/8" TH.
W/ OVERSIZED HOLE

TAPED

ALUM. CHANNEL
1 1/4" X 1" X 1/8" TH.

TAPED

TACK-WELD ALUM.
BLOCK 3/4" X 1/4" TH.

3/4" STOREFRONT
LAMINATED GLASS

SHIM SPACE & SETTING BLOCK

STRUCTURAL SILICON
COORD. W/ ARCHITECT

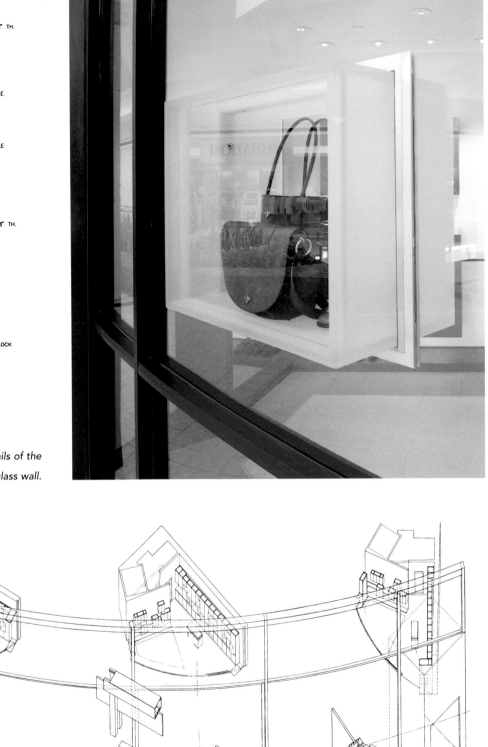

Construction details of the
glass wall.

Calvin Klein Madison Avenue

John Pawson

With the opening of this boutique in one of the world's foremost luxury commercial zones, Calvin Klein has brought together in a single space all the essential facets of his work as a designer. The store exhibits not only men and women's clothes, bags, and accessories, but also perfumes, jewelery, crockery, and items for the bathroom and bedroom.

When he conceived this establishment, Calvin Klein did not have exclusively commercial considerations in mind. His main intention was to create a space not only for displaying his products but also for communicating his ideas and view of fashion.

The similarity between this boutique and an art gallery is deliberate and justified. The usual sales techniques have no place here. On the contrary, the visitor is invited to stroll through a space in which personal ideas about elegance and luxury are expressed. Thus, the impeccably displayed and illuminated garments and objects are present not merely to be sold. Their presence and

Location: *New York, USA.*
Design date: *1995.*
Completion date: *1996.*
Architect: *John Pawson.*
Photography: *Kristoph Kicherer, David Cardelús.*

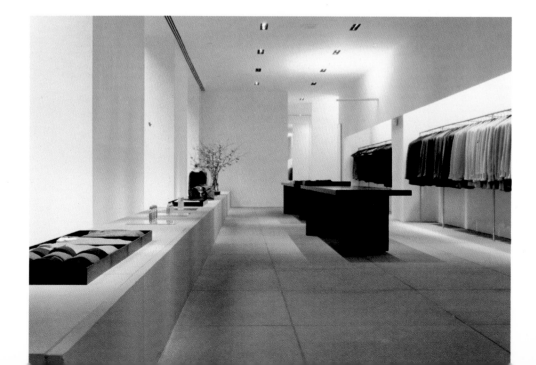

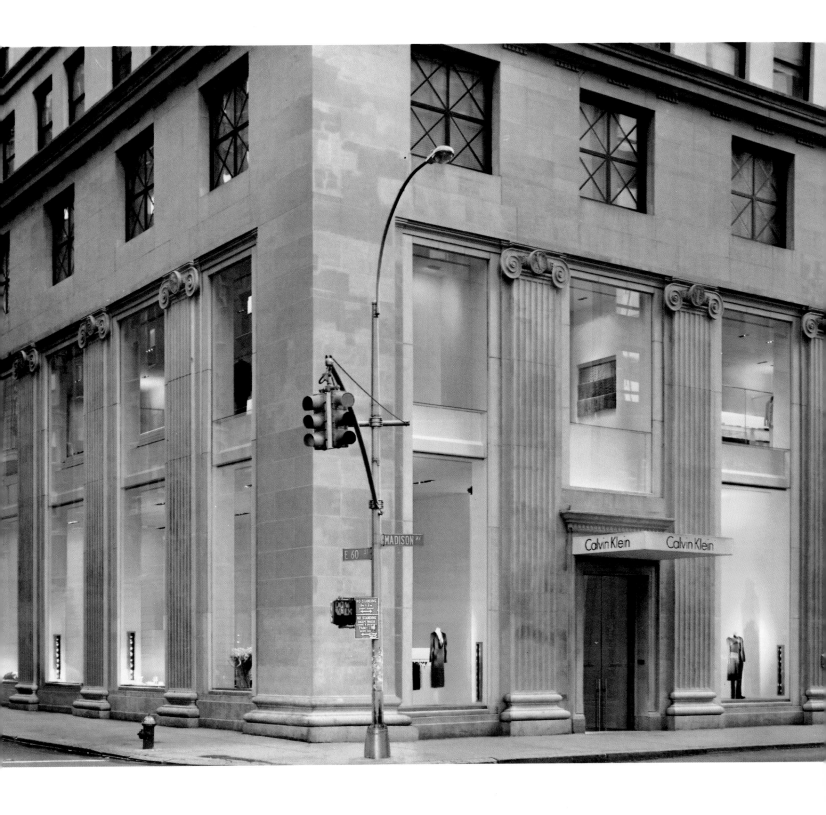

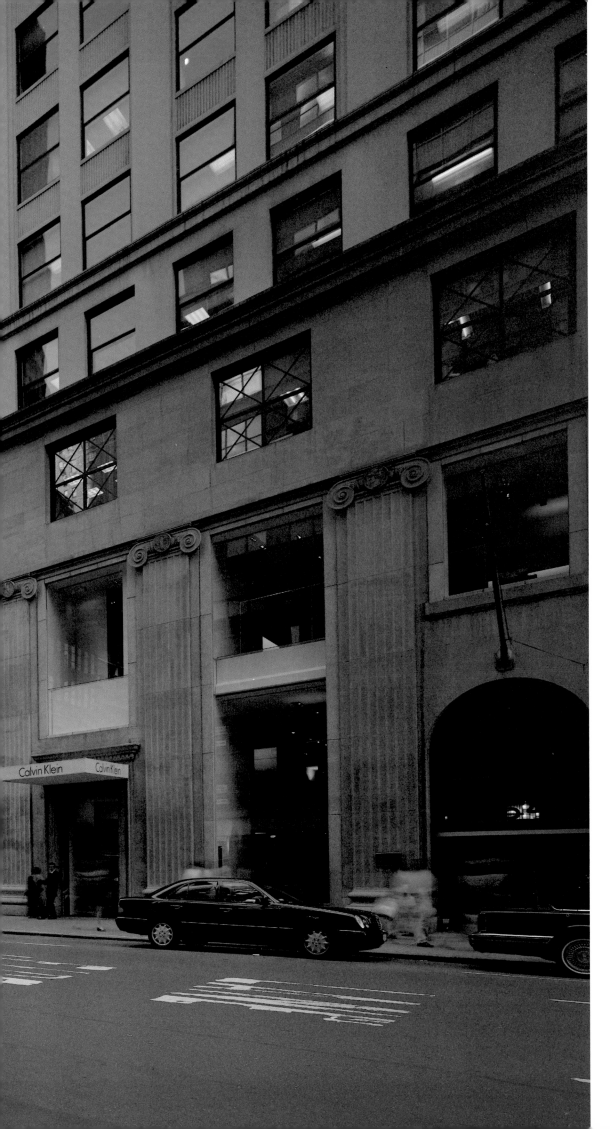

View from Madison Avenue.

Some of the world's most luxurious stores are on Madison Avenue. A boutique with a square footage of around 20,000 is almost unprecedented here. An excessive compartmentalization and overstocking would therefore be counter-productive, since the sensation of a privileged place would be lost.

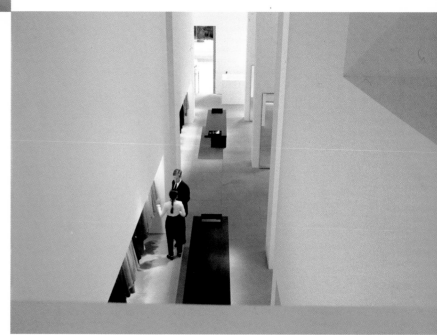

The space, the furniture, the lighting, and the objects themselves are all informed by the same spirit, a personal idea of beauty and luxury. The main intention was to create an atmosphere with which to imbue the visitor.

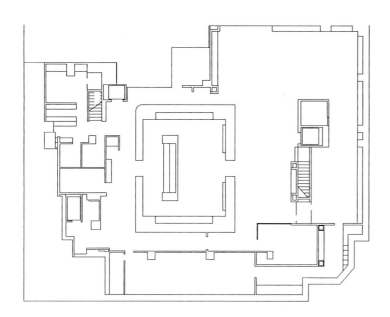

Ground floor.

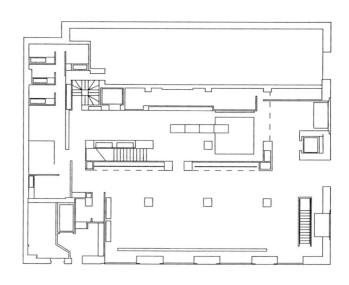

Third floor.

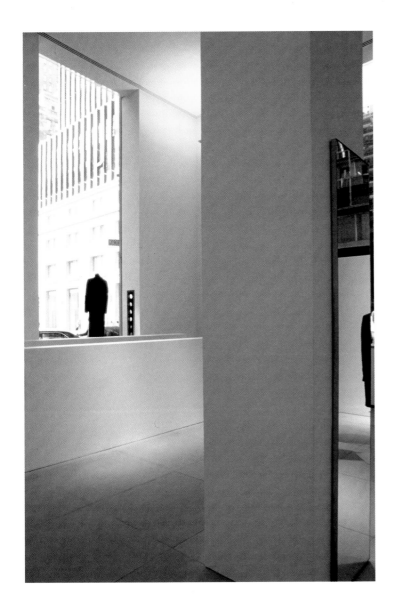

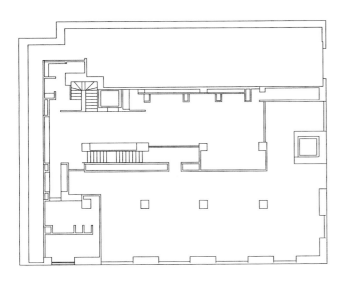

First floor

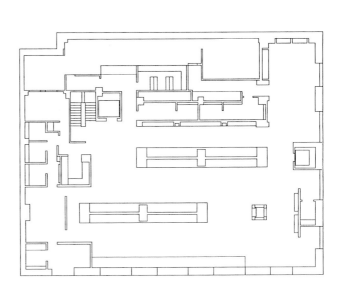

Second floor.

location in the space are intended to create an atmosphere that is in fact the definitive value to be transmitted. By purchasing a coat or a bag, the customer comes to momentarily possess part of this perfect space.

For this reason, the relationship between architecture, finishes, lighting, furniture, and the products themselves is not dictated by a hierarchical window-dressing and advertising strategy. Everything is designed to create a peaceful, harmonious ambience in which visitors may take their time, unhindered by obstacles.

"In New York, luxury is space and light." (Calvin Klein). As the American designer knows only too well, in the hectic, stressful context of today' s cities the chance to accede to a calm, ordered place where all is immaculate and perfectly ordered means a qualitative change, the opportunity to enter a different reality. In short, to attain luxury.

"In this project we strove to avoid the usual disorder and visual pollution caused by lamps, standard ceilings, and air conditioning installations. In many stores these essential elements are treated as if they were invisible, but if they are left to themselves they corrupt any space." (John Pawson).

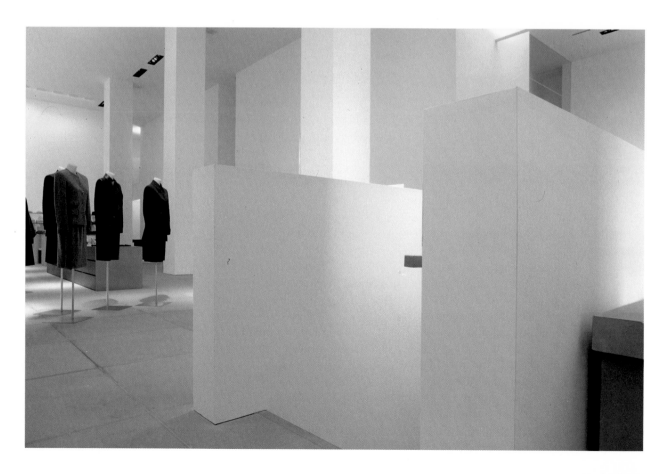

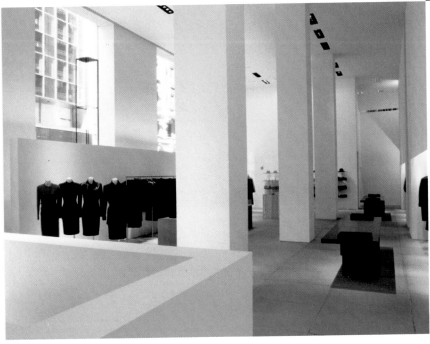

Women's fashion and accessories are on the ground and second floors, joined by a double space that connects them visually. An elevator leads directly from the entrance to the men's fashion floor.

The boutique is on the four ground floors of the former J. P. Morgan Bank building, with its classical-style façades. The only exterior intervention consisted of the substitution of the original windows for fixed, frameless panes so that the building would become a huge display window. The boutique has a total of 20,000 square feet, with a ceiling of up to 20 feet. The ground floor has been dedicated to women's accessories, the mezzanine half-floor to women's clothes and the top floor to men's fashion. The basement accommodates the exhibition of objects for the home, distributed in independent rooms, and accessories for the bathroom, the kitchen, and the dining room.

The interior is defined by stone flooring, white walls and, above all, the meticulous arrangement of objects. Unlike most stores, this one makes no attempt either to guide or direct the customer. On the contrary, visitors are allowed to move around calmly, unhurriedly, feeling privileged and forming part of the venue's atmosphere. The arrangement of the establishment serves as a guiding reference.

Giorgio Armani Boutique

Peter Marino

Perhaps we no longer live in an era of monuments. Our contemporary circumstances of constant mutation and nomadism, of incessant change, have forced us to look beyond the former need for permanence that some modern works still pursue.

Architecture that prepares spaces for consumption has been among the first to explore the possibilities of brief existence: attempting to design decors, define spaces of light and shadow, and produce figures in movement. These are privileged venues in which to apply every technique of visual persuasion toward the passer-by, the voyeur prepared to be seduced by objects, the individual who seeks self-realization in the purchase of commodities.

In his boutique for Armani, Peter Marino presents a physical and therefore temporal construction that acts at once both as the container and representative of something as ephemeral as fashion. Marino decided to tackle this initial paradox by trying out a less cinematographic, less visual, less hedonistic form of seduction, a form less immersed in consumerism and instead informed more by austerity and reflection.

Location: *Nueva York, USA.*
Completion date: *1996.*
Architect: *Peter Marino.*
Collaborators: *James Carron, Kevin Wingate, Stephen Moser, Sarah Marsh, Osamu Mochizuki, Arturo Padilla, Philip Cozzi.*
Photography: *David Cardelús.*

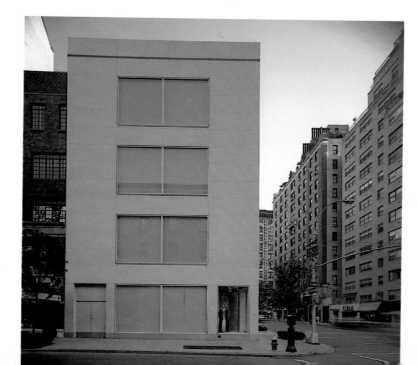

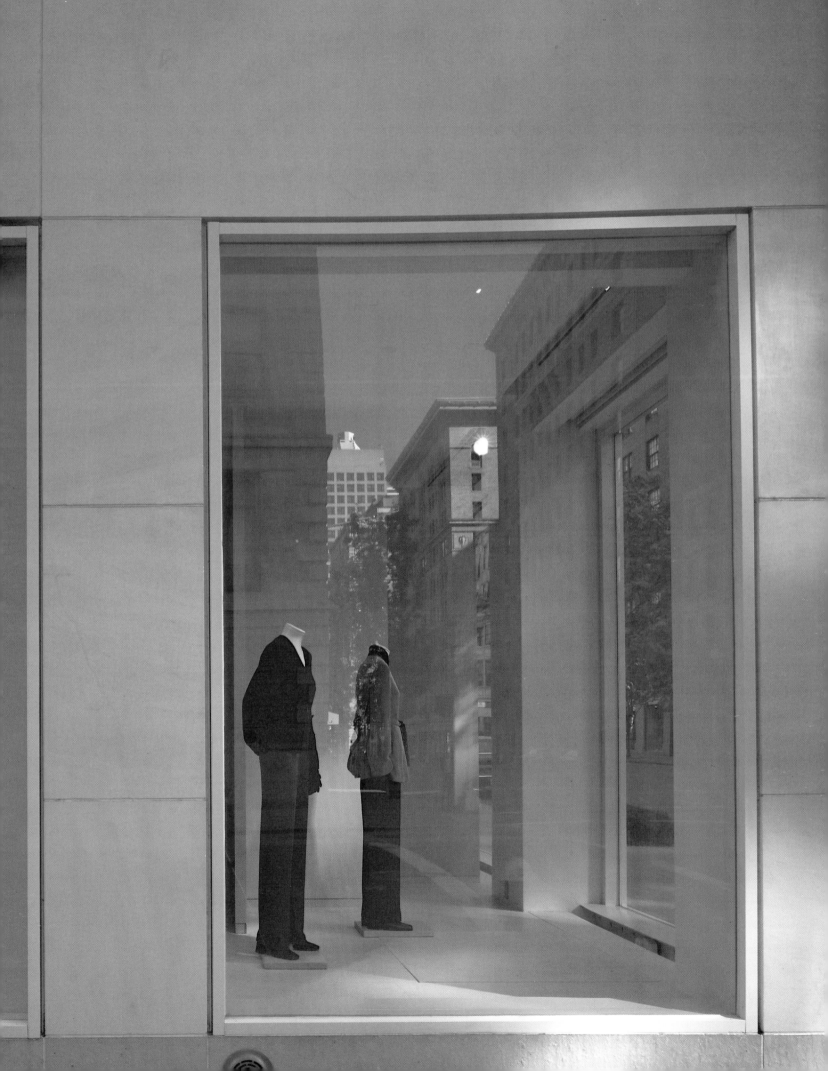

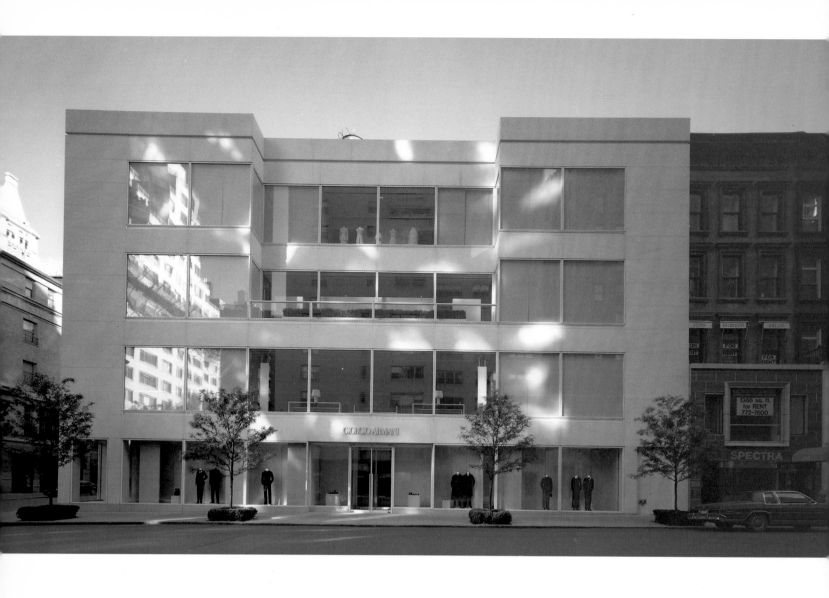

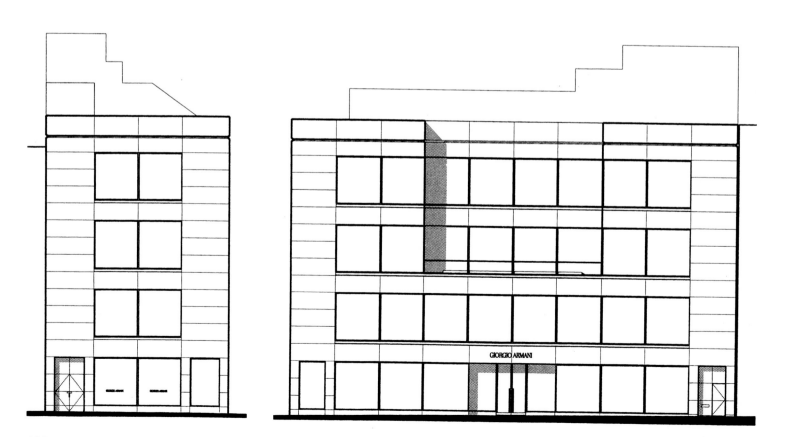

Peter Marino's intention was to achieve maximum formal and conceptual tension through limited use of forms and elements, and to reach the essential through the elimination of decorative elements.

His aim in this is to free art from all referential, representative, or metaphorical functions. The work seeks neither to evoke nor to appeal to anything except itself.

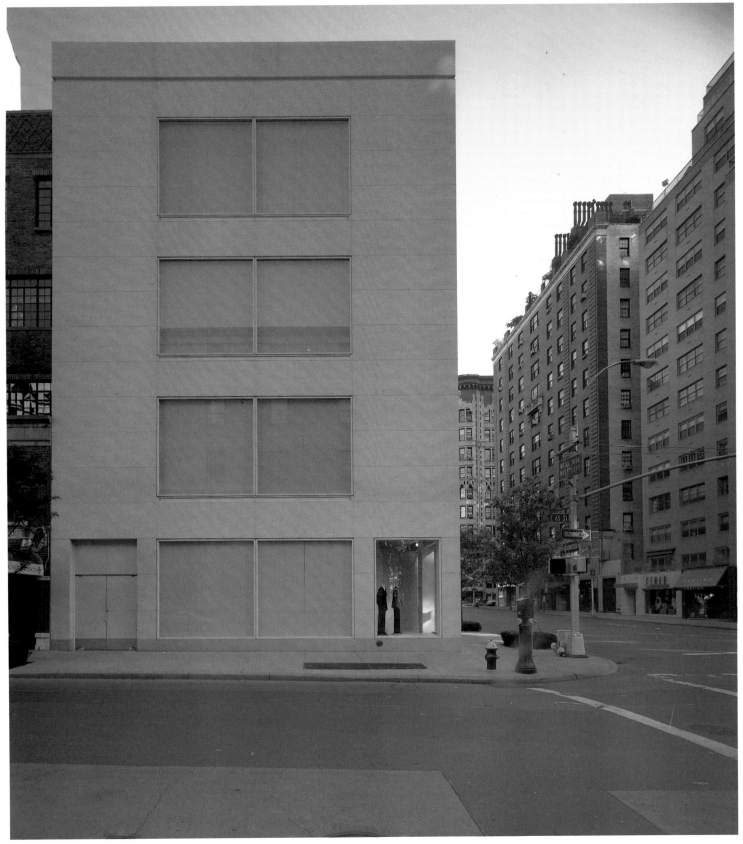

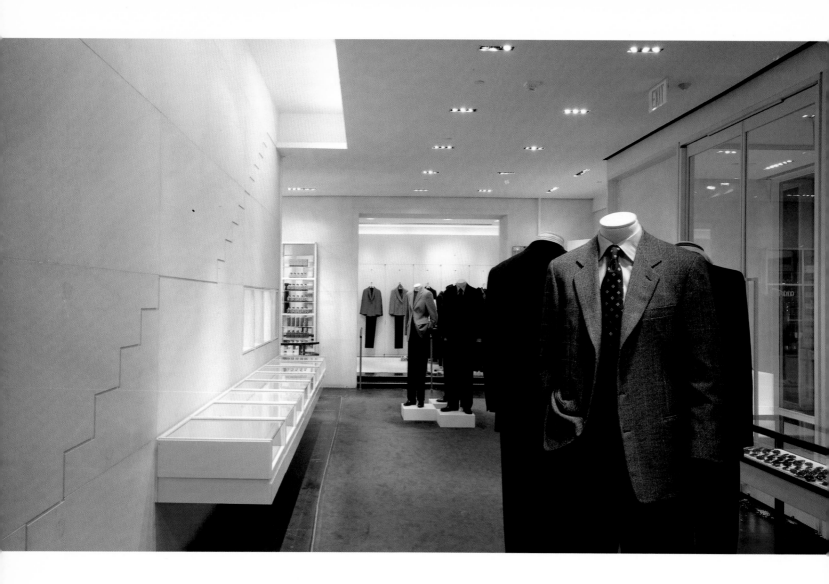

Much criticized for its seeming indifference and scornfulness toward the surrounding urban context, this building on the northwest corner of Madison Avenue and 65th Street is a "white box" that stands out against a dark background of old, brick constructions. It is precisely this dark background, this patina left by the passage of time, which transforms Marino's building into an "ideal" object, a shining, abstract container untouched by the foul breath of the city.

As a reaction to the predominant aggressiveness and disorder of the urban context, the Armani boutique is introverted, withdrawn, and ascetic. Marino stresses the ability of all installations or interventions to transform the surroundings and endow them with a new identity.

In reaction to the squandering and overproduction of information, the

The will exists to achieve spaces that are globally and instantly perceptible, gestalt forms that directly address the mind of the observer, eluding all sensualist contamination. Despite these efforts, however, Peter Marino admits that "all forms, even the most abstract and geometric, end up referring to something: a stair, an umbrella, the moon... No. You must strive to find forms incapable of suggesting the slightest idea. Neutral, insignificant, mute forms."

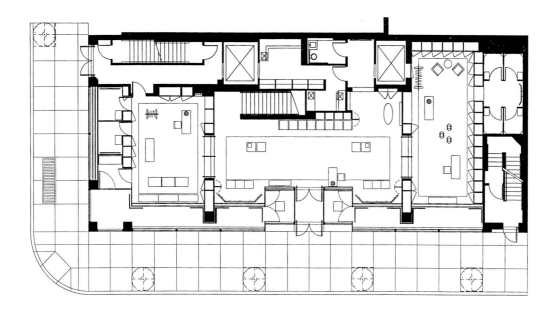

Ground floor.

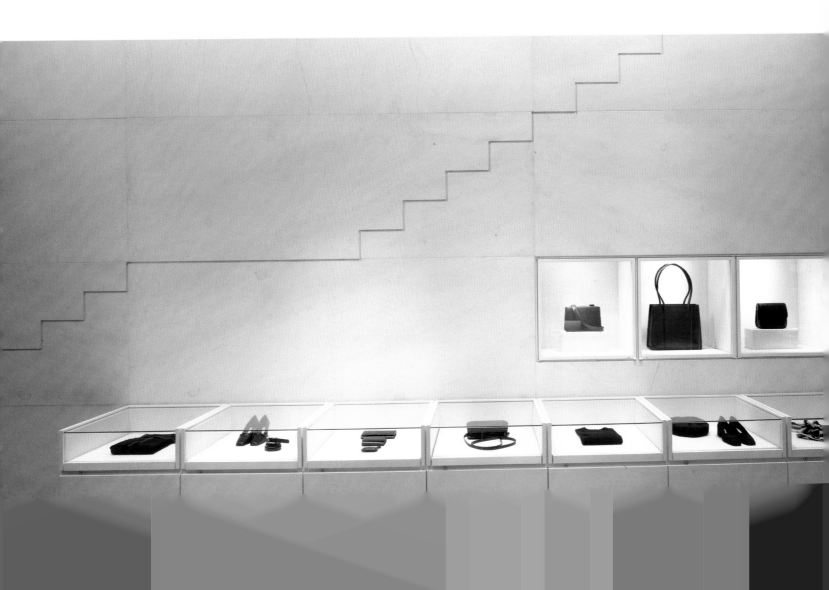

Several views of the second floor. Unlike other commercial establishments, the Giorgio Armani Boutique is divided into relatively independent rooms, where customers may be attended personally.

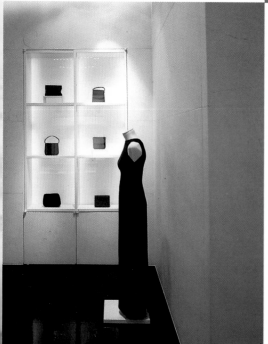

First floor.

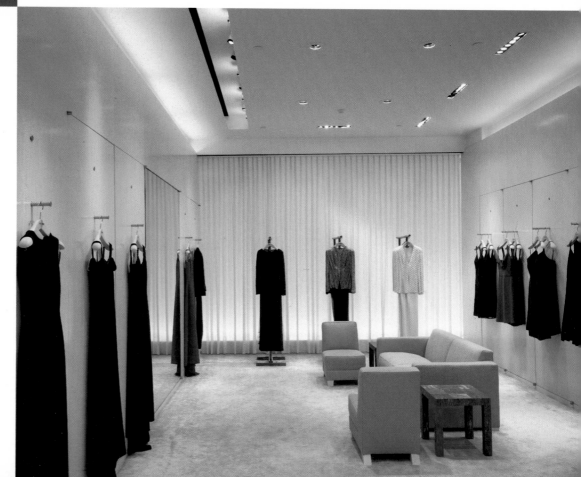

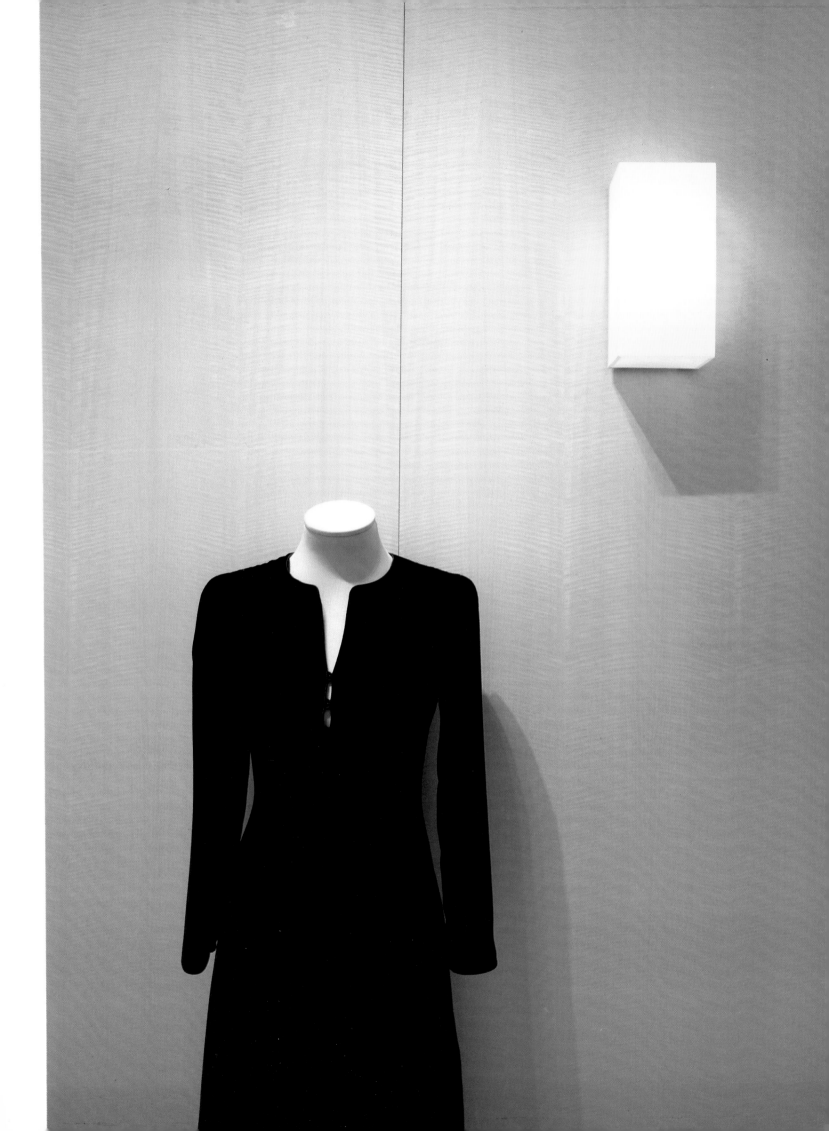

There can be no doubt that not only this boutique but also those of Calvin Klein, Issay Miyake, Bottega Veneta, and Jill Sander make direct reference to art galleries. This is no trivial observation, since it reveals not a sales technique or strategy but rather a scission in the concept of art. Today' s concept of art is a modern one that began to emerge during the Renaissance. Before that, art was understood to mean something closer to the modern idea of craft; that is, care in the manufacture of objects. This concept can be transferred to the world of fashion. Thus, if we take into account that the separation between fine arts and the applied arts is quite a recent one, the parallel between boutiques and painting and sculpture galleries is neither forced nor artificial; on the contrary, it reflects a natural vocation.

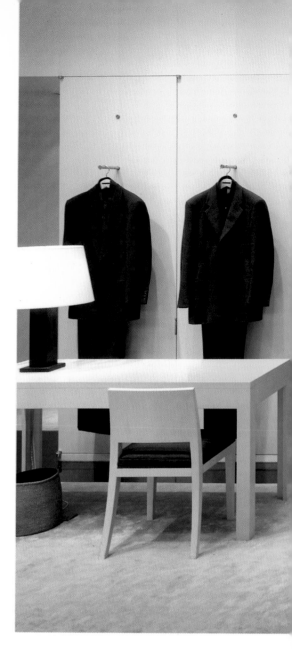

architect pursues maximum rationality and bases new concepts of space, scale, perception, and composition on the repetition of forms alluding to industry and mass production. From the perspective of the world of commodities, Marino' s Minimalism opposes repetition. It seems to imply that we must resist the excess of objects and saturation of figurations, and that what human beings need is an empty space that will allow them to forget former references and find themselves.

Marino seeks unity of formal language as a guarantee of the quality of the architectural work. His œuvre reveals sophistication and technological purity alongside fascination for the world of materials: "We must be faithful to mate-

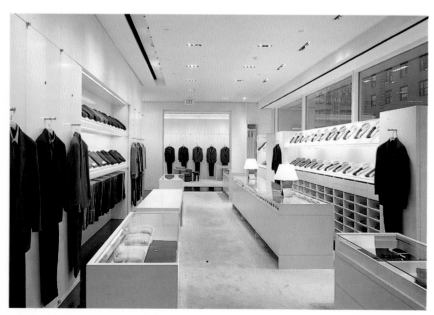

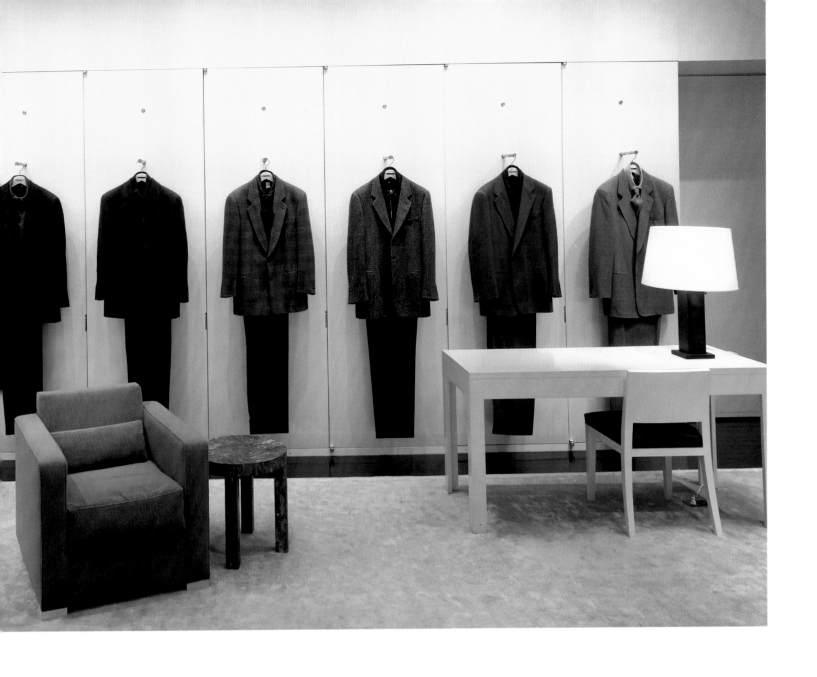

The second floor, devoted entirely to men' s fashion.

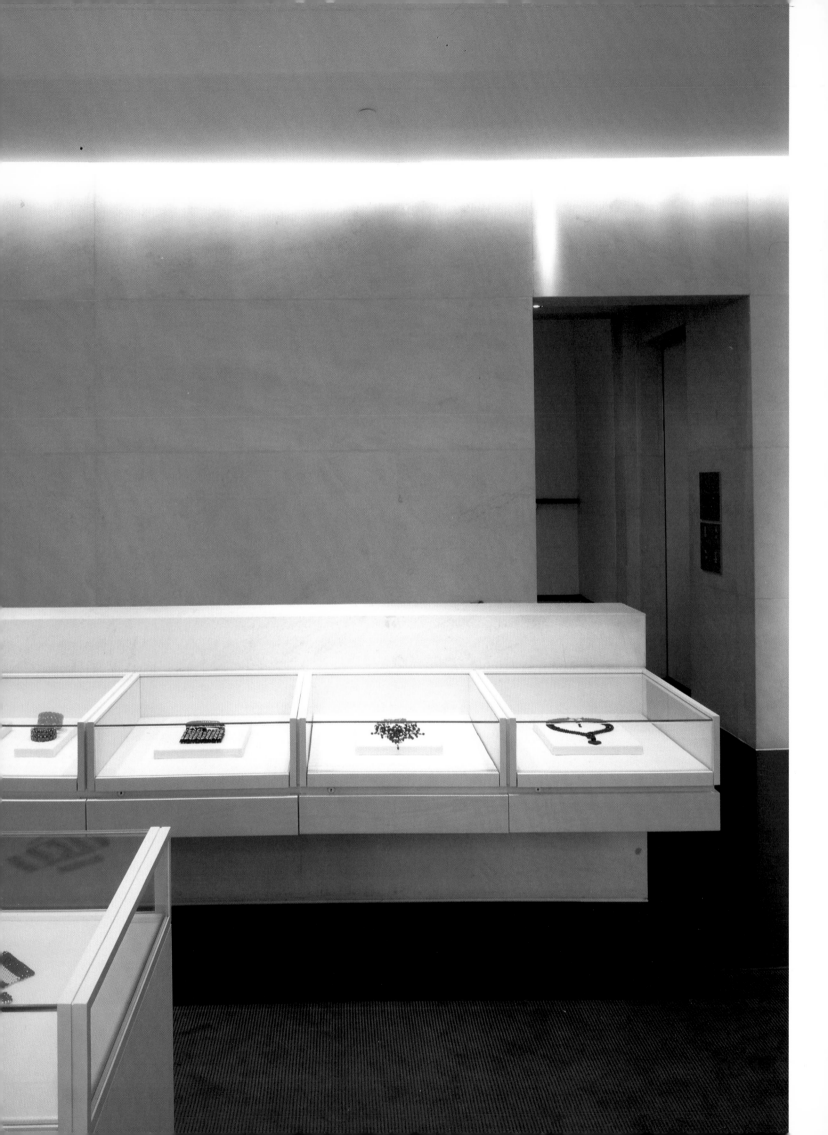

Third floor plan.

rials," he asserts. He uses French lime-
stone and glass to express the material
quality of form, but he empties this form
of social, cultural, and historical content,
and accepts technology as an everyday,
natural fact. The structure is of steel and
rests on existing foundations.

Color disappears because it is dis-
tracting and bothersome. The only col-
ors accepted are pure ranges of black
and white; that is, the absence of color.
In a way, the Armani style also pursues a
certain asceticism and abstraction in a
world of overabundance and effete and
excessive ornamentation. Although this
may not have been his ultimate objec-
tive, Peter Marino' s building certainly
represents the style it contains.

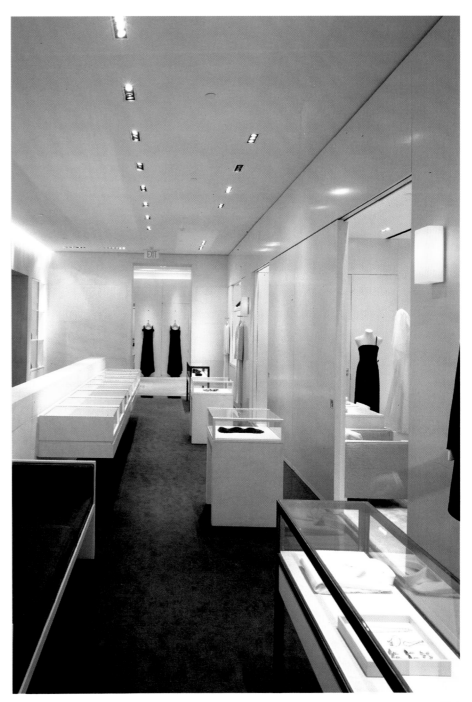

Tadao Ando

1941. Born in Osaka, Japan.

1962-1969. Teaches himself architecture. Travels in the United States, Europe and Africa.

1969. Founds Tadao Ando Architect & Associates.

1975. Azuma House.

1981. Koshino Houses, Hyogo.

1995. Pritzker Prize.

Main works, 1990-1997: Buddhist Water Temple, Hyogo. Japanese Pabilion at the 1992 Seville Expo. Forest of Tombs Museum hall, Well am Rhein. Sanctuary Museum, Osaka. Meditation space for the UNESCO headquarters.

Carlo Baumschlager

1956. Born in Bregenz, Austria. Studies at the Vienna Technical School.

1982. Graduates from the Hochschule für Augewandte Kunst.

1984. Founds a studio With Dietmar Eberle.

Dietmar Eberle

1952. Born in Hittisau, Austria. Studies at the Vienna Technical School.

1984. Founds a studio With Carlo Baumschlager.

Main works, Baumschlager & Eberle entre 1990-1997: Häusler House. Burger House. Holz Altenried Warehouse and offices. Raittensen Bank offices in Bregenz. Martinspark Hotel, Dornbirn.

Francois de Menil

1945. Born in Houston, Texas. During the seventines and eighties produces and directs documentaries, films and theater pieces.

1987-1990. Works With Richard Meier, Kohn Pedersen Fox Associates y Nagel & Lesser.

1991. Founds his own architecture studio.

Main works 1990-1997: Esquire offices in New York. Byzantine Fresco Chapel Museum, Houston. Bottega Veneta store in New York New Jersey, Boston and Tokyo.

Daniel Freixes
Varis Arquitectes

1946. Born in Barcelona.

1970. Studies at the Escuela Superior de Arquitectura, Barcelona. Founds Varis Arquitectes with Vicente Miranda, Eulalia Gonzalez and Pep Angil.

Main Works, 1990-1997: Parc del Clot, Barcelona. Cinema Museum, Girona. Corner Bar in the Gran Hyatt hotel on Potsdamer Platz, Berlin (with Rafael Moneo).

Massimiliano Fuksas

1944. Born in Rome.

1969. Graduates in architecture from Roma University.

Main works, 1990-1997: Sports complex in Paris. University of Brest Literature Faculty. St. Exupery School in Noisy-le-Grand. Entry of the Niaux caves. Saint-Clair student residence.

Mikko Heikkinen

1949. Born in Savonlinna, Finland.

1969-1986. Works for the Kristian Gullichsen, Sôderlun-Valovirta, and A-konsultit studios.

1974. Founds a studio with Marku Komonen.

Markku Komonen

1945. Born in Lappeenranta, Finland.

1974. Graduates in architecture from the Technical University of Helsinki.

1974. Founds a studio with Mikko Heikkinen.

Main works by Heikkinen & Komonen 1990-1997: RovaniemiAirport Terminal. Escue Services School in Kuopio. European Cinema School, Denmark. Old-people's home in Vantaa.

Jacques Herzog

1950. Born in Basel, Switzerland.

1975. Graduates in architecture from the ETH Zurich.

1978. Forms an association with Pierre de Meuron.

Pierre de Meuron

1950. Born in Basel, Switzerland

1975. Graduates in architecture from the ETH Zurich.

1978. Forms the association with Jacques Herzog.

Harry Gugger

1956. Born in Grezenbach,, Switzerland

1990. Graduates in architecture from the ETH Zurich.

1991. Joins the Herzog & de Meuron team.

Cristinte Bisnwanger

1964. Born in Kreuslingen, Switzerland

1990. Graduates in architecture from the ETH Zurich.

1994. Joins the Herzog & de Meuron team.

Main works by Herzog & de Meuron entre 1990-1997: Ricola factory in Mulhouse. Housing on Schutzenmatt St., Basel. Antipode 1 student residence, Dijon. Residential complex on Pilotengasse, Vienna, Gootz Art Gallery, Munich.

Adolf Krischanitz

1946. Born in Schwartzech/Pongau, Austria.

1979. Having completed his architecture studies at the Technischen Universitat Wein, sets up his own studio in vienna.

1988-1989. Guest lecturer at the Technischen Universität München.

Since **1992** lecturer at the hochschule der Künste, Berlín.

Main works, 1990-1997: Exhibitions pavilion in Karlsplatz, Vienna. Housing in the Pilotengasse, vienna. Exhibitions hall in Krems houses.

Peter Marino

Born in New York.

1971. Graduates in architecture from Cornell University.

1971-1978. Works for Skidmore, Owens & Merrill and I.M.Pei/Cossutta & Ponte.

1978. Funds Peter Marino & Associates.

Main works, 1990-1997: Barneys in New York, Los Ángeles, Chicago and Tokyo. Stores for Chanel, Yves Saint Laurent, Calvin Klein, Donna Karan, Christian Dior...

Hiroshi Naito

1950. Born in Yokohama, Japan.

1974. Graduates from the University of Waseda.

1976-1978. Works for Fernando Higueras, Madrid.

1979-1981. Works with Kiyonori Kutake in Tokio.

1981. Founds Naito Architect & Associates.

Main works 1990-1997: Autopolis Art Museum. Fishing Museum Shima Art Museum. Houses. 11, 12, 13, 14, 15, 16.

Hiroshi Nakao

1961. Born in Kobe, Japan.

1989. Graduates in architecture from Tsukuba University.

1989. Founds his own professional studio.

Main works 1990-1997: N House in Kobe. S House in Mishima. A House in Kobe. I House in Tokyo. Summer House in Komoro.

John Pawson

1949. Born in Halifax, UK.

Pawson has come relatively late to architecture. Having worked for seven years in the family textile mill in Yorkshire, he traveled in India, Australia and Japan, where he taught for seven years at the Nagoya Business University.

1981. Founds his own architecture studio.

1989. Neuendorf house in Majorca, with Claudio Silvestrin.

Main works, 1990-1997: House for John & Catherine Pawson Londres. Jigsaw stores in London, Yokohama and Tokio. Calvin Klein stores in New York, Tokio and Seoul. Michael Hue-Williams and Kitty North galleries in London.

Dominique Perrault

1953 Born in Clermont-Ferrand, France.

1978 Graduates in architecture from the Paris Architecture University.

1979 Studies urban planning at the National Civil Engineering School, Paris..

1980 Graduates in history at the Social Scinces School, Paris.

1982-1984 Works for APUR (Atelier Parisien d'Urbanisme).

1985 Founds his own professional studio.

Recent projects: Ivry-sur-Seine; water purification plants. Ground Andre Block of 93 apartments, Paris. Swinming pool and cycle track, Berlin.

Rudy Ricciotti

1944. Born in Algiers.

1977. Founds his own studio in Bandol, France.

Main Works, 1990-1997: School in Sausset-les-Pins. Villa Bonnefoy in Toulon. Regional Traffic Information and Information and Coordination Center, Marseille. Dance hall in Saint-Raphaël.

Eduardo Souto de Moura

1952. Born in Oporto, Portugal.

1974-1979. Works in Alvaro Siza's studio.

1980. Graduates in architecture from Oporto University.

1980. Founds his own design studio.

Main works, 1990-1997: Cultural Center, Oporto. House in Alcanena. Bom Jesus House. Geosciences Institute, Aveiro. University.

Shigeru Uchida

1943. Born in Yokohama.

1966. Graduates from the Kuwasawa Design School, Tokyo.

1970. Founds Uchida Design Studio.

Main works, 1990-1997: La Rananta Restaurant. Mira Mar and Bahia blanca restaurants on the top floor of the Osaka World Trade Center. foyer of the Kyoto Hotel.

Ignacio Vicens y Hualde

1976. Graduates from Madrid University.

1982. Founds Ignacio Vicens & Jose Antonio Ramos Arquitectos Asociados.

Jose Antonio Ramos Abengozar

1982. Graduates in architecture from the Escuela Tecnica Superior, Madrid.

1982. Founds Ignacio Vicens & José Antonio Ramos Arquitectos Asociados.

Main works by Vicens & Ramos 1990-1997: Huete House in Las Matas. Mercado Alcázar de San Juan. Market. Cultural Center and Library in Socuéllanos. Santísima Trinidad Paris Church in Collado Villalba.